the
ultimate guide
to digital nature photography

by the **Mountain Trail Photo** team

in association with:

NATURE PHOTOGRAPHERS NETWORK
WWW.NATUREPHOTOGRAPHERS.NET

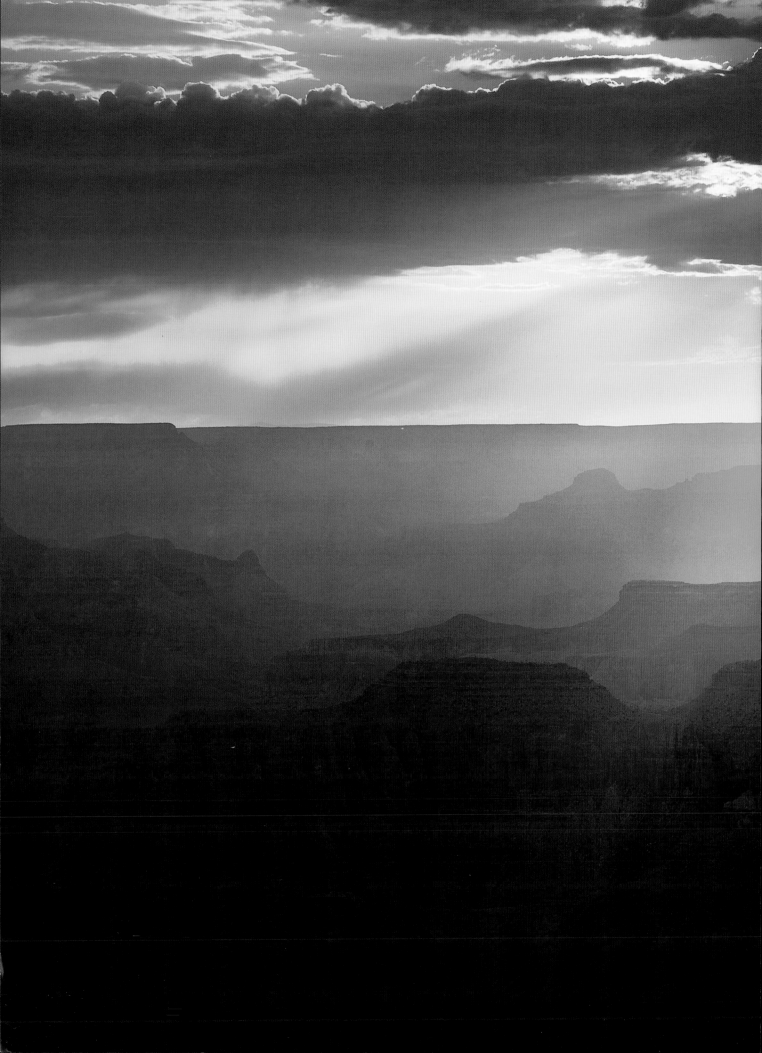

the ultimate guide
to digital nature photography

featuring images by:

richard bernabe

ian plant

jerry greer

joseph rossbach

george stocking

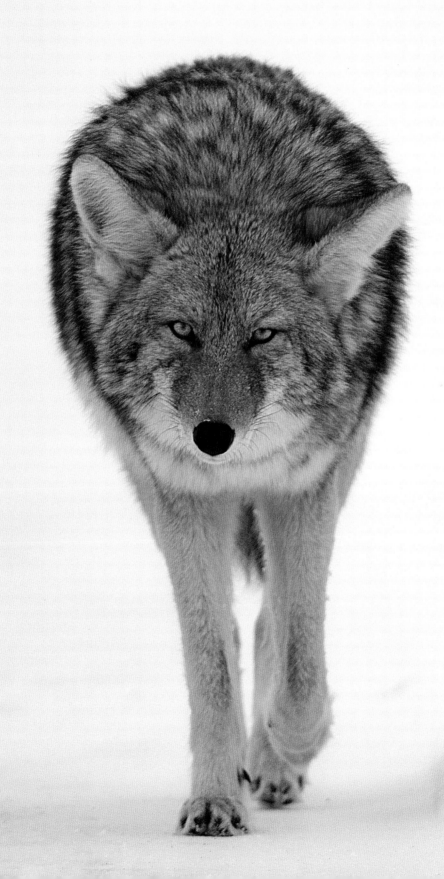

bill lea

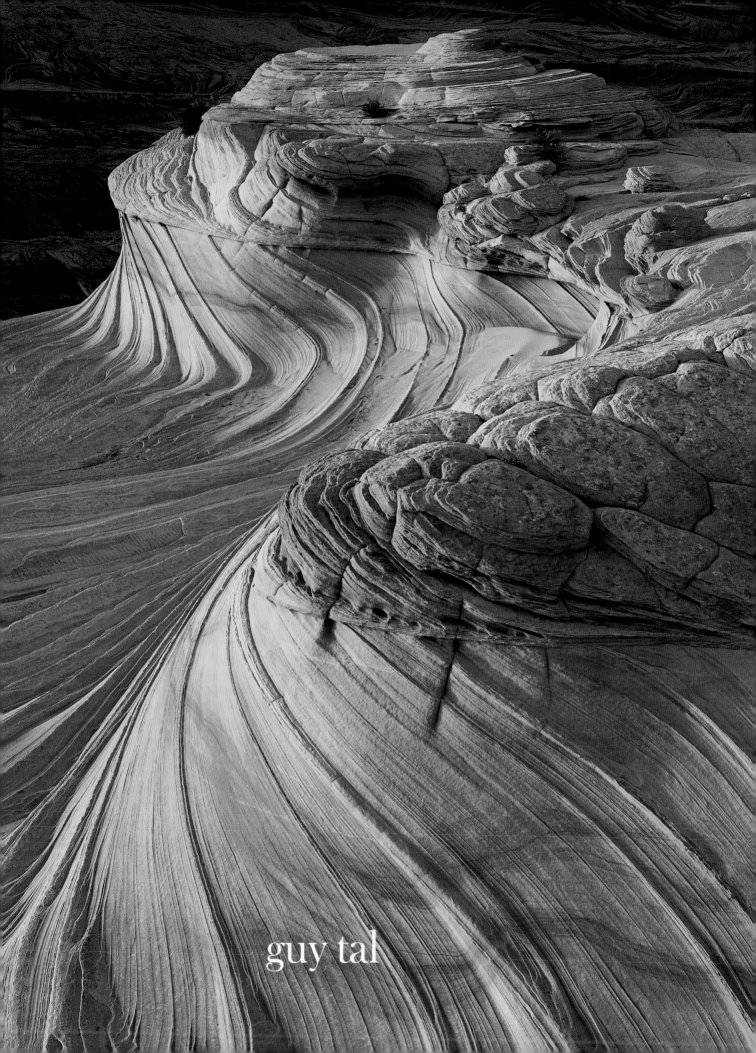

guy tal

nye simmons

jim clark

marc adamus

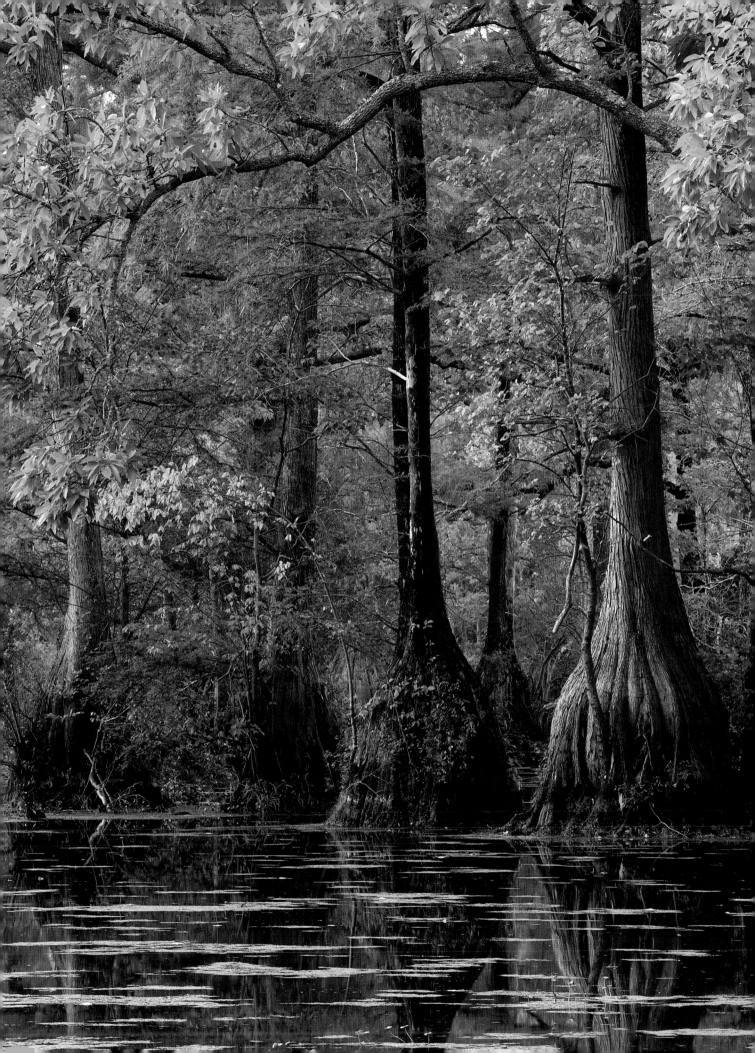

the ultimate guide

to digital nature photography

by the **Mountain Trail Photo** team
www.mountaintrailphoto.com

in association with:

NATURE PHOTOGRAPHERS NETWORK
WWW.NATUREPHOTOGRAPHERS.NET

MOUNTAIN TRAIL

PRESS

Celebrating America's Most Scenic Places

www.mountaintrailpress.com

Book design: Ian Plant & Richard Bernabe
Executive editors: Richard Bernabe & Ian Plant
Contributors: Richard Bernabe, Ian Plant, Jerry Greer, Joseph Rossbach, George Stocking, Bill Lea,
Guy Tal, Nye Simmons, Jim Clark, and Marc Adamus
Copy editor: Abbey Greer
Entire Contents Copyright © 2009 Mountain Trail Press
Photographs © Individual Photographers
All Rights Reserved
No part of this book may be reproduced in any form without written permission from the publisher.
Published by Mountain Trail Press
1818 Presswood Road
Johnson City, TN 37604
ISBN: 978-0-9799-1718-9
Printed in China
Second Printing, Summer 2009

Library of Congress Control Number: 2009900507

Front Cover: *Cloud over Mount Tom, Sierra Nevada Mountains, California (by Guy Tal).*

Title Page: *White-tailed deer fawn, Shenandoah National Park, Virginia (by Ian Plant).*

Two-Page Spread: *Summer monsoon sunset from Desert View, Grand Canyon National Park, Arizona (by George Stocking).*

Opening Pages:
Richard Bernabe: *Tidal stream, Edisto Island, South Carolina.*
Ian Plant: *Snowy egret, Chesapeake Bay, Maryland.*
Jerry Greer: *Crabtree Falls, Blue Ridge Parkway, North Carolina.*
Joseph Rossbach: *Potomac Cascades, Great Falls Park, Virginia.*
George Stocking: *Sandstone feature, Vermillion Cliffs National Monument, Arizona.*
Bill Lea: *Coyote walking along a snowy path, Yellowstone National Park, Wyoming.*
Guy Tal: *Sandstone formations, Coyote Buttes, Arizona.*
Nye Simmons: *"Hardwood Tapestry in Fog," Blue Ridge Parkway, North Carolina.*
Jim Clark: *Eastern tailed blue butterfly, Canaan Valley State Park, West Virginia.*
Marc Adamus: *"November Seventeen," Banff National Park, Canada.*

Left: *Cypress and tupelo swamp, Merchants Millpond State Park, North Carolina (by Jerry Greer).*

the shot of a lifetime . . .

We've all had those moments. Moments when you see something so incredible you know no one back home will believe you—unless—you have a picture! You reach for your camera and start firing away. You get home and expectantly review your images, only to find that the Bigfoot you saw tap-dancing under a rainbow is all fuzzy and underexposed. Time to cancel all of your daytime talk show appearances . . .

Don't miss that once-in-a-lifetime shot because you don't know how to properly use your equipment! And certainly don't take that once-in-a-lifetime moment and render it oh-so-boring because you don't know how to make the most of the lighting and compositional opportunities offered to you! Our mission is to make sure this never happens to you. To that end, our goal is for this book to teach you both technical proficiency and artistic skills in a way that no other book will.

That way, when you are presented with that "no one is going to believe me" moment, you'll nail it, just like Mountain Trail Photo team member Bill Lea did when he got this image of tap-dancing bears (sorry, no Bigfoot or rainbows in this one, but heck, this bear image *is* super cool). These were *wild* bears, not trained animals or animals on a game farm. They're both black bears, but the one on the right has a rare white coat. When the two bears got close, Bill sensed a brewing conflict, and a photographic opportunity.

Long hours photographing bears had taught him that such encounters often get feisty. Sure enough, the two bears playfully scuffled before parting ways. Many years of experience in the field all culminated at this moment, and Bill knew the proper camera settings, and the proper composition, to capture this unique moment, and what's more, to make it really shine.

Despite their name, once-in-a-lifetime moments happen more often that you would think. In fact, a skilled nature photographer makes it his or her business to find such moments on a regular basis. The techniques we discuss in this book will give you a better understanding of the natural world, its rhythms and its pulse, its myriad shades of color and tones of light, its wonderful diversity and abundant wildness. It will give you a better sense of your place in this world, and how to capture its primitive essence.

That way, you will be able to predict when once-in-a-lifetime moments will occur, and you can be in the right place, at the right time, camera ready, armed with confidence in your technique. You'll be ready for a lifetime of once-in-a-lifetime moments, and you'll love every minute of it!

Two black bears playing, Vince Shute Wildlife Sanctuary, Minnesota (by Bill Lea).

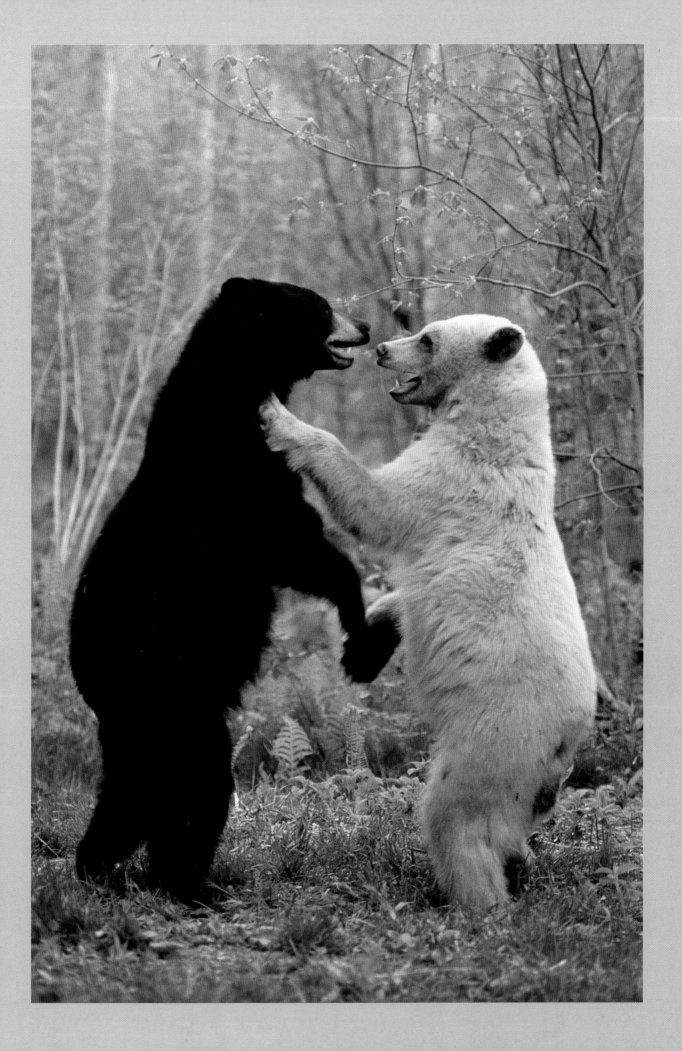

table of contents

table of contents

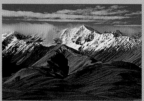
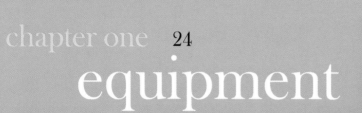

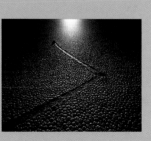

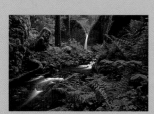
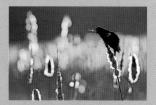
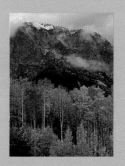
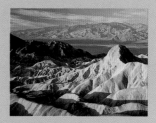
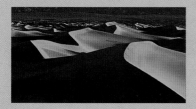

foreword foreword

As dawn broke, the December ice storm finally began to diminish. Over the course of about 20 hours it had created a winter wonderland, the likes of which I had never seen before. The photographic opportunities were both unique and countless, but we were without power and the house was getting cold. With the snow turning back to a cold drizzle, I ventured a few steps outside with camera in-hand to "grab a few shots" before getting to the task of snow removal and setting up a portable generator. The wondrous winter scenes would last only a few days but the power outage a week.

Like you, I am a nature photography hobbyist. Tied down to a full time job, my time spent peering through the camera's viewfinder is done entirely for self gratification and only as my very limited recreation time permits. Like you, my goal as an amateur photographer is to achieve the very best results possible without having to spend a lot of time or a fortune learning how to do so. The best way to accomplish this is to learn from the pros.

The Ultimate Guide to Digital Nature Photography is a compilation of expert tips and advice by some of today's most talented professional nature photographers. As the founder of the Nature Photographers Network™ and publisher of Nature Photographers Online Magazine, I have been fortunate over the years to view their photos and read their articles, each of which provides insight into the making of exceptional nature photos. I never cease to marvel at the places they have been or the lengths they go to in the pursuit of their craft. For the authors of this guide, nature photography is not only a profession, but an all-encompassing passion as well.

In this book, the authors' collective expertise and passion are clearly communicated in an easy-to-understand fashion. They will walk you through the basics of equipment selection and operation, and then explain and illustrate how to find, capture and produce digital nature photos that stand above the rest. The Ultimate Guide to Digital Nature Photography compresses decades of photographic experience and countless clicks of the shutter into an effective, easily digested guide that will quickly make you a better nature photographer.

As I stepped out the door on that cold winter day, I absorbed the crystalline ice world in front of me. Even with the limited experience typical of an amateur, the lessons I had learned from reading and viewing the work of the pros quickly came into play. On a tiny ice formation on a shrub in front of our house, I brought to bear the lessons of seeing, lens selection, setting tripod/camera position, composing, selecting f-stop, plane of focus and exposure. Later in the day, after the snow was cleared and heat back on, instead of being greeted with disappointment on my monitor, I was elated with perhaps one of my best nature photos ever. After reading this book and applying the lessons learned, I'm sure you will be pleased with your results too.

Jim Erhardt, Founder
Nature Photographers Network & Nature Photographers Online Magazine

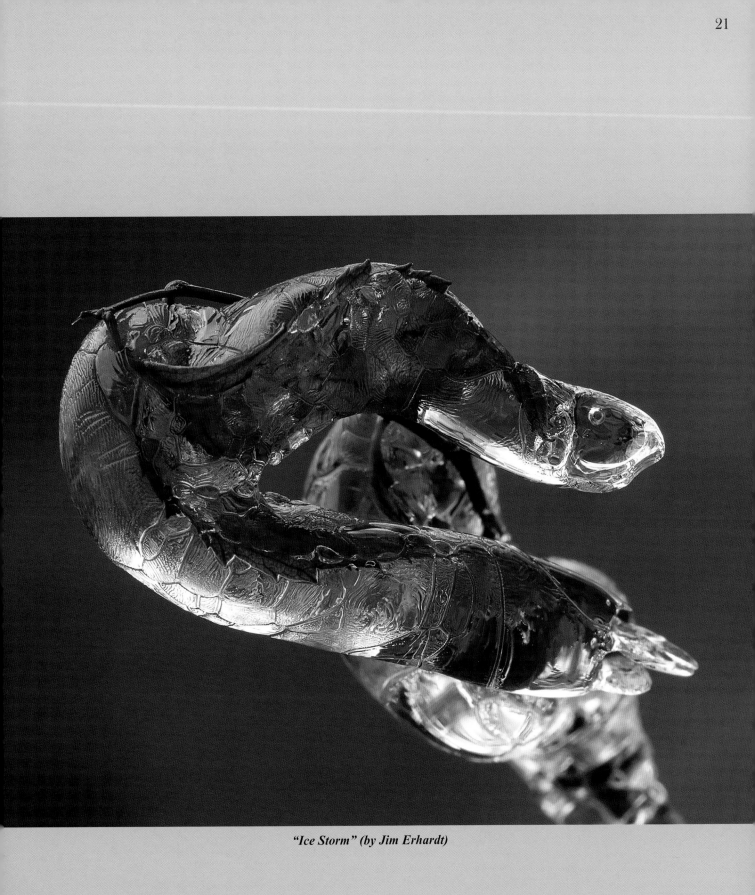

"Ice Storm" (by Jim Erhardt)

introduction

W e're not going to waste any time trying to make you a good photographer. Good photographers are a dime-a-dozen, and we know, deep down, that good is not good enough for you. Instead, we're going to make you a *great* photographer. Sure, we'll teach you the basics, and take you through your baby steps until you can walk on your own. But we're not going to stop there. This book will teach you how to fly.

Nature photography is, in many ways, the most difficult of art forms. It is difficult because you lack control over your environment. You are not working in a studio with a controlled climate, controlled lighting, and controlled poses. Instead, you are at the mercy of the clouds, wind, weather, and biting insects. And to top it all off, you are further at the mercy of your capricious subjects—you cannot tell a flowering plant to be in bloom for you, and you cannot make a grizzly bear do *anything*, let alone pose for you in the perfect light. You cannot make the sun shine brighter or the fog thicker or the ocean stop spraying salt water all over you and your camera. They say great art springs from suffering. Well, let's face it—few suffer more than nature photographers!

In order to become a great nature photographer, you first need to learn to *anticipate*. You cannot make the grizzly bear do what you want, but you can learn its behaviors, and learn to be in the right place at the right time. But anticipation is only half the battle—in order to turn all of your preparation into great images, you need to learn to *react* to what the scene offers. So, once you know where the grizzly will be and when it will be there, you must wait for that moment when it all comes together (if ever it does), when light, mood, and pose create a stunning image. And when this happens, you had better be ready to click the shutter, and more important, you had better know what you are doing!

There's nothing worse than the feeling you get in the pit of your stomach when you know you missed a once-in-a-lifetime shot for no better reason than simply not knowing what to do. Let's face it, we've all been there—and none of us liked it. Our goal is for you to never feel that way again.

Collectively we've been photographing the American wild for over a century; sold over 100,000 nature photography books and calendars; taught hundreds and hundreds of photography workshop students; and our images and instructional articles have been published in dozens of nature and photography magazines. Even with all this experience, we don't pretend to be experts on a subject as prodigious as nature photography. One can never be an expert—there's always more to learn, it seems, no matter how much you know—but we can offer some practical advice, some inspiration, and perhaps even some wisdom. This book will take your photography to places you never dreamed of before.

The Mountain Trail Photo Team
www.mountaintrailphoto.com

"Edge of Dreams," Southeastern Oregon (by Marc Adamus)

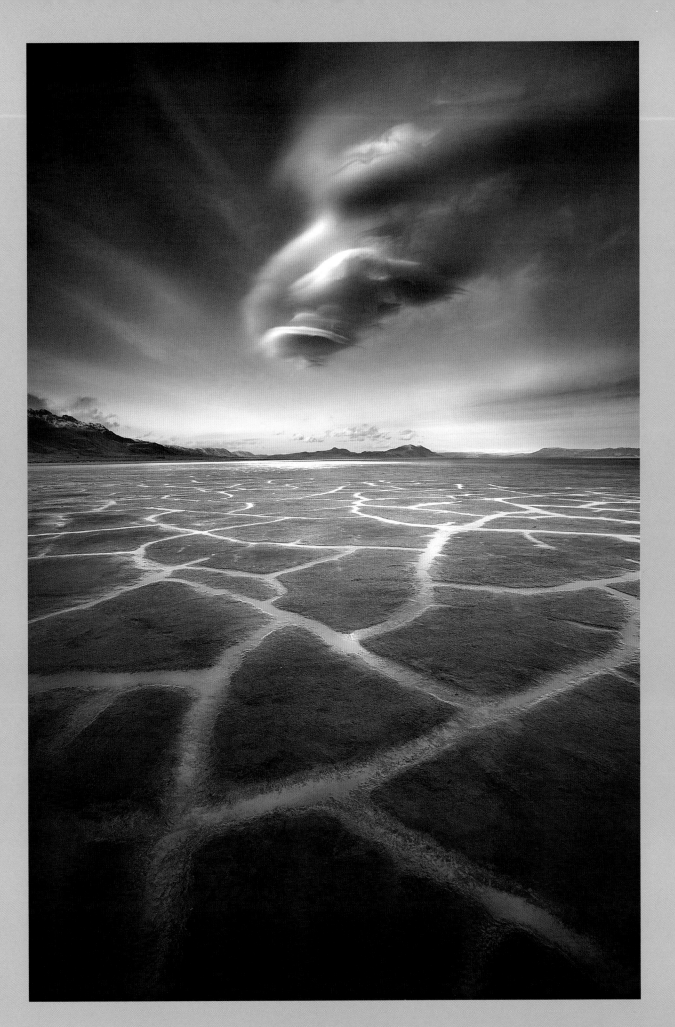

equipment

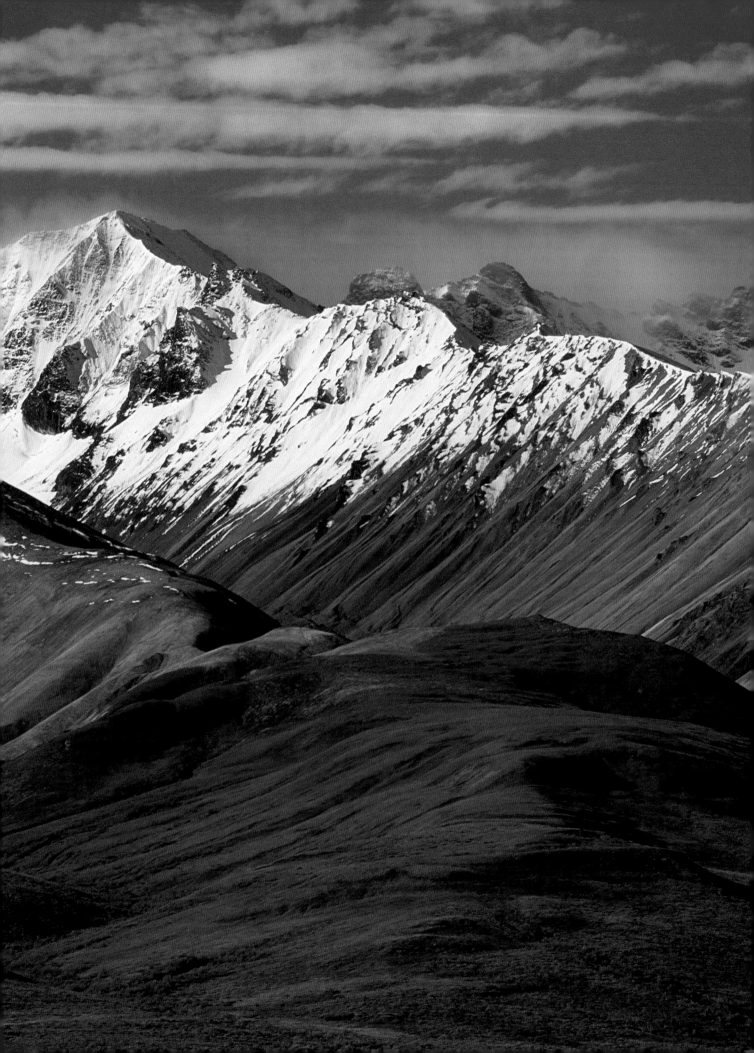

It is often said that cameras don't take pictures, people do. With that said, it would be extremely difficult to do photography without a camera! Some photographers obsess and agonize over their photography equipment choices while others dismiss it all as only necessary tools to transform their vision into a tangible photograph. The right approach probably resides somewhere between the two, which means that at least some attention to photography equipment is important and necessary.

CHOOSING YOUR CAMERA

There are so many choices out there, it can be hard to settle on just one. For decades film cameras dominated the nature photography world, but within the past few years, the digital camera has come into its own. Beyond the basic film-vs.-digital choice, there are many different camera formats that can be used in nature photography, ranging from the popular point-and-shoot consumer cameras to the enormous and complex old style large format cameras.

Of course, not every camera system is well suited to all types of nature photography. While a large format camera might be suitable for landscape work, it will not be very useful if you are primarily interested in photographing wildlife or macro subjects. And while a compact consumer camera might be easily portable, it may not have sufficient quality to meet your needs as a serious nature photographer. Even if you plan to specialize in one type of nature photography, it makes sense to buy a camera system that maximizes

your versatility. Who knows—even if you decide to only shoot landscape, there may be occasions when you want to photograph wildlife—or, you might want to use an extra long lens to get an "intimate" landscape shot.

But is there one camera system that will allow you to shoot all types of nature photography and still get high quality results? Of course! The answer is the versatile Digital Single Lens Reflex camera—the incredible DSLR.

Above: Polychrome Pass, Denali National Park, Alaska (by Bill Lea). You don't want to end up in a distant location and find out that you don't have the right equipment! A rugged, weather-sealed DSLR is perfect for difficult shooting environments like the Alaskan wilderness.

Right: Morton Overlook, Great Smoky Mountains National Park, Tennessee/North Carolina (by Jerry Greer). Picking the right equipment won't necessarily mean you can get shots like this, but it sure helps! A DSLR's instant feedback helps when working with tricky compositions and light.

THE DSLR ADVANTAGE

The versatile DSLR camera is the most popular camera type in the world. DSLR stands for digital single lens reflex; where the composition, metering, and actual exposure of the digital sensor are all done through the lens. DSLRs are the most commonly used cameras for nature photography, and for good reason. They possess certain distinct advantages over other camera formats and over film cameras as well. To name a few . . .

Instant feedback: Digital cameras allow you to instantly review an image right after you have taken it, even allowing you to zoom in 100% to see if the image is correctly focused. The ability to instantly review images, make sure your exposure is correct, and delete your mistakes is of enormous value. You know right away whether you got the shot or not!

Cost: DSLRs are considerably cheaper than larger digital formats, and the cost of shooting digital is much cheaper than the cost of shooting film. Not to mention, you don't have to waste time with film processing.

Quality: Most DSLRs today offer higher quality than all but the largest of film formats.

Variable ISO: ISO, analogous to film speed, can be freely changed between shots, allowing you to use a slow speed to capture a finely detailed landscape shot one moment, and a high speed to capture a bird exploding into flight the next. Try doing that with film!

Ruggedness: Most DSLR camera bodies are mechanically robust, giving them more than adequate protection from mishaps in the field and inclement weather. Many DSLRs are sealed for water and dust, weatherproof, and even shock-

proof. Not all DSLRs are created equal, however, and those with a better build quality and ruggedness have a higher price tag attached to them.

Versatility: DSLRs can be used effectively for everything from wildlife to close-up photography and nearly everything in between. A wide variety of lens choices, flash systems and camera accessories are available to fit almost any style or genre of outdoor photography your heart desires.

WYSIWYG: When you peer through the viewfinder, you are essentially looking through the lens–the same avenue the light will be traveling to expose the digital sensor. What you see is what you get!

Modularity: Having a camera system with a separate body and lenses gives you the advantage of mounting an extremely wide range of lenses on a single camera body. You can literally go from shooting a 1200mm telephoto to a 12mm wide-angle scene within seconds.

Artistic control: Digital cameras give you complete control over the image creation process, from start to finish. Having a "digital darkroom" allows you to control brightness, contrast, color, and saturation for an image, as well as giving you the option of making localized adjustments—all without having to spend hours in a dark room filled with noxious chemicals!

The DSLR Advantage: Sand dunes at dawn, Death Valley National Park, California (by Ian Plant). DSLR cameras capture images with stunning detail and color, perfect even for large reproductions and fine art prints. Their versatility and portability make image capture easy and fun.

Canon's 5D Mark II, a 21-megapixel full frame DSLR. Courtesy of Canon USA.

DSLR TYPES

Okay, so we've convinced you to get a DSLR—now what? There are two basic DSLR platforms from which to choose, each based on differences in image sensor size. Quite simply, the imaging sensor is the heart of your DSLR and the source of much of its image quality. It is the device that captures light on millions of pixels and photosites and converts it into digital data. The two most commonly used sensors in today's digital cameras are the CCD (charged coupling device) and CMOS (complimentary metal-oxide semiconductor). Both are equally capable of producing quality images, they just accomplish it in different ways.

Whether based on CCD or CMOS technology, DSLR sensors come in two basic sizes. The first is called "full frame," and is based on an imaging sensor that is the same size as traditional 35mm film, 36 x 24mm. The second size is called an APS or "cropped" sensor because it crops out the edges when used with lenses that are created for 35mm photography.

FULL FRAME SENSORS

The larger surface area of full frame sensors can accommodate more pixels and photosites than the smaller varieties. All things being equal, these sensors generate higher quality images and capture a greater range of tones than the APS-sized varieties. They also provide for a bigger, brighter viewfinder, making it a much easier task when focusing manually.

The larger, full frame sensors are much more expensive to make, driving the prices of cameras they are installed in much higher than comparable cameras with smaller sensors.

CROPPED SENSORS

Smaller sensors have less real estate in which to pack megapixels, so in order to achieve the high megapixel counts found in full frame sensors, something has to give. What gives, essentially, is per-pixel quality.

So why make cropped sensors? Well, several reasons. Cropped sensors are cheaper to make, driving the price down for the cameras that house them. Cropped sensor cameras also tend to be lighter and smaller than their full frame cousins. Another, less intuitive advantage comes from lens quality. Camera lenses tend to be sharper in the center, with sharpness falling off when one reaches the corners. When using lenses designed for full frame cameras on a cropped sensor camera, those nasty inferior corner areas are literally cropped out, leaving only the sharpest parts of the lens for image making.

Another advantage—or disadvantage, depending on your point of view—comes from this cropping

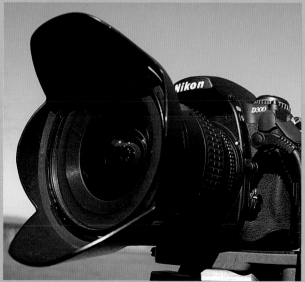

Nikon's D300 12-megapixel digital camera.

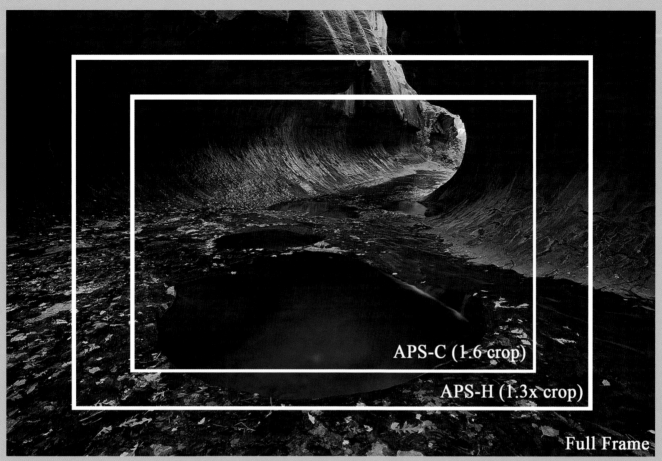

The Subway, Zion National Park, Utah (by Guy Tal).

factor. When lenses are used on a cropped sensor camera, their angle of view is altered and the working focal length changes. Most "crop factors" are 1.3x (APS-H size), or 1.5x or 1.6x (APS-C size), so to determine the translated focal length in terms of actual angle-of-view, you would multiply the focal length of the lens by the crop factor. For example, an APS-C DSLR with a 1.5x crop factor and a 24mm lens has the same angle of view as a 36mm lens on a full frame body: 24 x 1.5 = 36.

An obvious drawback when using a cropped-sensor camera with a wide-angle lens is that it's not nearly as wide as intended. This, of course, is an advantage if your desire is to have a longer focal length when shooting birds or wildlife. The crop factor acts as a focal length multiplier, making your 400mm lens the equivalent of a 600mm lens when used with an APS-C 1.5x sensor. In order to mitigate the crop-factor penalty on the wide end, lens manufacturers now make extra-wide lenses specially for APS sensors—but they still can't get quite as wide as with full frame.

WHICH TO CHOOSE?

Which camera format you choose will depend on your budget and shooting preferences. Full frame sensor cameras are great for landscape and ultra-wide angle shooting, although cropped sensor cameras work just fine for most landscape work. Many wildlife photographers prefer cropped sensor cameras because of the lens multiplication factor. Photographers who shoot both landscape and wildlife often have two bodies: a high resolution full frame camera for landscapes, and a cropped sensor camera that is used for wildlife and as a backup landscape camera.

A quick note on other digital formats: point-and-shoot compact cameras are simply not adequate for serious outdoor photography. Larger format digital cameras (based on medium and large format camera systems) have higher quality but are much more expensive (a complete system can cost up to $50,000 for just the camera and a few lenses) and much less versatile, making them impractical for most nature photographers.

DSLR FEATURES

The good news is that most modern DSLRs are of exceptional quality, so it almost doesn't matter which one you get, you will have in your hands a superlative creative tool. Still, there are many important features of a DSLR that are worthy of consideration. Which features are important to you depend on the style of your work, what you are shooting, and how much money you want to spend on equipment.

RESOLUTION

If you believe the marketing hype, resolution is king. Digital camera manufacturers are constantly innovating to produce DSLRs with higher and higher "megapixels." What is this all about?

The amount of data and detail that a digital camera can capture is called resolution, which is measured in pixels and megapixels (millions of pixels). The more pixels a camera can capture, the higher the resolution it is said to have. For example, a resolution of 3900 x 2600 pixels = 10,140,000 pixels or a 10 megapixel camera. Another example: a resolution of 5700 x 3800 pixels = 21,660,000 or a 21.7 megapixel camera.

This is oversimplifying things a bit, but by and large the greater the resolution, the better detail and print quality your photos will possess. More pixels and a higher resolution also give you an advantage when cropping an image. The more pixels you start out with, the more pixels you end up with after cropping. Many of today's digital cameras are resolution monsters, capable of delivering stunning, poster-sized prints that are rich in detail and color.

NOISE

Noise and resolution are like enemy combatants grappling with one another. Increasing sensor resolution is usually done by packing more pixels into an already crowded room. These smaller pixels generate noise.

What is noise, you ask? Digital image noise is random specks or graininess, of different brightness levels and color, visible in your image. Several things can cause noise. First, noise is generated by a dense pixel array. That's why cropped sensor cameras have less quality than their full frame counterparts; the denser pixel

Digital Noise

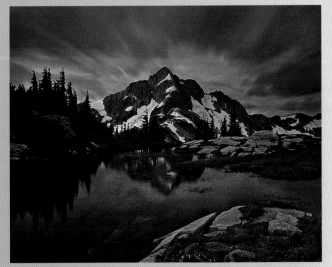

"Still Dreaming," Washington (by Marc Adamus).

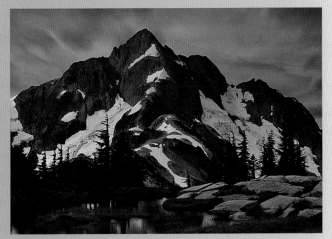

100% crop of the image taken at an optimal ISO.

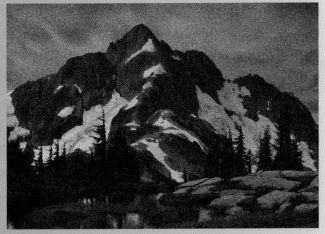

100% crop taken at high ISO.

when the sensor heats up. And fourth, noise is generated when you bump up your ISO to freeze action or to deal with low light situations.

So, as a general matter, higher resolution usually results in more noise. Camera manufacturers have found ways to reduce the creation of noise by creating better hardware—and to mitigate the effect of noise by creating better software—so that some high resolution cameras today actually have better noise characteristics than older, lower resolution models. A camera's noise profile is an important consideration when contemplating a purchase, and worth researching ahead of time.

Iso

ISO determines how sensitive a sensor is to light. This number is analogous to film speed with higher ISO numbers being considered "fast" and lower numbers "slow." Most sensors have a "base" sensitivity of around 100 or 200 ISO, so increases in ISO are accomplished by pushing the sensor's capabilities, which introduces noise.

In the days of color transparency film, your maximum speed was usually around 400 or so—beyond that, film got increasingly grainy and virtually unusable for even small print reproductions. With digital cameras, however, speeds of 3200 and higher are possible. This opens up a whole new world of photographic possibilities for the DSLR user. The ability to work in low light and to stop fast moving action at the touch of a button (and, we might add, without having to change film) has revolutionized nature photography, allowing photographers to push the limits of what was previously considered possible.

Cameras differ in their ability to control noise at high ISO settings, which is typically accomplished through software algorithms. How well a camera handles high ISO noise, and whether such high settings are necessary for your style of shooting, are important considerations when selecting a DSLR.

pitch creates more noise. Second, noise results from underexposure. Digital sensors record photons, and there are more of them in bright areas than in dark. As a result, dark areas of an image have noise in them, whereas properly and overexposed areas have less or no noise. Third, during very long exposures, noise is generated

Left: Middle Prong in spring, Great Smoky Mountains National Park, Tennessee (by Joseph Rossbach). High resolution DSLR cameras capture images with fine detail.

LCD SCREEN

The LCD (Liquid Crystal Display), located on the back of the DSLR, is used for previewing images immediately after they are captured, and viewing menus and image settings. LCD screens vary in size and resolution; the bigger and sharper the screen, the easier it is to use the screen to critically view images.

Live View in action.

LIVE VIEW

Live View is an important camera feature that offers several advantages over the standard optical viewfinder. Live View enables you to see and compose your images with the camera's LCD screen. You can zoom into the image to 100%, which helps tremendously with precise manual focus. Live View is great for checking exposure before an image is taken, and for composing images in confined places. The one negative of Live View is that is can quickly drain your camera's battery power, so it should only be used when necessary.

SPEED

If you do wildlife photography, an important consideration is how many continuous frames per second (FPS) a camera can capture. The higher FPS, the more image-creation opportunities you will have as a fast-moving animal or bird passes in front of you. For this type of photography, 5 to 6 FPS or more is recommended.

Another specification to consider is the buffer size of the camera. The buffer is where the image data is temporarily stored before being written to the memory card. If the buffer fills up, the camera stops taking any other pictures before the remaining image data is written to the card and the buffer is cleared. Camera manufacturers will specify how many continuous JPEGs or raw image bursts can be taken before the buffer fills.

MIRROR LOCK-UP

Mirror lock-up is a feature that some DSLRs have that helps in eliminating unwanted vibrations caused by mirror slap. Before the shutter opens to expose the sensor, the camera's mirror must flip up and out of the way. This potentially causes slight vibrations and soft images during slow shutter speeds. By locking up the mirror before pressing the shutter release, these vibrations are avoided. Mirror lock-up is definitely something you want—it is very useful for landscape and macro work.

DEPTH-OF-FIELD PREVIEW BUTTON

When you peer through the viewfinder or use Live View, you are viewing the scene through the widest aperture of the lens, regardless of the f-stop setting you have chosen on the camera body. This is for ease of viewing and the ability of the camera to autofocus effectively. It is only when you press the shutter release that the lens stops down to the effective aperture for the duration of the exposure. Therefore, you are only seeing the scene with an extremely shallow depth of field that is consistent with the widest aperture of the lens. The depth-of-field preview button mechanically stops the lens down to the working aperture, giving you the ability to see the scene as it would appear in the captured image. Depending upon what f-stop is chosen, the viewfinder will become dark so it helps to give your eyes some time to adjust before viewing the results.

VIDEO

One of the newest capabilities of DSLRs is high definition video. The video feature uses the same still photography lenses with no additional or specialized equipment needed. Although not necessary for nature photography, it can be useful if you wish to dabble in multimedia.

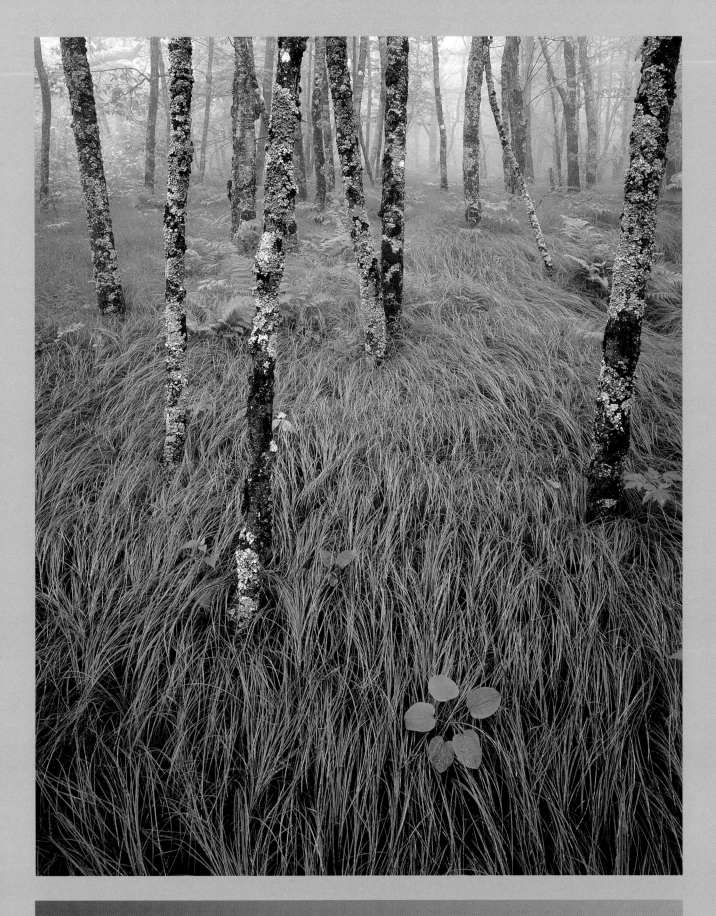

Flowing grass, Craggy Gardens, Blue Ridge Parkway, North Carolina (by Ian Plant). *Mirror lock-up and depth-of-field preview are two essential features when composing highly-detailed landscape images.*

APS Crop Factor Lens Conversion Chart

Below is a chart showing popular focal lengths and their focal length equivalents when used on various APS cameras.

Full Frame	1.3x (APS-H)	1.5x (APS-C)	1.6x (APS-C)
12mm	16mm	18mm	19mm
14mm	18mm	21mm	22mm
17mm	22mm	26mm	27mm
20mm	26mm	30mm	32mm
24mm	31mm	36mm	38mm
28mm	36mm	42mm	45mm
35mm	46mm	53mm	56mm
50mm	65mm	75mm	80mm
70mm	91mm	105mm	112mm
100mm	130mm	150mm	160mm
135mm	176mm	203mm	216mm
180mm	234mm	270mm	288mm
200mm	260mm	300mm	320mm
300mm	390mm	450mm	480mm
400mm	520mm	600mm	640mm
500mm	650mm	750mm	800mm
600mm	780mm	900mm	960mm

LENSES

Once you've selected your camera, you'll find yourself confronted with a bewildering array of lens choices. Not to put any more pressure on you, but lenses are the most important pieces of equipment you will own. Cameras merely record light reaching the sensor—but lenses bend and twist that light, creating the very image that is recorded. Also, the quality of the lens is important: low quality lenses can ruin a great shot or even prevent you from making it, and high quality lenses give you more flexibility to achieve your vision. In fact, in many respects lens choice is more important than camera choice: a high quality lens on a relatively low megapixel camera will still yield sharp images, but a low quality lens on even a super-high megapixel camera will show its flaws. So it is important to make sure you have the right lenses, and sufficient variety so that your vision will suffer no compromises.

That said, remember that lenses, like every other piece of equipment you will ever own, are nothing more than hammers and screwdrivers: they are only tools, and it is your artistic vision that will define your work. Of course, having the right tool for the job is important (remember the old expression "don't bring a knife to a gunfight"), and some tools are better than others. Just don't freak out about lens choice: most modern lenses are pretty good, so get the best lenses that you can afford, and don't worry if your lenses aren't all top of the line or state of the art. Great images can be made even with bad lenses!

First, we'll discuss the *types* of lenses that are available. Then, we'll discuss various lens *features* that you should consider when making lens purchases. Finally, we'll discuss considerations concerning the quality of lenses.

As previously mentioned, any discussion of lenses is complicated by the fact that camera manufacturers offer several different sensor sizes. These different sizes mean that a lens of the same focal length will offer different fields of view on different cameras. To recap, this effect is called a "multiplication factor" based on the standard 35mm film size sensors. The smaller the sensor, the greater the multiplication factor. For example, an APS-C sized sensor offers a 1.6x multiplication factor over a standard sensor. So a 100mm lens used on an APS-C sensor offers an equivalent field of view as a 160mm lens on a normal sensor. Confused? The table above will help.

Right: Grizzly bear (by Bill Lea). Despite its relaxed pose, Bill didn't want to get too close to this enormous grizzly bear! A long telephoto lens was perfect for keeping a respectful distance even when getting a tight, frame-filling portrait.

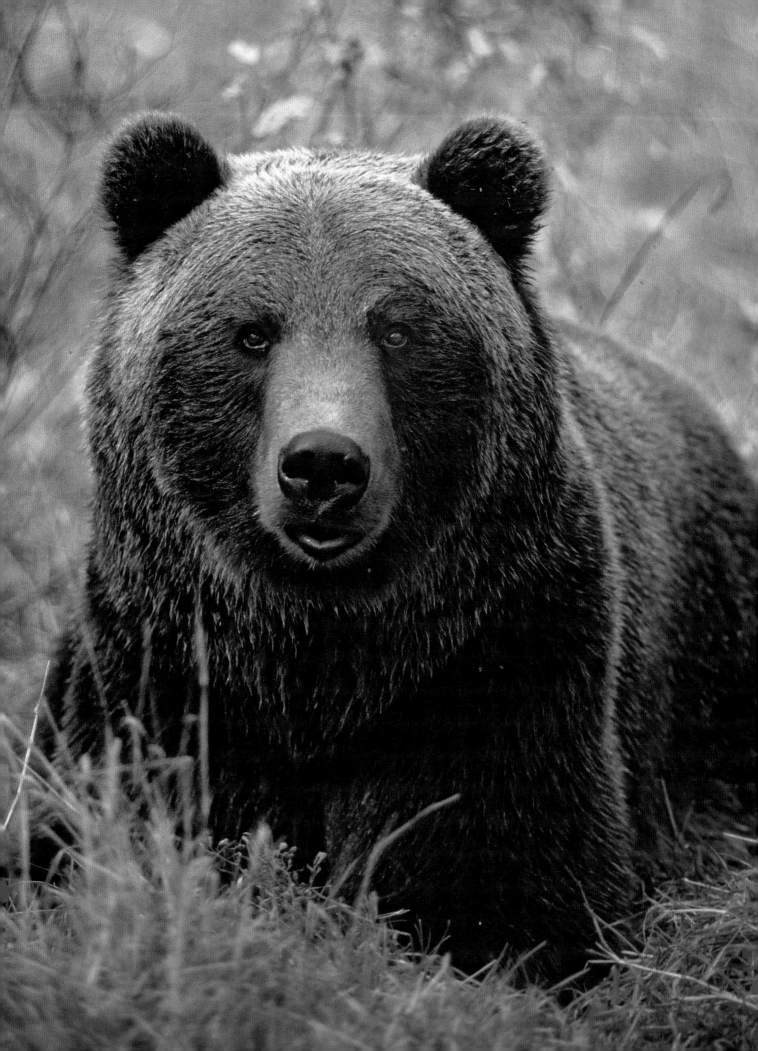

So many lenses to choose from! Courtesy Canon USA.

NORMAL LENSES

So-called "normal" lenses are those lenses that offer a field of view that is similar to what our eyes see. Traditionally, a 50mm lens is considered the base-line—anything more than 50mm magnifies the scene compared to what human eyes would see, and anything less offers a wider view and makes elements in the scene appear smaller. On smaller size sensors, a normal lens would be around 30mm. In practice, lenses ranging from 40mm to 70mm (or approximately 30mm to 45mm in smaller sensors) are often considered "normal."

WIDE-ANGLE LENSES

Wide-angle lenses offer a field of view that is wider than normal lenses. They "take in more" of a given scene, and make objects in that scene appear smaller. Landscape photographers often use them because of their expansive field of view. Wide-angle lenses are very useful when juxtaposing nearby foreground elements with more distant background elements, such as a field of flowers (foreground) below rocky peaks (background). Wide-angle lenses are usually in the range of 20-35mm (12-22mm for smaller sensors).

ULTRA-WIDE ANGLE LENSES

Ultra-wides reside in the very lowest end of the lens millimeter range. Any lens wider than 20mm can lay claim to the title of ultra-wide (or below 12mm for smaller size sensors). Ultra-wides offer a truly unusual perspective, taking in much more of the scene than our eyes can see. Their wide angle of view make them useful only in specific

circumstances, such as when working in tight spaces like a deep slot canyon. They are also useful for scenes that simultaneously require a lot of sky and foreground, such as a beach scene with a beautiful sunset sky.

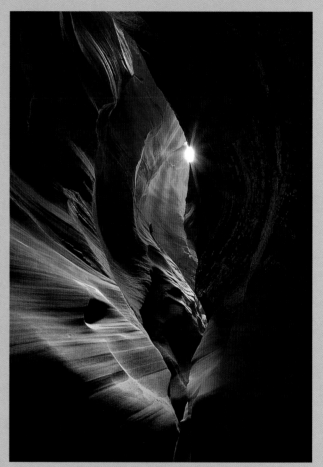

Wide and super wide angle lenses are perfect when working in tight spaces (by Marc Adamus).

FISHEYE LENSES

Fisheyes are super wide-angle lenses that are not corrected for distortion. The wide and super-wide angle lenses discussed above are corrected to render all straight lines in a scene as straight lines (known as "rectilinear" correction). Fisheye lenses, on the other hand, render all straight lines that do not travel through the center of the image as curved. As a result, horizon lines, trees, and just about anything else that should be straight gets rendered as curvy. For this reason, fisheye lenses are considered specialty lenses, typically only used when fisheye distortion is needed for artistic effect, or where straight-line distortion isn't really an issue. So it should come as no surprise that

fisheyes aren't often used in nature photography, which is a real shame because they can yield some very interesting results. Fisheye lenses start as wide as 4.5mm for smaller sensor cameras and 8mm for full frame cameras—now that's getting really wide!

A fisheye lens renders straight lines, such as the horizon at Assateague Island, as curved (by Ian Plant).

Long Lenses

Lenses that record a narrower field of view than normal lenses are known as long lenses. Long lenses are often called telephoto lenses, although the term is technically incorrect. Telephoto refers to a common design of long lenses; long lenses can also be designed as "mirror" lenses that are smaller and lighter in weight (and generally somewhat inferior in quality) than telephoto designs. Lenses in the 80-400mm range are considered long (or 50-300mm for smaller sensors).

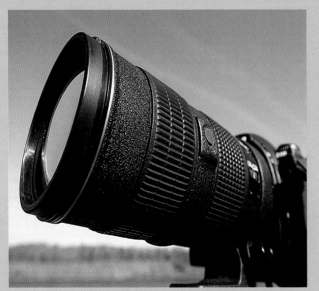

Nikon's 200-400mm VR (Vibration Reduction) lens.

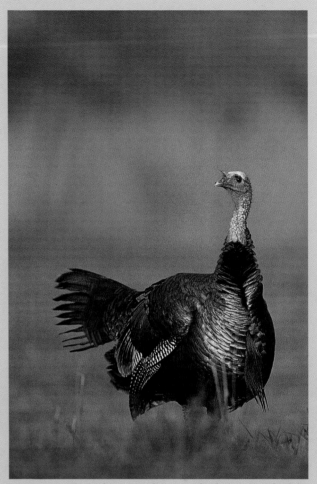

Long lenses and super telephotos are ideal for wildlife such as this wild turkey (by Bill Lea).

Super Telephotos

These are the longest of the long lenses, and with a few exceptions are always of telephoto design. Super telephotos are the Godzillas of the lens world; they are big and heavy, and make great defensive weapons if marauders ever beset you. Not that you would ever want to swing one as a club: these lenses are also super expensive, with the most exotic costing over $100,000! Most aren't *that* expensive; rather, these lenses tend to cost somewhere between $1,000 and $10,000, depending on focal length and maximum aperture size. Super telephotos are also characterized by huge front glass elements that allow in lots of light, enabling use of big apertures (and therefore faster shutter speeds). These are specialty lenses for capturing images of distant or small wildlife. Super telephotos are usually 400mm and above. Most are fixed focal length lenses, but some zoom varieties can be found.

PRO POINTER
by Jerry Greer

Using the rise and fall feature of a perspective control lens, instead of tilting the entire camera up or down, keeps vertical lines parallel. This can be helpful when photographing a forest scene. Normally, pointing a camera with a wide-angle lens up in such a scene would cause distortion and all of the straight lines of the trees would appear to converge. Using rise instead prevents this from happening. I use the tilt feature to manipulate the focal plane of the lens. By tilting, I can bring the near and far subjects into the same focal plane without stopping the lens down to very small apertures (which will cause soft images due to lens diffraction). Once I've tilted the lens and have the near and far objects in the same focus plane, I can stop down the lens just enough to get the elements above and below the plane into sharp focus. In doing this, it takes much less stopping down than fixed focal plane lenses. Where it would take f/22 or more on a fixed lens, a tilted perspective control lens can bring a scene into perfect focus at much smaller, and much sharper apertures. I find f/8 to f/11 to be the "sweet spot" of most lenses.

Above: A scene like this benefits from the use of a perspective control lens. Using the tilt feature I was able to create a focal plane that optimized focus throughout the whole image.

Below: I also use perspective control lenses to stitch multiple images to form panoramic images. By shifting the lens left and right of center, you can create three different images that can later be stitched together on the computer. We discuss stitching more in Chapter Five.

MACRO LENSES

Macro lenses are used to get close-up shots of small things. Some lenses are dedicated macro lenses; others are general purpose lenses that have some "macro" functionality built in. What this really means is that they have some extra close focusing capability. Most dedicated macro lenses will give you 1:1 focus capability, which allows for "life-sized" focusing; whereas most general purpose lenses will not focus closer than 1:2 or even 1:4.

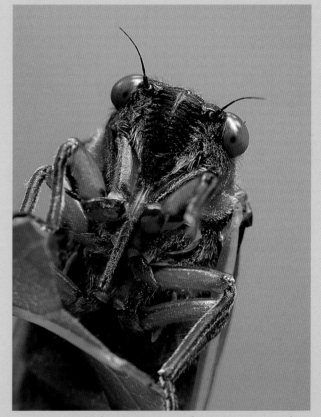

A macro lens is necessary for getting in-your-face shots of insects like this cicada (by Jim Clark).

PERSPECTIVE CONTROL LENSES

Perspective control (PC) lenses, sometimes also called tilt-shift lenses, are specialty lenses designed to correct distortion and change the lens' plane of focus through physical movement of the lens element. Although mostly used by architecture photographers, perspective control lenses can be very useful to nature photographers, especially for landscape work. PC lenses typically have two basic functions: shift and tilt. Most PC lenses allow you to revolve the lens to apply

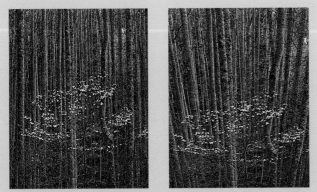

The same image with rise (left) and without (right).

these movements either vertically or horizontally.

Shift (also known as rise/fall when applied vertically) is a lens movement that allows the photographer to correct distortion in an image. Ever been walking around a big city taking pictures when you have pointed your camera up to photograph tall buildings? Notice how all the buildings tend to converge? Shift solves that problem and keeps the buildings standing straight, with no convergence.

Tilt (sometimes called swing when applied horizontally) is used to change the focal plane of an image. By changing the focal plane, you can bring all the important areas of an image into sharp focus. For example, imagine taking a photograph of a field of flowers with distant mountains. Tilt allows you to get the whole image in focus, from the nearest flowers to the farthest mountains. Normally this is accomplished by using a very small aperture to increase depth of field (see Chapter Two), but depth of field has its limitations. First, sometimes you simply can't get enough depth of field to render a whole image in focus. Second, lenses lose sharpness when you use very small apertures. Third, use of smaller apertures means you have to use a longer shutter speed: if your field of flowers is blowing in the wind, you will need to use the fastest shutter speed you can to stop motion. Tilt can solve all of these problems, allowing you to achieve more focus throughout an image than depth of field alone, and accomplishing this while allowing you to use optimal apertures and shutter speeds.

The drawbacks of PC lenses are as follows: they are fixed in focal length, they do not have auto-focus, they tend to be rather expensive, and they are made for only a handful of focal lengths. Both Nikon and Canon make PC lenses. In addition, third party manufacturers make PC adapters designed to allow use of medium format lenses on DSRLs. Because of their larger size, such lenses offer extreme tilting and shifting movements.

No tilt applied.

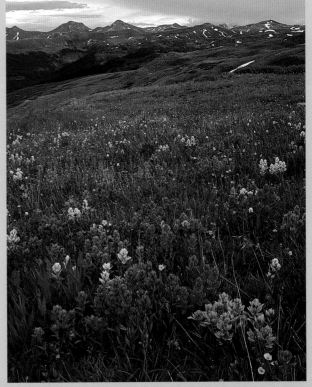

The same image with tilt applied (by Nye Simmons).

IMPORTANT LENS FEATURES

Once you've determined which types of lenses you want and your budget, there are several important features that you must assess, some of which will affect price.

Weight and size: If you are planning on doing a lot of backcountry expeditions to get the shots you want, you're going to want light-weight and compact lenses. If you plan on RV-ing across the country, maybe you won't be bothered by heavy lenses. Remember, however, that even if you are not straying far from your car, heavy lenses can be difficult to carry (even for short distances) and can hamper you if you need to be creative and spontaneous.

Canon's 500mm lens is big and heavy!

Zoom vs. fixed: Although fixed focal length lenses often have an edge in terms of quality, many modern zoom lenses are excellent optically. Zoom lenses give you many focal lengths in one lens, thus allowing for greater flexibility when composing images. Zoom lenses, however, are often "slower" than primes; that is, they have smaller maximum apertures and thus don't let in as much light, reducing your shutter speeds. If you don't plan on shooting a lot of action, this probably won't be a problem.

Maximum aperture: Some lenses have a larger maximum aperture than others. Such lenses are called "fast" lenses because they let in more light, thus allowing for faster shutter speeds. Most "slow" lenses have a maximum aperture of f4 or f5.6, whereas fast lenses will have maximum apertures of f2.8 or f2, sometimes even larger. What is fast for a lens is relative: whereas f4 or f5.6 are considered slow for wide-angle lenses, super telephotos, with their huge front elements,

A wide maximum aperture can create a pleasing background blur (by Jim Clark).

are considered fast lenses at these apertures! Having a fast lens is important for any photography requiring you to freeze fast action, such as wildlife. Such lenses can also be useful if shooting in low light or at night. Fast lenses are not usually considered critical for landscape photography. Lenses with large apertures are also useful when photographing wildlife and macro subjects, as using a larger aperture reduces depth of field, thus throwing the background into a pleasing out-of-focus blur.

Autofocus: Most modern lenses have autofocus (but not all do), whereas most older lenses are manual focus. Autofocus is very useful when shooting action, including wildlife. Manual focus lenses are perfectly acceptable when shooting landscapes. Note that not all autofocus systems are created equal: some are faster and less noisy than others.

Image stabilization: While some new cameras have image stabilization built in to the sensor, many SLR camera systems still rely on image stabilization in the lens. Image stabilization (also

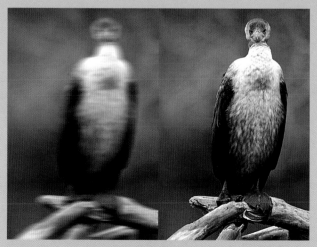

Image without (left) and with (right) image stabilization (by Joseph Rossbach).

called "vibration reduction" as well as several other proprietary names) basically is a gyroscope placed within the lens to help prevent shake caused by camera movement. Camera movement is usually most apparent when hand-holding a lens, but can also occur when the camera is on a tripod (such as when it is windy). Image stabilization reduces vibrations and thus allows for sharper images. It is very helpful when trying to shoot hand-held in lower light. Most common on longer lenses, image stabilization is also found on some normal and even wide-angle lenses.

Lens quality: It is important to buy lenses with as much optical quality as you can afford. High quality lenses will render images with considerable sharpness and contrast; many low quality "consumer" lenses will create images that appear mushy. Lens quality often falls off in the corners of the image, and some lenses perform well when stopped-down to small apertures but perform poorly when used wide-open at large apertures. How important this is to you depends on the kind of shooting you do. For example, landscape work requires sharp corner-to-corner performance, but does not require high performance at large apertures; whereas low-light night photography or wildlife photography will require high quality performance even wide-open. Often you get what you pay for—but then again, there are plenty of expensive lenses that are not very good, and some cheap ones that are diamonds in the rough. Some research is in order. There are many on-line sources that you can turn to that review lens quality, including the Mountain Trail Photo website.

New vs. used: Used lenses are often a great alternative to buying new. There are some good bargains out there, but buyer beware! If buying a used lens, inspect the glass and make sure it is free from dust, haze, scratches, or fungus. One advantage of buying new is that the lens will be covered by a manufacturer's warranty. These warranties typically last a year.

Durability: Another important consideration is the build and durability of the lens. Some lenses are made out of cheap plastic and wouldn't survive a stiff breeze. Others are built like a tank and look like they could survive a nuclear blast.

More expensive lenses often offer weather sealing. It won't protect the lens from a dunk in the ocean, but it will help keep rain and dust out.

Nature can wreak havoc on lenses, especially snow, ice, and dust (by Jerry Greer).

USE OF THIRD PARTY LENSES

There are a few third party manufacturers that make lenses for multiple camera systems. Sometimes these lenses are high-quality, cost effective alternatives to "brand name" lenses. Sigma, Tamron, and Tokina make some great lenses for use on many of the major brand name cameras. All of these lenses not only physically fit the camera they are made for, but also electronically fit: they retain any electronic features they have, such as autofocus, and they can communicate with the camera sensor to relay image data.

Some photographers go even further and use a wide variety of lenses on their cameras using adapter rings. For example, it is not uncommon to see Contax, Olympus, or even bizarre cold war era Russian lenses used on Nikon and Canon cameras. When using an adapter ring, your lens and camera cannot communicate electronically, so autofocus, electronic aperture, and image data are lost (the aperture needs to be set manually). Many of these "alternative" lenses are very high in optical quality (and often very cheap!), thus offsetting the loss of electronic features. They may be useful for landscape and macro work, but their lack of autofocus makes them difficult to use for wildlife photography.

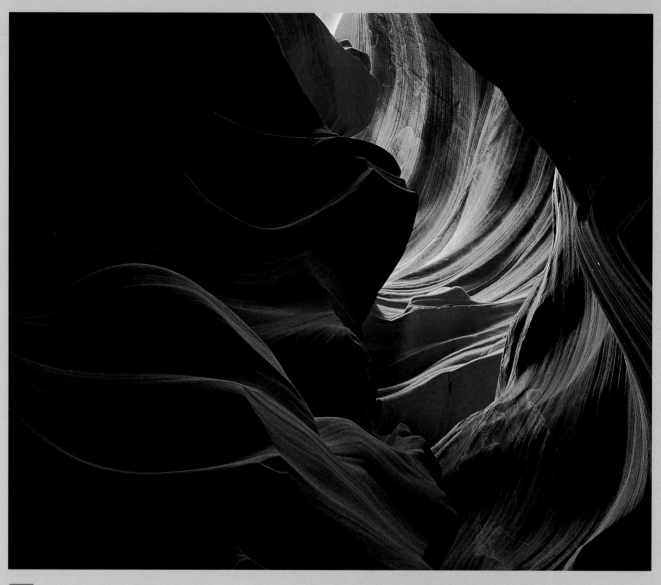

IMAGE STORAGE

One thing that makes digital photography so great is the fact that you don't have to carry film around. But digital images don't just float around in the ether—they need a physical repository of some sort. Since most DSLRs don't have built-in hard drives, some sort of media storage device is necessary when working in the field.

MEDIA CARDS

Most DSLRs accept one of two types of storage media: Compact Flash (CF) or Secure Digital (SD) cards. SD cards are an emerging standard, although many cameras still use CF cards (including Canon's DSLR line). Suffice to say that for all practical purposes either format is perfectly acceptable. In other words, whether a camera uses SD or CF cards (or some other type of card such as

Memory Stick or XD) should not be a primary consideration when making a DSLR purchase. When you have made your camera selection, however, make sure to buy the right kind of card for the camera.

Once you have figured out whether your camera takes SD or CF cards, then it becomes a question of how many cards you need to buy and how much storage capacity they have. Cards in either format are extremely lightweight and easily portable, so buy as many as you think you need. Cards come in storage sizes as large as 16 or even 32 gigabytes (GB), which can hold a lot of images, even from high resolution DSRLs. Of course, you might not need cards with that much storage; 1GB is probably the minimum size card you would need, whereas 4GB cards are great for landscape work and will keep you shooting all day without having to change cards. Higher GB cards may be necessary for wildlife work, espe-

cially if there is a lot of action. Having a bunch of smaller cards might make more sense than having one high capacity card, so that you may spread your risk of loss a bit—if you use only one card and lose it, you can lose hundreds of images in one fell swoop, whereas if you lose one of your many smaller cards, your loss is less substantial.

Another consideration when buying a media card is write speed. Some cards write data faster than others. A slower card may not be able to keep up with your digital camera, which might compromise your camera's burst rate speed. This is especially critical when photographing a lot of action, such as with wildlife.

PORTABLE STORAGE

When your media cards fill up, you need to transfer the data stored on the card to somewhere else. Many nature photographers bring laptops with them, and transfer files from media cards to the laptop's hard drive on a daily basis. This allows one to review and process digital files in the field, which can be very useful—knowing that you "got the shot" can save you time and allow you to focus your efforts on new subjects.

Of course, laptops don't make sense when you are in the backcountry for any length of time, or staying somewhere without access to electricity. Small, portable, battery-powered image storage drives are useful in such situations. These high-capacity hard drives typically have built-in card readers and even LCD screens for reviewing images. Backing up images is always a good thing; consider bringing two portable drives instead of just one so that you don't lose a week's worth of images if one drive should fail!

Left: Slot Canyon, Paria Drainage, Arizona (by Guy Tal).

Below: Nesting ruffed grouse, West Virginia (by Jim Clark).

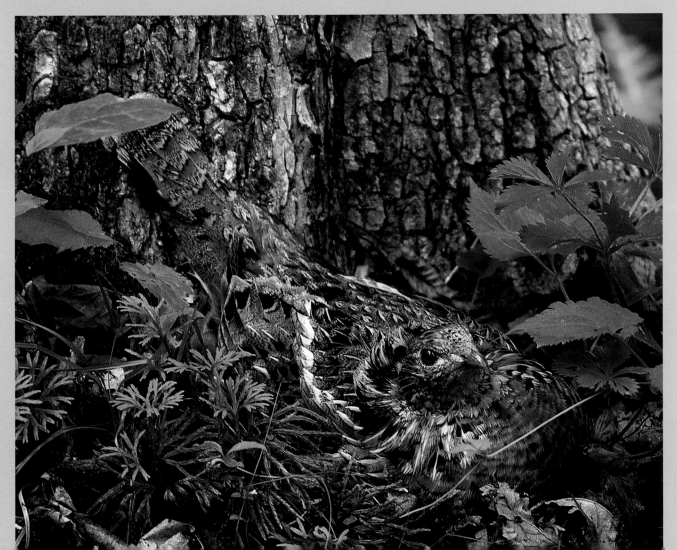

TRIPODS

A tripod is a necessary evil. At times it feels like your worst enemy, but you learn to value a good tripod as a faithful friend. A tripod provides necessary stabilization and support for your camera and lens. It also helps you slow down and think about the composition a bit more.

The tripod is actually composed of two separate, necessary parts: the legs and the head.

THE PERFECT TRIPOD?

Sorry, it doesn't exist. For every positive feature a tripod possesses, there is a nagging compromise to consider. You want a light tripod for hiking long distances? You will have to compromise stability. If it's ultimate stability you need, you will be burdened with more weight to carry and a higher price tag. Choose the features that are most important to you and your style of photography and learn to deal with the compromises.

TRIPOD HEADS

The tripod head is what screws into the top of the tripod and actually supports your camera. The three most popular tripod heads are the ball head, the 3-way pan/tilt head, and the gimbal style head for telephoto lenses.

Courtesy Kirk Enterprises.

Ball heads: Because of their small size and ease-of-use, many outdoor photographers prefer a ball head on their tripod. The ball head is like a ball and socket, with the camera attached to a locking platform on the ball. You are free to move the camera in any direction with ease, and it can be locked into shooting position with just a single knob. Most ball heads also have a tension adjustment, and a separate knob for panning horizontally. Because of their versatility, ball heads are popular with landscape, close-up, wildlife, and general nature photographers alike.

3-way pan/tilt heads: This is the classic head that used to be standard on the nature photographer's tripod. It can be rotated horizontally (panned), tipped forward and back, and tilted side to side. Each movement is independent of the others, so moving in three dimensions requires three separate actions of the photographer. This tediousness, in addition to the protruding handles, has made the 3-way pan/tilt head much less popular than the ball head in recent years.

Gimbal type heads: Gimbal type heads are odd-looking, J-shaped devices that support large telephoto lenses on tripods. They attach to the lens itself, balancing the weight of the lens and camera perfectly. Because the lens and camera are almost weightless when attached to the head, the photographer is free to swing the lens back and

PRO POINTER
by Bill Lea

Choosing the appropriate tripod can be difficult. Here are a few things you should keep in mind:

__The maximum height__. You want a tripod that reaches to your eye level.

__The number of sections__. Most tripods come in either three or four leg sections. A three-section tripod is generally more stable, quicker to extend and put away, and with fewer leg joints, less prone to possible repairs. A four-section tripod packs away to a physically smaller size, which makes it ideal for travel and backpacking.

__Weight carrying capacity__. Before buying a tripod, be sure its load capacity matches the equipment you are using.

__Construction material__. Carbon fiber materials are light and dampen vibrations very well, and as a result are preferred by most nature photographers. They are also expensive. Steel tripods are affordable but heavy. Aluminum varieties are a reasonable compromise between the two. Wood tripods are heavy but useful when working in fresh or sea water, two environments that can be especially punishing to tripods made of other materials.

__The minimum height__. This consideration is important for macro and close-up photography where getting very close to the ground may be important. A tripod with a detachable middle column or no column at all will get lower to the ground. Also, a smaller tripod is more portable.

A telephoto lens mounted on a gimbal-style tripod head.

forth, up and down with very little effort. These are essential for wildlife and bird photographers, who often use heavy 400mm, 500mm, and 600mm lenses.

ILTERS

Filters are used to alter the light traveling through your lens to the camera's sensor. Filters can alter light in a variety of ways, such as changing the color of the light, reducing the amount of light, or even polarizing the light.

There are two basic filter styles. The first is the screw-on filter, which screws on to the filter thread at the front of a lens. These filters tend to be cheaper, but there is a significant downside: lenses don't all have the same size filter thread. In fact, there are dozens of different filter thread sizes available. So, you might find that you have to buy a lot of filters to fit all of your different lenses. To alleviate the problem, companies manufacture what are known as "step-up" and "step-down" rings that allow you to use one filter on multiple lenses. So, for example, if you have two lenses, one with a 67mm filter thread and the other with a 72mm filter thread, you can buy a 72mm filter and use a "step-down" ring that goes from 72mm to 67mm. Of course, you still might have to buy a lot of rings to fit all of your lenses,

but these are cheap. It is best to start with a larger filter and work your way down: a 67mm filter with a step-up ring might not be large enough to effectively cover a lens with an 82mm filter thread. Screw-on filters can also create problems when you stack more than one filter on top of another.

The second style of filters are used in a filter holder. These filters are often square or rectangular and slide into a holder that accepts multiple filters. The holder is connected to the lens via an adapter ring that fits the lens' filter thread. So, once again, you might need to buy a lot of adapter rings, but you never have to own more than one of any kind of filter. Filter holder systems allow you to stack up to three or four filters without the same sorts of problems you get when stacking multiple screw-on filters. Filter holder systems tend to be a bit more expensive, but their versatility is useful for serious work.

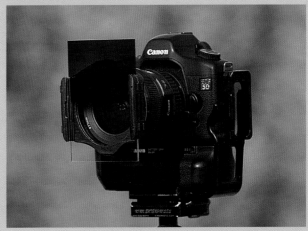

A filter holder system.

There are really only three important filters used in digital outdoor photography: the polarizing filter, the neutral density filter, and the graduated neutral density filter. Many other filters that were essential for film photography are no longer needed. Filters for color temperature correcting, for example, are redundant, since digital cameras have a white balance adjustment (See Chapter Two). The three filters mentioned above, however, have not outlived their usefulness in the digital age, and are discussed more below. Some photographers also use UV or so-called "skylight" filters, which are essentially clear glass filters. They don't really serve any useful function other than to protect the front element of a lens.

POLARIZING FILTERS

Without getting into the complicated physics of light, let's just say that these filters polarizes light and leave it at that. How does it affect your photography? Polarizing filters remove unwanted glare from surfaces such as water, wet rocks, foliage, and other shiny objects, and accordingly increase the saturation of their colors. They also darken blue skies and enhance contrast and color in clouds. There are two types of polarizing filters available: linear and circular (which refers to how the light is polarized, not the shape of the filter). The metering and autofocus sensors in almost all modern digital cameras will not work properly with linear polarizers, so circular polarizers are recommended. Polarizers are most effective when the camera and lens are facing 90 degrees from the source of light, the sun. Virtually no polarizing occurs while facing the sun or when the sun is at your back.

The same image without (left) and with (right) a polarizer.

NEUTRAL DENSITY FILTERS

Quite simply, neutral density (ND) filters are darkened glass that block light. They are neutral gray and impart no color cast to the image, hence the word "neutral." ND filters are useful for obtaining slower shutter speeds in bright light. If you want to impart a certain silky motion to a waterfall scene, but there is too much light to allow the needed slow shutter speed, you can block out some of the light with an ND filter. This is useful for any situation where you want slower shutter speeds or larger f-stops than the existing light intensity will allow. ND filters come in different strengths which indicate how many "stops" of light they block. Each stop lets in half the light, so a "1-stop" ND filter lets in half the light as no filter, and a "2-stop" filter lets in half the light of a 1-stop filter, and so forth.

The same image without (left) and with (right) an ND filter.

GRADUATED NEUTRAL DENSITY FILTERS

Graduated neutral density (GND) filters are similar to neutral density filters except that they are graduated from dark (the dense, light-blocking part) to clear. They also come in different strengths, denoted by stops. They serve a different function than ND filters, however. GND filters are useful for scenes with a great deal of contrast, where the range of light values exceeds the camera's ability to record them. A sunset is just one example where metering the brightness of the sky would darken or silhouette anything in the foreground and metering the dark foreground would overexpose the sky. By placing the dark section of the GND filter over the sky and the clear section over the foreground, the light values of the scene are now more balanced and detail in both the sky and foreground can be obtained.

This image of Devil's Garden in Grand Staircase-Escalante National Monument in Utah (by Ian Plant) doesn't work without an GND filter. Properly exposing the shadowed foreground leaves the much brighter sky overexposed. A two-stop GND filter is used to achieve a balanced exposure.

PRO POINTER
by Nye Simmons

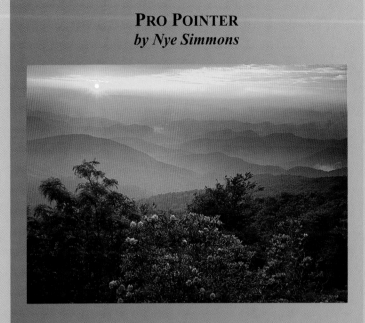

GND filters ("grads") allow you to balance areas in your composition that have a severe difference in luminance values. Here are some tips to help you get the most out of using grads:

—Use a filter holder system as opposed to screw-on grads. You can adjust grads in a filter holder system, rotate them, and combine them with other filters like a polarizer or add additional grads if needed.

—A sky that is too dark relative to the rest of the scene just doesn't look natural, so be careful and don't apply too much darkening to the sky. Most skies look good a bit brighter than mid tone.

—Grads come in several configurations with both hard and soft edge versions. The soft edge filters are best suited to wide angle lenses and the hard edge to normal and telephotos.

—Stop down your lens to your selected aperture using your camera's depth-of-field preview to determine where to accurately place the grad line; when the lens is stopped down it is easier to see where the transition zone is, which changes depending on the f-stop.

—There is a brighter band of sky right on the horizon. If that bothers you, certain manufacturers make "reverse grads" that are darker at the horizon and transition in a reverse fashion, giving a more even sky.

Above: *For this image of rhododendron trees blooming along the Blue Ridge Parkway in North Carolina, a 3-stop neutral density grad was needed to balance the exposure of the sky and the foreground rhododendrons. With a shot like this, very careful placement of the grad line is necessary. I placed the transition zone in the mountains right above the foreground trees. A digital camera, either with Live View or instant feedback when reviewing images on the camera's LCD screen, helps take some of the trial-and-error out of the process.*

ACCESSORIES

Thought you were done, eh? Not yet! There are plenty of useful accessories out there that will help you make great images.

CAMERAS BAGS, AND VESTS

After getting the camera, lenses, and filters, the next item to consider is a place for all your stuff! This is a never-ending quest for photographers of all skills and ages: finding the perfect camera bag.

The three most important considerations for any camera bag should be protection, capacity, and portability. Although they come in a variety of styles and sizes, these criteria should be met before deciding upon one. Here are a few options to consider:

Courtesy LowePro.

Shoulder bags: Shoulder bags have one big advantage and one disadvantage over the alternatives. The advantage is accessibility. Getting to your gear is a snap, with most featuring easy access from the top without having to set the bag down on the ground. This is especially important when working in and around water or sand. Its disadvantage is its bulky shape and awkwardness, especially if you are walking or hiking any long distance.

Backpacks: The pros and cons of the camera backpack are the exact opposite of those of the shoulder bag. Backpacks are ideal for carrying large amounts of photo gear over long hikes. It leaves both hands free for climbing and evenly distributes loads over both shoulders. The backpack is agonizingly difficult, however, for reaching your gear without taking it

Courtesy LowePro.

off and putting it on the ground. Despite this drawback, the camera backpack remains the favorite for the majority of nature photographers.

Camera vests: The vest would seem to address both deficiencies of the shoulder bag and backpack. Your photo gear is very accessible, with many large packets within reach for stuffing lenses and other camera accessories. It also frees up your hands and is relatively unobtrusive. Its primary problem is gear protection, especially if hiking difficult terrain or crawling over rocks and through thick underbrush. It also offers very little protection from the rain. A vest is ideal, however, for carrying equipment on short-term assignments or light projects.

FLASH

Courtesy Canon USA.

Electronic flash units can both improve your photography and offer myriad new creative options as well. Flash can be used to freeze action of fast moving wildlife subjects, to improve macro photography, and to create fill flash (which mixes a controlled amount of electronic flash with available ambient light in order to illuminate shadows and reduce contrast).

Although some DSLRs come with a built-in pop-up flash, many don't. In any event, built-in flash units don't have much power and can't be moved off camera, thus limiting their utility. An off-camera flash is much more useful. If you plan to add a flash unit to your gear list, the primary specification to look for is the guide number (GN). A higher GN indicates more power and a lower number less. Other important considerations include the angle of coverage and recycle time of the flash. The angle of coverage lets you know whether or not your flash unit will illuminate the entire scene if you are using your favorite wide-angle lens. Look for a flash that will cover the widest lens that you plan on using with flash. The recycle time refers to the amount of time the unit needs to recover between flash bursts at full output—the quicker the better for action.

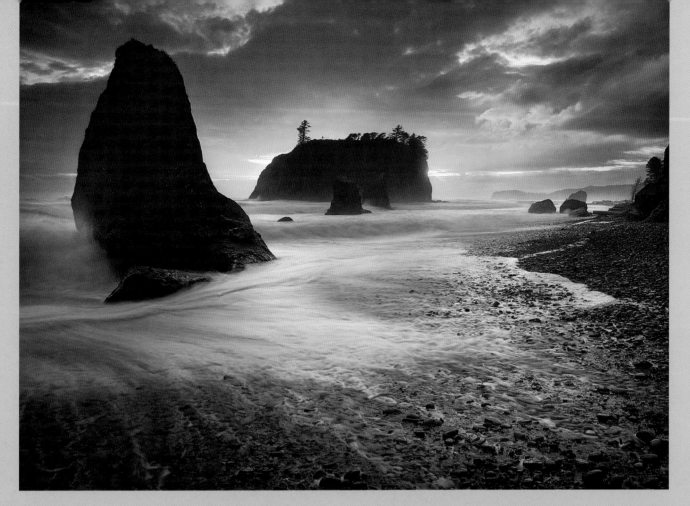

A flash extender is a useful attachment that mounts directly to the front of the flash unit and projects the flash output into a more concentrated area. By doing so, it extends the reach of the external flash so that it can be used with telephoto lenses. Flash extenders are very useful when photographing distant wildlife subjects.

POWER

Spare camera batteries, battery chargers, and car charging accessories are indispensable when spending long periods of time in the field.

SHUTTER RELEASE

An essential camera accessory for the nature photographer is a remote shutter release. These are offered as wired or wireless. Their primary purpose is to avoid unwanted vibrations caused by pressing the on-camera shutter release button. This is particularly true when the shutter speed used is longer than 1/60 of a second.

BUBBLE LEVEL

A bubble level is a nifty little device that fits into the hot shoe of your camera (where you connect your flash) and helps determine if your camera is level or not. Most have two bubble levels built in to them, for both vertical and horizontal images.

SENSOR CLEANING KITS

Sooner or later, it's going to happen. At some point while editing some recently taken photos on the computer, you are going to notice some alien black dots on your image files. This is dust and dirt that has entered the camera while changing lenses and now has stuck to the camera's imaging sensor. Although several newer camera models have sensor cleaners built right into the camera, even these sensors will eventually get dirty. Aside from cloning dust spots out during post-processing, the only thing you can do to fix the problem is to clean the sensor. Sensor cleaning kits are inexpensive, easy to use, and come in many different designs and methods.

(Above) "Coast of Wonders," Olympic National Park, Washington (by Marc Adamus). A bubble level is useful when trying to make sure your horizon is level, whereas a remote shutter release helps prevent unwanted vibrations that could potentially ruin an image's sharpness.

making the image

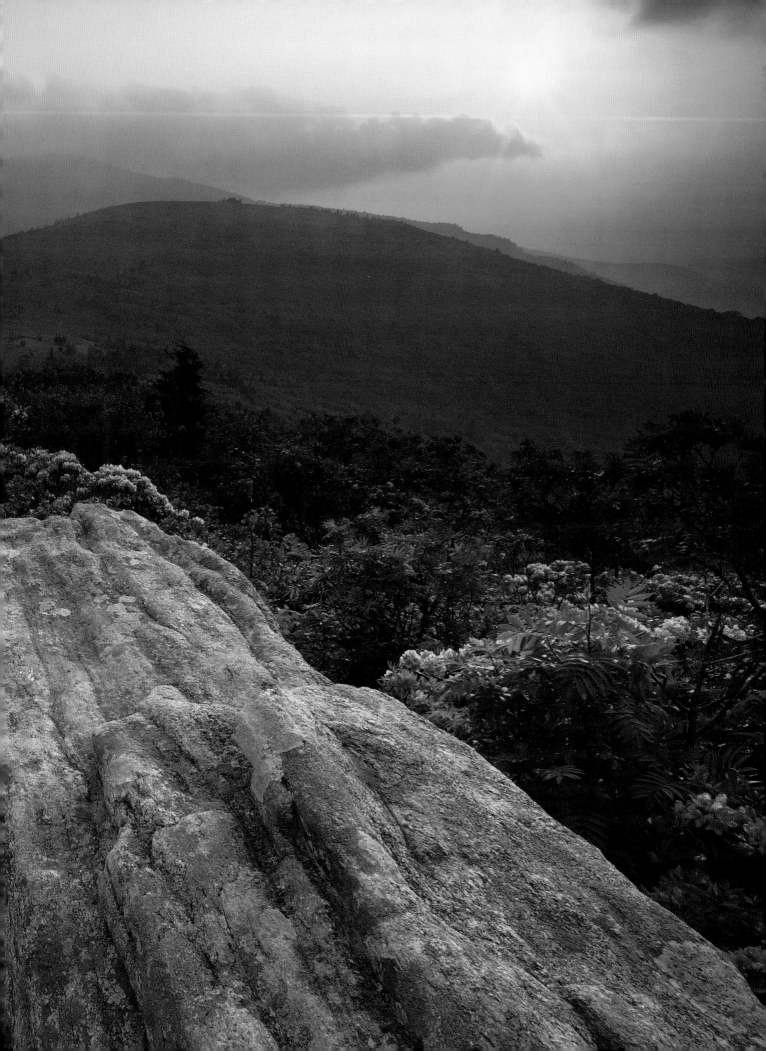

All right, so now you have your camera and some lenses. You even have some of the fancy accessories: a tripod, an electronic cable release, maybe even a flash. Now what? Now it's time to take some pictures! But how does all this stuff work? Don't worry, we won't abandon you now—here's everything (well, almost everything) you've ever wanted to know about how your equipment works but were afraid to ask . . .

EXPOSURE

It would be difficult to come up with a concept or skill in photography more important than exposure. Quite simply, exposure is the amount of light the image sensor captures when you take a picture. Capture too much light and the picture is overly bright and washed out; not enough light and the picture is too dark and murky. Getting it just right requires a good working knowledge of a few of your camera's basic controls: the f-stop, shutter speed, and ISO.

THE F-STOPS HERE

An f-stop is a fancy photographic term that describes the amount of light that passes through the aperture of the lens. The aperture is the physical diameter of the lens opening. There is often much confusion about the real meaning of apertures and f-stops, but we will only deal with f-stops here, since this is the measurement the camera uses.

F-stops can be a little confusing to learn since the numbers are not intuitive and hardly descriptive. Higher f-stop numbers indicate smaller aperture diameters (and less light) while lower numbers represent larger diameters (and more light).

These are common (whole) f-stops:

<More Light							Less Light>
f1.4 f2.0 f2.8 f4 f5.6 f8 f11 f16 f22 f32							

As you can see, the higher the f-stop number, the less light that will strike the image sensor, while the lower f-stop numbers mean more light. Each whole f-stop represents twice as much light when

Above: Roan Mountain sunset, North Carolina/Tennessee (by Jerry Greer). Knowing how your camera works helps get shots like this!

Right: Dawn breaking, Hunting Island, South Carolina (by Richard Bernabe). Good exposure and white balance technique bring this image to life.

"opening up" from a smaller f-stop and half as much light when "stopping down" from a larger f-stop. For example, f8 represents twice the exposure of f11 and only half of f5.6.

An f-stop also affects the depth of field of your image. Depth of field refers to how much of the scene is in focus, from near to far. Smaller f-stops create images with lots of depth of field, while larger f-stops render a scene with shallow depth of field. We will discuss depth of field in more detail later on in this chapter.

SHUTTER SPEEDS

Shutter speeds are much more intuitive and easy to understand. Basically, the longer the shutter remains open and the image sensor is exposed to light, the brighter the image will be. Conversely, the faster the shutter speed, the darker the exposure will be. Shutter speeds are represented in seconds or fractions of seconds.

These are common shutter speeds in whole stops.

<More Light							Less Light>
1 sec. 1/2 1/4 1/8 1/15 1/30 1/60 1/125 1/500							

As with f-stops, each whole shutter speed represents twice as much light as the previous faster shutter speed and half as much light as the previous slower shutter speed. The choice of shutter speed will also ultimately impact how your subject is presented aesthetically. Fast shutter speeds will stop or freeze fast-moving action whereas slow shutter speeds will blur or give the image the illusion of motion.

ISO

ISO is analogous to film speed and describes the image sensor's sensitivity to light. The higher the ISO number, the more sensitive the image is to available light and therefore, the greater the possibilities to take pictures in low-light situations. ISO and how it affects the image is explained in more detail in Chapter One.

Each higher number doubles the sensor's sensitivity to light while each lower number reduces

the sensitivity by half. Common ISO speeds, expressed in whole stops, are listed below.

<Less Light							More Light>
50 100 200 400 800 1600 3200 6400 12800							

While higher numbers allow faster shutter speeds or smaller f-stops in relatively lower light, there is no free lunch. Higher ISOs typically mean more digital noise is introduced into the image, which is usually undesirable. A good rule-of-thumb is to always shoot with the lowest ISO setting that conditions will allow, to better your chances of getting clean, noise-free image files.

EXPOSURE VALUE

Combining these three values—f-stop, shutter speed, and ISO—will give you a certain *exposure value*, or *stop*. Both of these terms are often thrown about freely by photographers and they may seem intimidating, but they really only represent the actual exposure of your image—its brightness or darkness—once an f-stop, shutter speed, and ISO are combined. The same exposure value can be achieved by combining these variables in many different ways. This is called reciprocity, but you don't have to remember the name of this concept, only what it really means.

For example, a shutter speed of 1/60 at f8 with an ISO of 400 represents a certain amount of light or exposure. We can call that Exposure Value 1 or EV1. We can also arrive at EV1 using 1/30 at f11 with an ISO of 400. Since 1/30 of a second is twice as much light as 1/60 and f11 is half as much light as f8, they cancel each other out, giving you the very same exposure with which you started.

Now that you have a basic understanding of exposure, the next step is learning to get the *right* exposure. The DSLR has several tools and techniques to help you get there, as well as a few pitfalls—but don't worry, we'll safely guide you through them all!

Left: "Radiance," Rock Creek Wilderness, Oregon (by Marc Adamus). Tricky lighting in scenes such as this require a thorough understanding of exposure.

LIGHT METER

The light meter in your DSLR is the instrument that measures the amount of light coming through the lens. It basically helps you determine what the proper exposure is or will be. Your camera meter works in a specific way: it only measures the amount of reflected light, which is a product of both the intensity of light falling on the scene and the reflective properties of the scene itself. Since lighter tones and colors reflect more light than those that are darker and vice versa, the camera's meter will tend to overcompensate by underexposing scenes of lighter than average reflectance and overexposing scenes with darker tones and colors. The meter's results are established by the intensity of light that would be reflected from a scene or object appearing as middle gray or a mid tone. That is generally recognized to be 18 percent gray or as having 18 percent reflectivity.

For example, if you are taking a picture of a white wall, the camera's meter will assume the white wall is a neutral gray and accordingly expose it so. Your resulting picture will not look white but gray. Conversely, take a picture of a black wall and the meter will do the same. Of course, most scenes you will photograph aren't all white or all black. In such situations, the meter will average all of the tones in the scene and try to render the average tonality as neutral gray. Camera meters can typically be set to different modes allowing them to meter the entire scene or just a select portion of it. The sidebar on the facing page explains these modes in detail.

Above: Toxaway Falls, North Carolina (by Nye Simmons). A scene such as this, with a mix of dark and light tones, can fool your camera's meter!

Camera meters vary in their sophistication, with the very best driven by complex computer algorithms that try real hard to make intelligent choices about proper exposure when confronted with mixed lighting and tones in a scene. Sometimes they get it right, often they don't. The great thing about today's DSLRs is that they allow you to make the final decisions about exposure.

Exposure Modes

DSLRs allow you to choose several different exposure modes. No matter which you choose, the camera meter makes decisions about exposure as described above.

Program: In Program mode, the camera makes all of the decisions for you, so you don't have to think about f-stops or shutter speeds or much of anything, actually. This exposure mode is not recommended for serious outdoor photography, since the act of thinking is a prerequisite to creative results.

Manual: When the camera is in the manual exposure mode, you can change the f-stop, shutter speed, or both. You have complete control over the exposure. You are not shooting blind, however: the camera will display an exposure indicator letting you know if your exposure is neutral, above, or below.

Auto Exposure Modes: Auto exposure modes are faster and more versatile than Manual, while still giving you some control over the exposure and creative aspects of the image. In Aperture Priority, you choose the f-stop that is appropriate for the situation and the camera automatically chooses a corresponding shutter speed. With Shutter Priority, it's the exact opposite. You choose a shutter speed and the camera chooses a recommended f-stop for the lighting conditions.

Which mode is most useful? It depends on what you are shooting, of course. Shutter priority is useful when shooting wildlife and your primary concern is having a specific shutter speed to stop action. Aperture priority works well when shooting landscape, allowing you to easily select an aperture that will give you the depth of field you want (more on that later!).

Pro Pointer
by Richard Bernabe

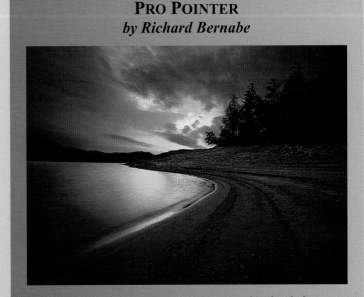

The DSLR has three primary metering modes that help it estimate the right amount of light needed to expose a scene properly. The particular metering mode that you choose will determine how the camera's meter interprets the scene and ultimately, exposes it. The three metering modes found most often on DSLRs are Multi-Segmented, Spot, and Center Weighted.

Multi-Segmented: Also referred to as Evaluative, Matrix, Honeycomb, and others, this mode evaluates the light intensity from the entire image frame and amalgamates the different readings to come up with a proper exposure. These readings come from various segments or zones throughout the scene, and a mathematical algorithm is applied to make the recommended exposure as precise as possible. This metering mode is more than adequate for most situations.

Spot Metering: In this mode, the meter is obtaining a reading of light intensity from a very small "spot" in the scene, from one to five percent of the total image frame. This mode is most useful for tricky lighting conditions where the scene is dominated by very bright and/or very dark areas. Spot metering gives you very precise control when there is a very narrow or small area of the scene that you want to meter correctly.

Center Weighted Metering: Center weighted metering mode gives more consideration to the light intensity located in the center of the scene, so that any subject in the middle of the viewfinder has the best chance of being exposed properly. The meter concentrates between 60 to 75 percent of the light sensitivity on the center of the image frame, with considerably less to the edges and corners. Center weighted metering used to be the only option on older film SLRs, but is probably now the least used of the three metering choices listed.

Above: This image of sunset reflected in Lake Jocassee in South Carolina required precise metering because of the sharp contrast in tones between highlight and shadow areas. A scene like this can fool even the best metering programs. In situations like this, center-weighted or spot metering can be helpful when trying to determine the correct exposure.

EXPOSURE COMPENSATION

Okay, you ask, so if your camera meter is trying to make everything neutral, how do you adjust exposure when shooting in auto modes? The answer: Exposure Compensation. This is a feature that allows you to adjust the exposure measured by your camera's light meter. That way, when taking a picture of the white wall discussed in the previous pages, you can adjust the exposure to make sure the meter gives the scene enough light to render the wall white.

With most camera models, the range of adjustment ranges from +2 to -2 stops in 1/2 or 1/3 stop increments. If you are using one of the auto exposure modes, such as Aperture Priority, the shutter speed will be changed to adjust exposure. In Shutter Priority, the f-stop is adjusted instead.

HISTOGRAM

The histogram is the most important tool on your DSLR for getting correct exposures. A histogram is a graphical representation of the tones contained within your image, and it appears on your camera's LCD screen after you take a picture. The graph has a vertical axis, which represents numbers of pixels, and a horizontal axis, which represents a spectrum of tones from pure black on the left to pure white on the right. An image's pixels are then distributed along this axis by tone and the higher they stack up, the more that have been captured. Simple enough, right? Okay, let's look at how the histogram can help you get correct exposures with your camera.

The first thing you should learn to avoid is overexposed highlights, or *clipping*. These are pixels that are pure white and are represented by the right side of the histogram being pushed to the extreme right side of the graph. These clipped pixels have no color information within them and cannot be darkened or managed in Photoshop or any other image editing software. When this happens, use exposure compensation to create a slightly darker exposure that does not contain these clipped highlights.

Just like avoiding overexposure and highlight clipping, it is also important to avoid underexpo-

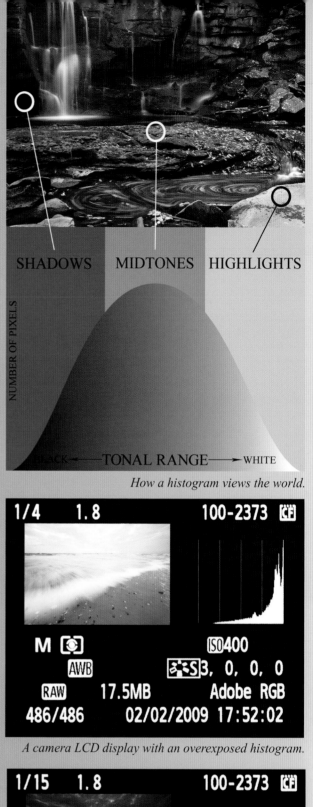

SHADOWS MIDTONES HIGHLIGHTS

NUMBER OF PIXELS

BLACK ◀——— TONAL RANGE ———▶ WHITE

How a histogram views the world.

1/4 1.8 100-2373

M ISO 400
AWB 3, 0, 0, 0
RAW 17.5MB Adobe RGB
486/486 02/02/2009 17:52:02

A camera LCD display with an overexposed histogram.

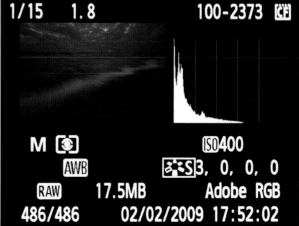

1/15 1.8 100-2373

M ISO 400
AWB 3, 0, 0, 0
RAW 17.5MB Adobe RGB
486/486 02/02/2009 17:52:02

A camera LCD display with an underexposed histogram.

sure as well. Again, the histogram can be very helpful in recognizing and fixing it. A histogram with the majority of the pixels pushed to the left side of the graph could indicate an underexposed image. Using exposure compensation by adding light will move the pixels to the right, correcting the underexposure.

BOO THE BLINKIES!

One of the playback options on DSLRs is the Highlight Warning or the "blinkies." When this option is activated, any clipped highlights will blink as white, superimposed over a display of the actual image. If you are not sure if highlight clipping has occurred or you want to see where the actual clipping is in the image, use this very useful camera feature.

EXPOSE TO THE RIGHT

Many film photographers felt that color transparency film benefitted from slight under-exposure in order to fully saturate colors. In digital photography, this would be "expose to the left," referring to the left side of the histogram. There is a great advantage, however, to doing the opposite with a digital capture. Exposing to the right will result in cleaner, higher-quality image files from your digital camera. Digital cameras generate noise in underexposed areas of the image, and generate more data in properly exposed parts of the image. A histogram that has as much data to the right, without blinking highlight warnings, will usually give you cleaner image files and more leeway in processing the final file later.

Remember that when shooting to the right, your resulting image might appear too bright. You will correct this brightness later on the computer, adjusting the image's exposure back to the desired level.

When trying to avoid both over and underexposure, the ability to make adjustments and re-shoot the scene is a tremendous advantage to digital photographers compared to those using film. Even better, cameras with Live View offer an exposure simulation mode, which allows you to view the image's histogram before even taking the shot!

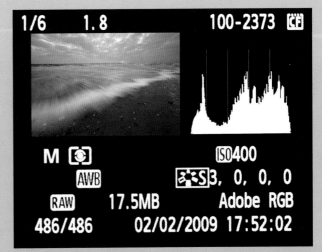

A properly exposed histogram as far to the right as possible.

BRACKETING EXPOSURES

Exposure bracketing is a technique where the photographer takes multiple exposures of the same scene or subject. This might be done for several reasons. The first reason is to hedge your bets in difficult or changing light. Another reason to bracket exposures is to cover the range of light in a scene, from the darkest shadows to the brightest highlights, when that range exceeds the sensor's ability to record all of the tones in one single exposure. Later, the multiple exposures can be combined on the computer to create High Dynamic Range (HDR) images. We'll discuss HDR techniques more in Chapter Five.

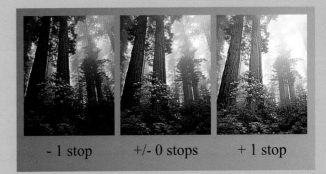

- 1 stop +/- 0 stops + 1 stop

Most DSLRs have an auto-exposure bracketing feature that is highly recommended if you plan on bracketing exposures. Auto-exposure bracketing lessens the possibility of the camera moving between exposures; camera movement can reduce your chances of being able to successfully conduct HDR merging or exposure blending later on when processing images on your computer.

WHITE BALANCE

White balance is the process of correcting color casts in images caused by different light temperatures. Daylight is considered "neutral," whereas yellow or orange light at sunset is considered "warm." Conversely, open shade—"cool" light from a clear sky where no direct illumination from the sun is present—is bluish in color. Objects tend to reflect the color of the light that falls on them. This is most obvious in objects that are white, thus the term white balance.

The white balance feature of your digital camera compensates for these color shifts. Since our eyes cannot detect the subtle changes in light and reflected color, the white balance adjustments bring the colors in our images back to how we saw them—neutral. If JPEG is the image format you are shooting, getting the right white balance setting on the camera is an important first step in color management. If you shoot raw, it doesn't really matter what your white balance setting is (as you can always adjust your white balance settings on the computer), but white balance is nonetheless something to be thinking about when creating the image. Choosing between JPEG and raw is discussed in the next section.

It's worth noting that "correcting" color casts is not always desirable. Artists have long realized the relationship between color and emotion. Fiery reds convey power, aggression or even fear. Cool blues can convey loneliness or sadness. Adding warm or cold temperatures to an image can also be used to accentuate the subject matter at hand. For example, one might be likely to consider adding or keeping a bit of a cool tone to a photograph of a winter scene; on the other hand, most photographers would not opt to "fix" the warm color cast in the golden light of sunset or sunrise.

Having a mix of cool and warm tones in a scene can be very effective, as it creates an element of contrast in the image, and the juxtaposition of contrasting colors can make each color stand out more boldly. The white balance setting in raw converters can allow you to fine-tune the balance between warm and cool.

Right: Rhododendron blooms, Redwoods National Park, California (by George Stocking). A cool white balance helps make this image pop. The light blue of the mist contrasts nicely with the warmer green and pink tones of the rhododendron.

White Balance Settings

Too cool . . .

Too warm . . .

Just right!

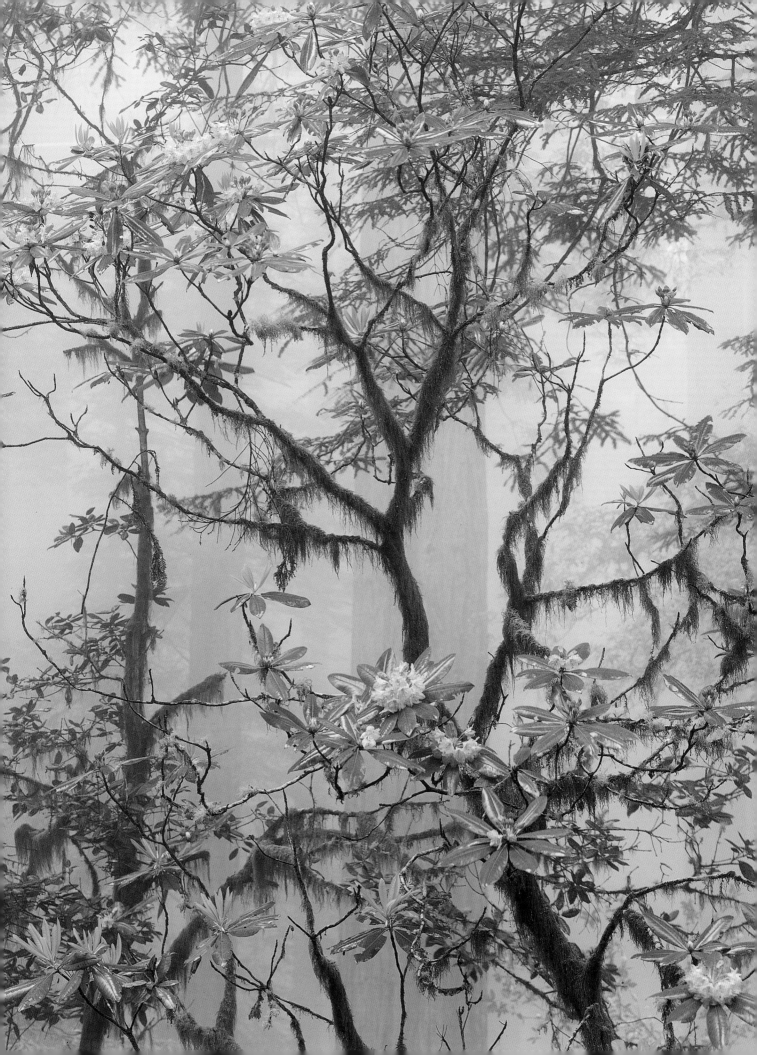

IMAGE QUALITY

Digital cameras basically have two quality settings: JPEG and raw (JPEG also has a number of quality sub-settings). Which to choose? Depends on how serious you plan to get. JPEG is fine for more casual photography. But if you really want to take your photography to the next level, consider raw.

JPEG

JPEGs are image files created in-camera from the raw image data provided by the sensor. Considerations such as white balance (discussed in the previous section) and color saturation have been applied to the image based on your camera settings. Any raw image data that does not conform to your camera settings are thrown away and are lost forever. Therefore, the JPEG file emerges from your camera as a complete product, compressed to a manageable size, ready to use, and easily interpreted by your computer and all image-editing software. This makes things easy, and is ideal for casual photography situations and perhaps for certain assignment work.

THE RAW ADVANTAGE

"Raw" isn't an acronym for anything, but generically refers to the "raw" data captured by the sensor. Various camera manufacturers have proprietary names for this file, Nikon's "NEF" and Canon's "CR2" among them. This is the original, un-compressed data from the sensor

without any manipulation from the camera. Special raw conversion software reads this data and allows you to choose which image values are applied to the converted image and which are not. This gives you tremendous leeway with artistic interpretation of the image and how you want it to look. You can adjust color balance, saturation, contrast, and even exposure, just to name a few, while previewing your adjustments on the computer monitor. Also, you can recover, to some extent, overexposed highlight data from a raw file. In short, you can do a lot with raw that you can't do with JPEG.

While shooting in raw mode, the camera settings that apply changes to your image such as white balance, hue/saturation, contrast, and sharpening, are irrelevant. They will, however, be applied to the LCD image replay on the back of your DSLR. The LCD display is a JPEG representation of how the image might look if those settings were used. Since you are shooting raw, the settings you

choose later might be similar or completely different. It is important to keep that in mind.

Once you understand these advantages and feel comfortable with the conversion process, you will appreciate the complete control you have over the image with raw, and will find the rigid way the camera handles JPEGs unacceptable.

Left: Gull in blowing sand, Outer Banks, North Carolina (by Jerry Greer). Jerry was able to optimize contrast, color, and saturation for this image during the raw conversion process, conforming the image to look the way he saw it.

Below: Altar of the Sun, Toadstool Geological Park, Nebraska (by Joseph Rossbach). Joe always shoots raw files to make sure he has as much image data as possible, giving him wider latitude to make post-capture adjustments.

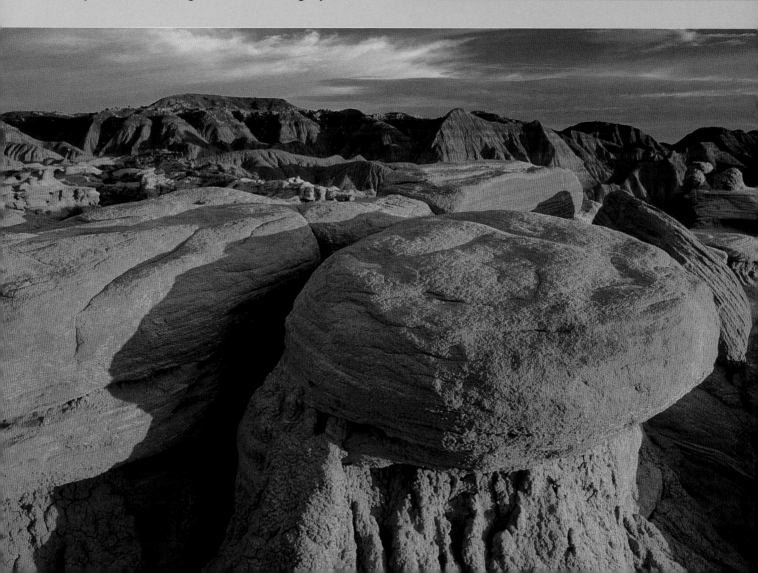

FOCUSING

You basically have two options when focusing your lens. The first is to use autofocus. Most modern lens are autofocus lenses. Digital cameras give you a choice of several different focus points. You may select any one given point, or allow the camera to select focus automatically. Autofocus may not work well in low light or with scenes that have little contrast. Also, autofocus can be tricked when the camera or multiple elements of the scene are in motion. While autofocus may be an indispensable tool for wildlife shooters, it may be of limited utility for landscape or macro shooters.

Some older lenses, as well as a few specialty lenses such as perspective control lenses, do not have autofocus and instead must be manually focused. Most autofocus lenses also have a manual focus mode. Manual focus is useful for subjects that are not moving quickly, or when critical focus is an issue. For example, when photographing wildlife, it may be necessary to turn off autofocus and to instead focus manually to make sure that the eyes—and not the animal's nose or ears—are in perfect focus.

It is important to note that all lenses have a range of focus that ends at "infinity," which is basically a point that is several hundred feet or more away from the lens. Infinity focus is marked on the focus scale of your lens using the infinity symbol. On the other end of the scale, lenses vary in how close they can focus. Telephoto lenses may only focus as close as 5 or 10 feet, whereas macro lenses can focus to within inches or less of the lens' front element.

DEPTH OF FIELD

When a lens focuses on something at a particular distance, everything at that same distance will be in sharp focus as well. This is called the focal plane. Anything that is closer or further away than that distance, however, is not on the same focal plane and will be out of focus. But since the human eye has a limited ability to discern degrees of resolution, some objects that are in front of and behind the focal plane will still appear to be sharp.

Autofocus Modes

Camera manufacturers have different proprietary names for their various autofocus modes, but they basically boil down to three different types:

One shot: *In this mode, when you press halfway down on the shutter release button, the camera focuses using the autofocus point you have selected (or, if you have selected automatic autofocus point selection, the camera selects a point for you). The camera will beep when focus is locked. Focus will stay locked as long as you keep pressing the shutter button, even if you change your composition. If you release the shutter button without taking a shot, you must repeat the process to get focus lock. You cannot take a shot unless focus is locked (or unless you turn autofocus off). One shot mode works well for subjects that don't move much.*

Continuous focus: *This mode is useful for shooting moving subjects. When you press the shutter release button halfway down in this mode, the camera focuses. If you continue to hold down the shutter button halfway, however, the camera will continue to adjust focus as your subject moves around the viewfinder. It is possible to take pictures in this mode even if your subject is not in focus.*

Hybrid mode: *Some cameras have a mode that automatically switches between one shot and continuous focusing if your subject moves.*

Drive Modes

Drive modes determine how fast you can shoot images.

Single shot: *When the shutter button is pressed, the camera will fire one shot at a time.*

Continuous shot: *As long as you hold the shutter button down, shots will fire continuously at the camera's maximum frames-per-second burst rate. The number of shots you can fire at a time will be limited by the size of the camera's buffer and how quickly your media card writes data.*

Self timer: *This mode delays firing the shot for several seconds after the shutter button has been pressed.*

This zone of apparent focus, from near to far, is referred to as depth of field. You can change depth of field by "stopping down," that is, by using a smaller aperture. Smaller lens apertures (for example, f16 and f22) create more depth of field, making more of a scene, from front to back, look sharply focused. Larger lens apertures (for example, f2.8 and f4) render a scene with a much more narrow depth of field. Wildlife images are often taken with large apertures to minimize depth of field. This is done to render distracting elements in the background out of focus, thus placing emphasis on the subject matter. Landscape images are often taken at small apertures such as f11 or f16 to maximize depth of field and ensure sharp focus from near to far.

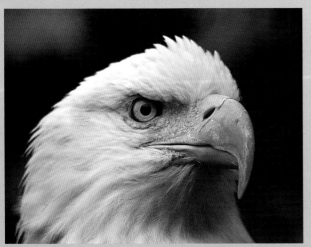

Using a wide aperture (f5.6) to render the background out of focus (by Ian Plant).

When looking through your viewfinder, your lens is set to its largest aperture. Use your camera's depth of field preview button, which closes the aperture to the f-stop setting you have chosen, to see the effect that stopping down has on image sharpness. Because you are letting in less light, things will get dark in your viewfinder; give your eyes a few moments to adjust. Live View used in conjunction with the depth of field preview button is much better—not only does the LCD screen adjust its brightness for you, but you can also zoom in to check focus in all the critical areas of your image!

It is important to note that lens quality diminishes when you use very small apertures. This is known as *diffraction*. Thus, while you may be able to render all of a given scene in focus at f22, diffraction will limit the ability of the lens to render detail in the image as sharply as it would if shot at a larger aperture. Don't avoid small apertures altogether because of diffraction—sometimes you need to use f22 to make sure everything in the scene is in focus—but just be aware of the limiting effects of diffraction and avoid very small apertures when possible.

HYPERFOCAL DISTANCE

Simply put, the hyperfocal distance is a point of focus that maximizes depth of field for any given aperture. Let's say you are using a 24mm lens to photograph a landscape scene where the closest elements in the scene are three feet away and the farthest point in the scene—the horizon—is at infinity. In order to achieve sufficient depth of field to make sure everything from three feet to

infinity is in focus, you need to select an aperture of f11 and focus at the hyperfocal distance (approximately six feet). Okay, so how do you know to do this? Some lenses come with built in depth of field scales, which show you where you need to focus the lens to make sure your near and far focus points are within a selected aperture's depth of field. Useful, huh? Alas, most modern autofocus lenses have truncated depth of field scales, or have dispensed with them altogether. So nowadays, if you want to calculate your hyperfocal distance, you must consult the hyperfocal chart that might have come with your lens' manual. You can also find depth of field or hyperfocal distance calculators online. Once again, Live View used with your depth of field preview button can make finding the hyperfocal point easier; simply move the focus point back and forth and check the critical areas of the scene until you have found the optimum point. One final tip: when focusing on a hyperfocal point, turn autofocus off.

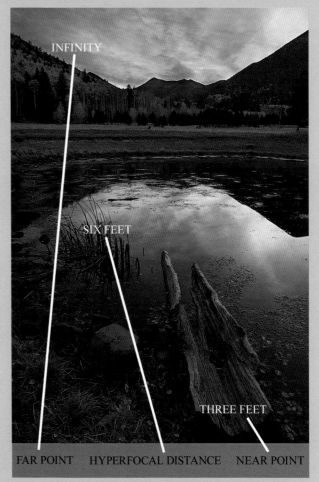

An example of using hyperfocal distance and a small aperture (f11) to focus (by George Stocking).

composition

Learning the art of composition is a challenge for all photographers. Let's face it, composition is a tough subject to master. What makes a composition "good" is difficult to define and often highly subjective: it's one of those "I know it when I see it" type of things. Nonetheless, in an effort to make mastering composition an easier task, we have attempted to distill the amorphous "I know it when I see it" into something more specific and user-friendly. Here it goes...

WHAT IS COMPOSITION?

Simply put, a composition is the arrangement of visual elements within the boundaries of the frame. The ability to produce a well-composed image is critical to the success and aesthetic appeal of your work. While good technical skills can be easily defined, quantified, and learned, there are no precise recipes for what makes a good composition. This is where your own artistic vision and creative talent come into play.

While not as well defined as, say, exposure or focusing, there are guidelines, processes, and considerations you can practice that will go a long way towards helping you arrive at a good composition and capture your subjects in a visually pleasing way. Remember, though, that all such rules and guidelines are mere suggestions. The ultimate test of a good composition is whether or not it "works" to evoke the kind of response you want, regardless of complying with any given rule. Don't be afraid to explore and even make a few mistakes along the

way—accidents often lead to artistic creativity and new ways of seeing.

FRAMING

Your most important compositional decision is what to include in the frame and what to leave out. Remember you are recording a very small portion of a much larger scene and your viewers may never know what was there beyond the image, excluded from the frame. Your goal is to distill the complexity of nature down to the most essential elements and only include what's needed to convey those things that attracted you to the scene —the things that prompted you to want to capture an image to begin with!

Above: The Racetrack Playa, Death Valley National Monument, California (by Guy Tal). Guy found an appealing, graphic shape in this simple zig-zag track made by one of Death Valley's famous "moving rocks."

Right: Bighorn Sheep, Yellowstone National Park, Wyoming (by Jim Clark). Composition is just as important to wildlife photography as it is to land-scape work.

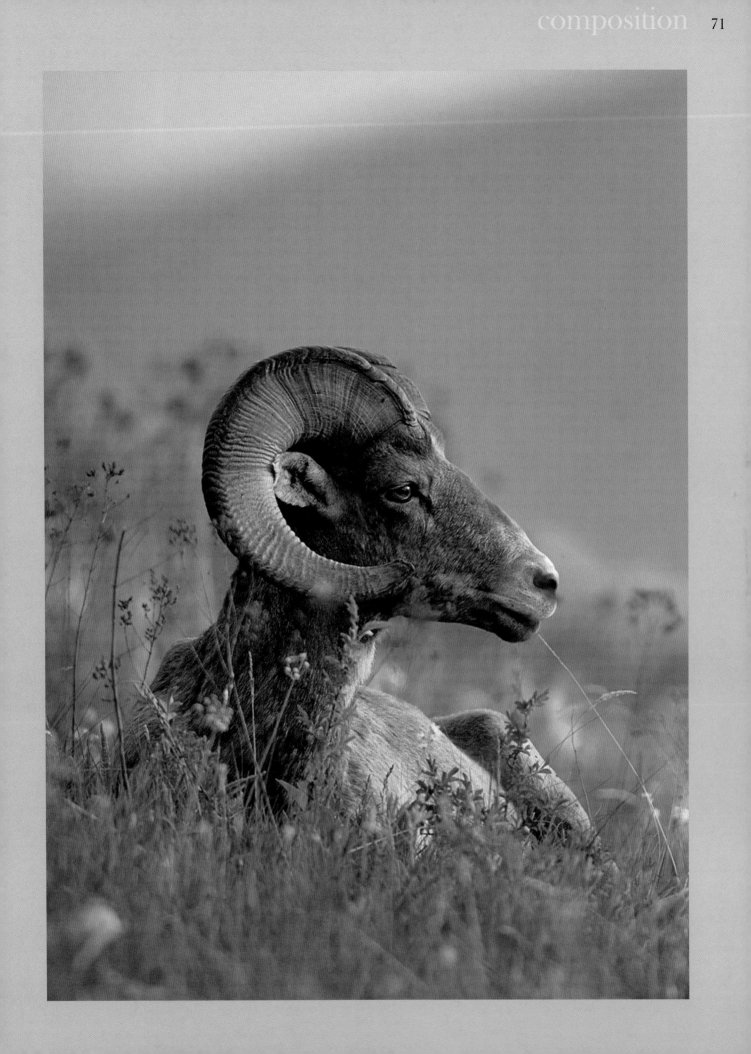

When it comes to framing, the obvious pitfalls are to include either too much, or not enough to make the image stand on its own. Be very judicious about what enhances your main subject or theme, and what distracts from it. As a general rule, anything that doesn't add to it will generally take away from the impact of the image.

Careful framing also involves making sure that prominent objects are not cut off at the edges and that unwanted elements (such as rogue branches, tripod legs, etc.) are not protruding into it.

Balance

Once you determine what elements should be included in, or excluded from, the frame, the next step is deciding where to place them. A well-balanced composition means making the best use of the frame's "real estate."

First, avoid merging or bunching of elements that should be clearly separated, and give them sufficient "breathing room." Secondly, important elements should be kept far enough off the frame's edges. Thirdly, avoid having a significantly higher concentration of prominent elements on one side of the frame versus the other. Generally, a more even distribution across the frame is more visually pleasing to the viewer, rather than drawing and holding their eye in just a small portion of it.

Perspective

Perspective is the visual relationship between your camera's position and the elements you are photographing. By changing your position, you can make objects appear larger or smaller, more- or less-prominent, and nearer or farther to the viewer or to each other.

A critical part of finding a good composition is to identify the most favorable spot to position your camera, or as Ansel Adams put it, "A good photograph is knowing where to stand." This means avoiding the initial instinct to plop down the tripod the moment you discover a photo-worthy scene and, instead, taking a few moments to determine the best angle.

Below: Grand Falls, Arizona (by George Stocking).
Even with great light, a strong composition is necessary to bring an image to its fullest potential.

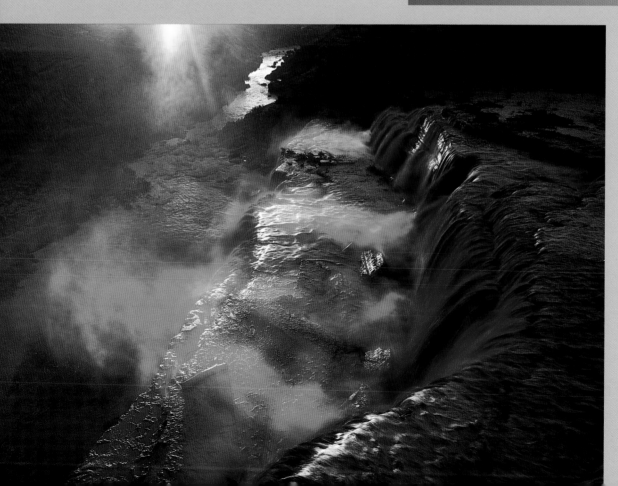

COMPOSITION STYLES

There are plenty of "rules of composition" out there. Some are helpful; others not so much. It is important to keep in mind, however, that the so-called "rules" are merely *guidelines;* following them will not guarantee a good image, and breaking them doesn't mean your image will be unsuccessful either. Their value is in helping you approach a scene, giving you some options to consider, and improving your understanding of visual design.

What follows are a series of composition guidelines, or more accurately, *design styles.* They by no means represent the complete universe of artistic possibilities. Furthermore, they aren't necessarily one-size-fits-all. Instead, you should feel free to treat these more like a Chinese menu: pick and choose several at a time if necessary, and mix and match at will. Sometimes you may find that two or more styles can be combined; sometimes one works just right; and sometimes none will work at all. Above all, be creative, and if a scene moves you but doesn't quite fit any of these styles, go for it anyway!

RULE OF THIRDS

The most universal "rule" of composition is the Rule Of Thirds. The Rule has been around since antiquity, aiding through the ages ancient Greek sculptors, Renaissance painters, and even post-modern performance artists. It states that when each dimension of the frame is divided evenly into three, there is aesthetic benefit to placing lines and objects along the dividing lines, at their intersection points, or within the off-center zones created by the intersecting lines. Basically, this "rule" dislikes the center of the image, and seeks to create compositional tension by moving important elements of the picture off-center.

While the Rule of Thirds is certainly not mandatory to the success of an image, it can be very valuable in avoiding the instinctive urge to point the camera directly at the most interesting object in the scene. By placing the subject in other areas of the frame, the composition as a whole may be more effective.

Rule of Thirds

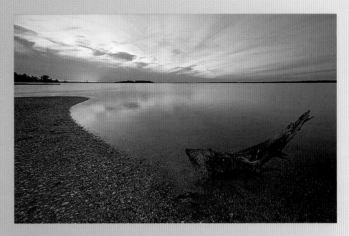

Opossum Island at sunset, Chesapeake Bay, Maryland (by Ian Plant): *The image above is a classic example of a composition based on the Rule of Thirds. As the grid overlay below demonstrates, the point of interest in the image falls on the third lines or at the intersection of two lines. The horizon has been placed on the upper third horizontal line, whereas the driftwood has been placed at the intersection of the lower third horizontal and right vertical lines. The eight off-center zones (bottom image) created by the intersecting lines can also be used as powerful compositional areas.*

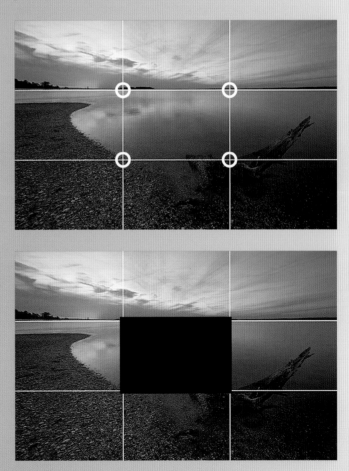

Repeating Patterns

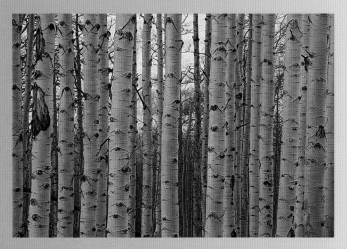

Glowing aspens (by Guy Tal): *This aspen grove shot wouldn't have worked if all of the tree trunks were bunched up. Guy made sure to move his camera around until he found sufficient spacing between the elements of the scene.*

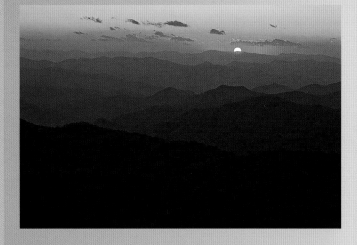

Fiery sunset, Blue Ridge Parkway, North Carolina (by Richard Bernabe): *The iconic stacked ridges of the Southern Appalachians make for a perfect layer image.*

Crested dwarf iris, Great Smoky Mountains National Park, Tennessee/ North Carolina (by Bill Lea): *Although merger of elements is often avoided, it sometimes works well, as with this simple arrangement of repeating flowers. An abstract shape is formed by the arrangement, which is reinforced by the fact that the repeating patterns touch each other—proof that rules are meant to be broken!*

REPEATING PATTERNS

The human eye is naturally attracted to repeating shapes and patterns. With this type of composition, the frame is filled with consistent or repeating patterns. Basically, you are looking for a relationship between elements in the scene that is based on their shapes. Sometimes unique elements can be added that break the consistency for added interest. Positioning such elements in the image using another compositional style—for example, the Rule of Thirds—can generally enhance the composition.

Most commonly, patterns are found in close-up views of interesting surfaces, although not always. Even something as large as a mountainside or a forest can yield interesting patterns that relate to one another in a pleasing way. A common example of a repeating pattern scene is a grove of aspen trunks; another common one is rippled sand. Repeating pattern compositions can also be very effective with wildlife images.

One type of repeating pattern shot is a layered composition, which consists of distinct, repeating bands stacked one on top of the other to fill the frame. Layers are usually arranged horizontally or diagonally and create multiple areas of interest for the viewer to explore, and can be very effective when they lead the eye from the foreground to the background.

Repeating pattern shots that avoid "merger" between the elements of the scene are often most successful. Usually, a clear division between the elements or layers of the scene helps create a sense of order. Sometimes, however, overlap between elements can form a unified compositional theme by creating abstract shapes or leading lines.

Right: "Gathering of Terns," Eastern Neck National Wildlife Refuge, Maryland (by Ian Plant). Ian couldn't resist photographing these terns gathered on a log poking just barely above the flooding tide. The repeating shapes of the birds attracted his attention, and they create an abstract diagonal line that cuts across the image. Additional interest is created by the lone seagull that breaks the repeating pattern of terns.

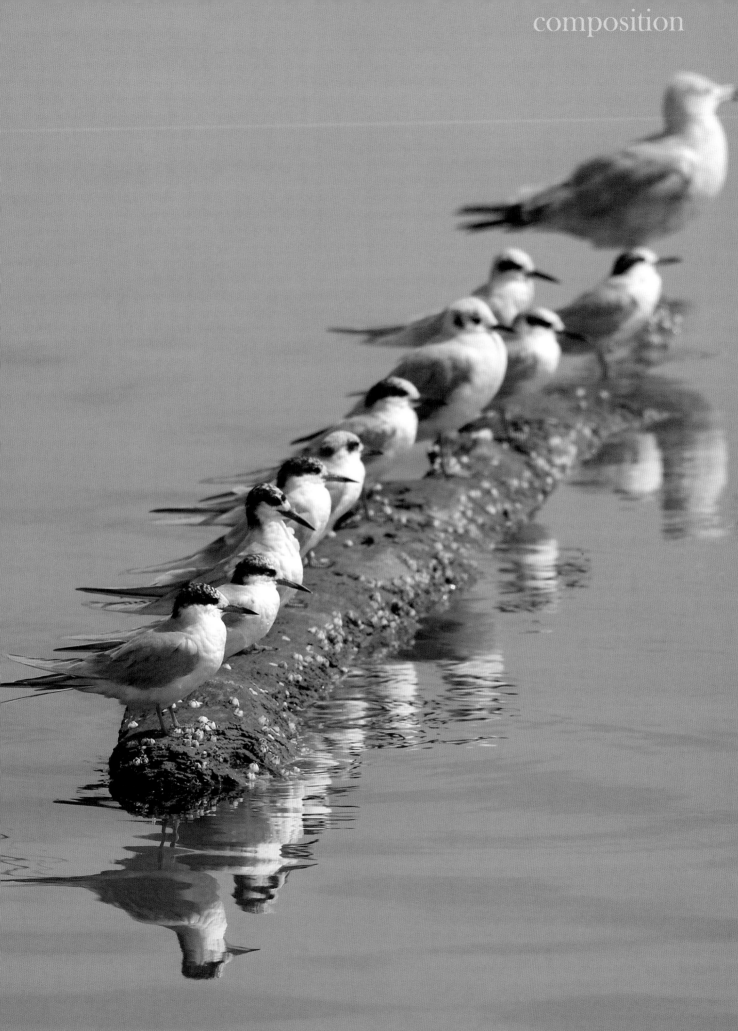

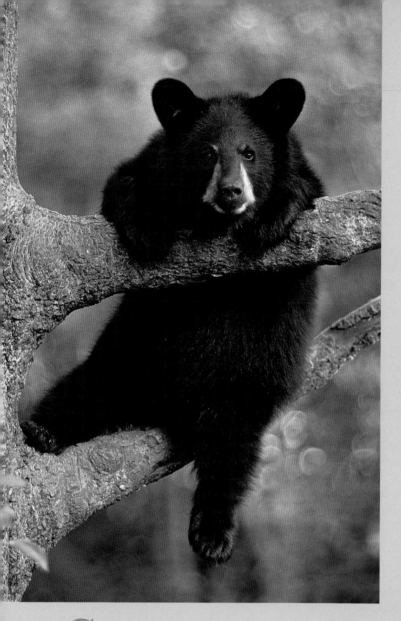

elements, carefully arranged to draw attention to specific portions of the scene. Intimate landscapes allow the photographer to create very personalized and unique expressions, rather than a general view of a place. Such images often are combined with another composition style, such as repeating patterns.

Photographers often capture symmetry in nature using centered compositions. For example, when photographing a sunset sky reflected in a body of water, often it is perfectly appropriate to place the horizon line right smack-dab in the middle of the frame. Take that, Rule of Thirds!

Upper Left: Black bear cub in tree (by Bill Lea). A classic example of a wildlife portrait. Bill used a wide aperture on a telephoto lens to throw the background out of focus, thus separating it from the main subject matter.

Below: "Rundle Mountain Reflected," Banff National Park, Canada (by George Stocking). When clouds are reflected in a lake or other body of water, try a composition that places the horizon in the middle, splitting the image and creating symmetry.

Right: Graveyard Fields, Blue Ridge Parkway, North Carolina (by Jerry Greer). A telephoto lens was used to isolate a portion of the landscape. Jerry focused in on a swath of especially brilliant color, and was careful to exclude from the image any elements that might detract from his composition.

CENTERED COMPOSITIONS

"Front-and-center" compositions, although anathema to the Rule of Thirds, are nonetheless appropriate in a great variety of situations, most commonly (but not exclusively) wildlife and macro photography. Essentially portraits, these compositions are usually most successful when the photographer can set the main subject significantly apart from its surroundings, most often accomplished by using a large aperture to throw the background into a pleasing blur (also known as *bokeh*) to offset the main subject.

Centered compositions are also used in landscape photography. Perhaps they are most commonly used in "isolated scenics" or "intimate landscapes." Intimate landscape compositions use careful, tight framing to capture unique characteristics and nuances in the scene. They generally rely on a small number of visual

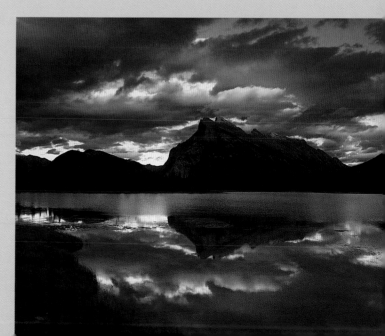

When composing a centered image, tight framing is often most effective. Be sure to exclude extraneous elements to the full extent possible, such as twigs sticking into the image from the corners, or elements that unduly break up repeating colors, patterns or shapes.

PERSPECTIVE PROGRESSION

Images with visual progression from foreground, to middle ground, to background can be very effective in leading the viewer's eye throughout the scene, and giving the viewer a sense of perspective, of *being there*. This style of image, also known as *near-far,* will often have prominent foreground, middle-ground, and background elements stretching from very near the camera's position and out to very distant subjects. Although mostly used with landscape photography, the principles of perspective progression can be applied to wildlife photography as well.

Basically, you start with a foreground element, like a clump of flowers or a rocky outcrop. This foreground element points to or otherwise relates to a middle-ground element, such as grove of trees, or a sinuous river. This middle-ground element, in turn, points to or relates to the background, such as distant mountain peaks. Sometimes perspective progression can be taken a step further, moving up to clouds in the sky. And sometimes it relies on only two elements, such as a foreground and background.

Perspective progression shots are often made using wide-angle lenses to give prominence to the near elements, which are juxtaposed against an interesting background. By getting close to the

Perspective Progression

"Ragged Top Glow," Ironwood Forest National Monument, Arizona (by George Stocking): A classic example of a perspective progression shot: a wide-angle lens is used to emphasize foreground elements (the cacti clumps), which in turn lead the eye to a middle-ground (saguaro and creosote bushes), which in turn lead to the background (Ragged Top Mountain). This progression of elements from foreground to background transports the viewer into the image, giving a sense of perspective that would otherwise be lacking.

Autumn snow, Wasatch Mountains, Utah (by Guy Tal): Perspective progression is achieved with a short telephoto lens. Although the "foreground" trees are not right in front of the photographer as would be the case with a wide-angle shot, a sense of progression between elements of the scene is nonetheless successfully conveyed, and a relationship between foreground and background is created.

foreground element with a wide-angle lens, its size relative to other elements of the scene is exaggerated, thus imparting a sense of depth and perspective to the image.

This visual trick can also be used with longer lenses, however, and even with wildlife shots. Instead of a "real" foreground, you have some element of the scene that is in the bottom part of the image, which leads or relates to something in the middle of the image, which leads to or relates to something in the top of the image.

Below: Fawn in ferns, Shenandoah National Park (by Ian Plant). Perspective progression is implied by the progression from "foreground" (the out-of-focus grass) to "middle-ground" (the ferns below the fawn) to background (the fawn itself).

Right: Spider lilies, Catawba River, South Carolina (by Richard Bernabe). A wide-angle perspective creates separation between foreground and middle-ground elements: the three spider lilies right in front of the lens are exaggerated in size relative to more distant spider lilies.

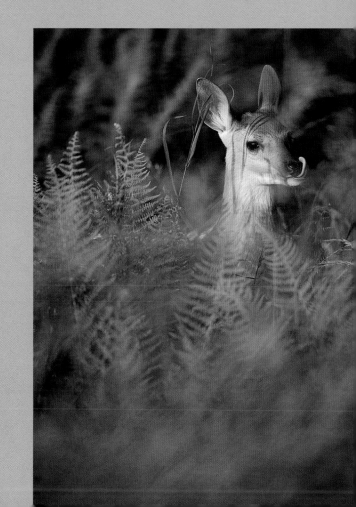

FRAMING

Framing your subject with other elements in the scene can be a very simple yet effective compositional tool. Examples of commonly used frames include trees, natural arches, and old barn windows. Frames can also be abstract, formed (for example) by areas of deep shadow or a contrasting color. Sometimes framing shots work best if the frame and the primary subject are in different light—for example, silhouetted trees framing a sunlit mountain peak.

HABITAT

In wildlife photography, including the subject's natural surroundings (as opposed to a tight framing of the subject, isolating it from its environment) is often referred to as a habitat image, also known as an environmental portrait. One way to think about habitat images is as combinations of wildlife and landscape photography. Special attention must be paid to the composition when making a habitat image—remember, it is not enough to simply show the animal in the context of its environment. For a habitat image to be successful, the various elements of the scene need to interact to create a pleasing composition.

Previous page: Little Stony Man Cliffs, Shenandoah National Park, Virginia (by Jerry Greer). An example of a traditional framed image.

Left: Yucca and full moon, White Sands National Monument, New Mexico (by George Stocking). George used the yucca to frame the rising full moon.

Top: Great egret at dawn, Chincoteague National Wildlife Refuge, Virginia (by Ian Plant). An abstract frame formed by areas of shadow; also a good example of an environmental portrait.

Above: Yearling black bear, Cranberry Glades Botanical Area, West Virginia (by Jim Clark). Showing the bear in its natural habitat.

Dream Lake, Rocky Mountain National Park, Colorado (by Joseph Rossbach). *Sometimes habitat shots happen by accident. Joe was setting up a landscape shot when a bull elk wandered into the scene. Sometimes you just get lucky!*

PRO POINTER
by Guy Tal

I think of photographic composition as a process of distilling an essence from the myriad of elements normally found in a natural scene. The random nature of found scenes often means that identifying a cohesive composition requires some effort and creative thinking. Placing a rectangular frame around those essential things that make up a good image, and expressly leaving out the ones that distract from it is not always a trivial task.

Budding photographers often prefer to study the scene through their camera's viewfinder, literally blocking out elements to assist in determining the best perspective and framing. While this method is effective, it is often responsible for as many misses as hits. Studying the world through a viewfinder imposes a very restricted way of seeing – limited to the format's specific aspect ratio, and the angle of view of a specific lens. It does make the decision easier, but it does so by eliminating many of the choices.

For example, the 3:2 ratio of most DSLR cameras may prevent you from seeing square or panoramic compositions. Seeing the world through a long lens may prevent you from identifying peripheral elements that can be successfully incorporated into your composition and, conversely, using a wide lens may prevent you from identifying intimate patterns.

While exploring a scene, I generally prefer to determine my composition without looking through the viewfinder. I move around a lot to see the scene from multiple perspectives and will often use my fingers to determine the most favorable framing before setting up my camera. This way I am not locked into the specific view as seen through the camera. Sometimes the most favorable composition requires cropping of the full frame, or stitching multiple frames, which may not be obvious when looking through the finder.

Above: On this day, a small storm moved in and the scene lent itself to a grand scenic. I determined where to draw the frame lines without using the camera and ended up capturing three images at a normal focal length, later to be stitched together on the computer to arrive at the composition I had in mind.

POWER SHAPES

Power shapes are simple geometric shapes that naturally attract and lead the eye. Power shapes are most often found in advertising and marketing materials, but are sometimes found in nature as well! Here are some of the most common examples of power shapes found in nature:

S- and C-curves
Simple and bold power shapes that are very effective in leading the eye throughout a composition.

Triangles
Another great power shape; they point rather than lead the eye, or they can be used to create compositional stability.

Circles
Circles capture the eye, forcing it to linger before going elsewhere. In nature, circles are often represented by swirling water.

Zig-Zags
Zig-zags push the eye back and forth, creating compositional excitement.

Remember, power shapes can be obvious (such as a curving river), or abstract, formed by a relationship between various elements of the scene. Advanced compositions will often have repeating power shapes, adding additional interest and complexity.

Below: Nascent ferns (by Jerry Greer). The swirling shapes create simple and graphic compositional elements.

Examples of Power Shapes

Zion Narrows (by Marc Adamus). *The meandering river creates a C-curve, which is transformed into an S-curve by relationship with the sloping canyon wall.*

Rhododendron and rainbows (by Nye Simmons). *The half-circle formed by the rainbow traps the eye, forcing it down to the foreground.*

Pelican flight (by Ian Plant). *This brown pelican taking off from the Chesapeake Bay forms a powerful triangle shape with its outstretched wings.*

Moving rock (by Guy Tal). *The rock's movement over the Racetrack Playa in Death Valley National Park, California, forms a zig-zag that engages the eye.*

Hunting Island (by Richard Bernabe). *The swirling waters of the Atlantic Ocean in South Carolina create an eye-catching swirling circle shape.*

Snake River Overlook (by George Stocking). *This classic view of the Grand Tetons is perhaps the most photographed S-curve in the United States.*

chapter three

LEADING LINES

Leading lines are vertical, horizontal, or diagonal lines that attract a viewer's attention and lead the eye to critical areas in your image. Leading lines can be tricky—if used properly, they propel the viewer into the scene; if used carelessly, they can confuse the viewer. So proceed with caution!

Distinct lines in your composition help the viewer navigate through the frame. Strong lines can also be used as visual anchors to create a sense of order in your scene. Diagonal lines often make for a more dynamic composition than horizontal or vertical ones, giving a sense of upward or downward motion as they lead the viewer's eye. For greater effect, diagonal lines can help create a

sense of depth in a two-dimensional image by converging at a point of interest.

While some lines generally have to be horizontal (such as distant shorelines, or the horizon itself) and others generally have to be vertical (such as straight tree trunks, utility poles, or buildings), there are many situations where a change in perspective can be used to position a line diagonally in the frame for more visual appeal. Examples may include roads, shadow lines, piers, bridges, or fallen logs.

Sometimes leading lines stretch from the foreground; sometimes they radiate from a center of interest into the corners of an image. Sometimes

the lines are obvious: such as a fallen tree trunk in a forest of ferns. Sometimes the lines are subtle: such as an abstract line created by a repetition of objects. Leading lines are often used in conjunction with perspective progression.

Note that not all leading "lines" are lines at all. Sometimes they are a curving shape rather than a line, maybe even an S- or a C-curve. Remember, we did warn you at the beginning of this chapter that there is a lot of overlap between these compositional styles!

Leading lines that all take the eye to the same location in an image create what is known as "vanishing point." Vanishing point is the point at which parallel lines receding from an observer seem to converge; think of parallel railroad tracks appearing to get closer together the farther they recede in the distance, eventually appearing to merge. In photography, vanishing point can be used to give the viewer a sense of perspective, and to create powerful compositions with radiating leading lines inevitably drawing the eye to a central point.

COUNTERPOINT

This one is going to be a little hard to define, so bear with us. Counterpoint is essentially an element of a composition that is set up in contrast or interaction with another. Such a juxtaposition of two or more counterpoint elements can make

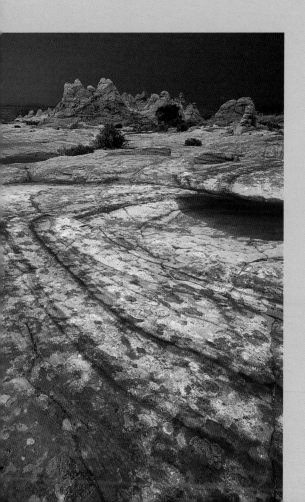

Previous page: "Forever Dreaming," Olympic National Park, Washington (by Marc Adamus). Marc used bold diagonal lines stretching forth from the foreground when composing this image of Washington's wild Pacific coast.

Above: Aspen skyward (by Guy Tal). Strong diagonal lines point to the same place, creating a vanishing point.

Left: Vermillion Highway (by George Stocking). This gentle curving line of sandstone leads the eye throughout the scene. This is technically not a perspective progression shot because there is no distinct foreground or middle-ground, rather one flowing line.

Right: "Cold and Alone," Jasper National Park, Canada (by Marc Adamus). The leading foreground line points the viewer directly toward the sun.

a powerful visual statement. Counterpoint can be strengthened if the two different elements have one or more dimensions of strong contrast. This contrast might be color (for example, one element is green and the other magenta, which are opposite on the color wheel); light (one is sunlit and the other is in shadow); or even movement (one is static while the other is motion-blurred). Not all counterpoint elements need to be in contrast; they can also complement each other.

Counterpoint can be used to create advanced and complex compositions that seem to break the rules. For example, you can often create effective compositions by centering a subject, and then using an off-center element to create counterpoint, attracting the eye away from the center.

PANORAMA

Though not an accurate use of the word, the term "panorama" is widely used to describe images where one dimension (width or height) is significantly longer than the other. Aspect ratios of 2:1 or greater commonly fall into this category.

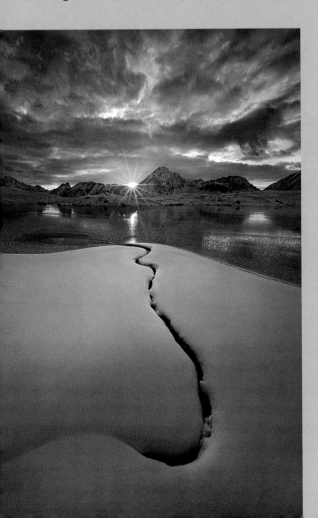

Counterpoint

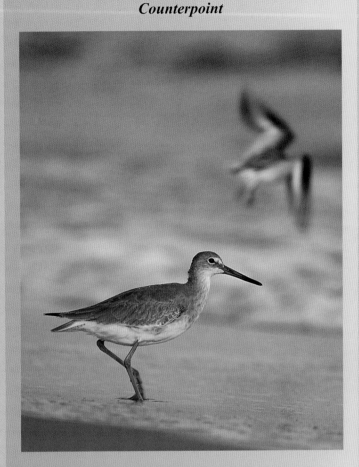

Above: Willets, Chesapeake Bay, Virginia (by Ian Plant): The flying willet is a counterpoint element to the willet on the shore, contrasting on several dimensions: focus (one willet is sharp while the other is out-of-focus), movement (one is stationary while the other is in motion), and shape (one is presenting a profile while the other creates an abstract shape).

Below: "Canyon Bonsai," Zion National Park, Utah (by Joseph Rossbach): Counterpoint is created by having one element in silhouette (the pinion tree) and the other in direct light (the sandstone mesa).

Panoramas may be horizontal or vertical and can be created by stitching multiple frames together, cropping a frame, or using specialized panoramic cameras.

Artist's Palette, Death Valley National Park, California (by Ian Plant). A panoramic image created by stitching several shots together.

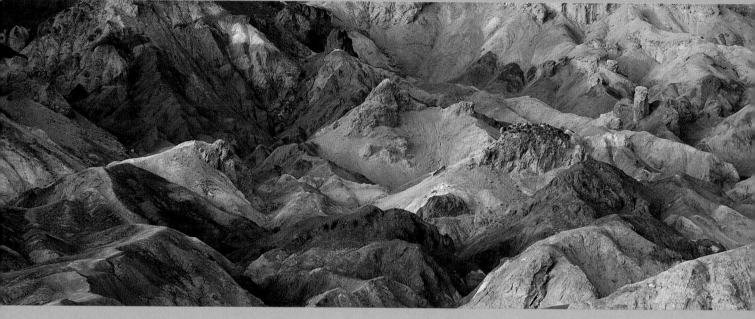

COMPOSITION WORKFLOW

Understanding the rules and guidelines of composition and having a sense of what makes a good image doesn't always translate into good field technique. One primary difference between photography and painting is that a painter begins with a blank page and decides what to add to it, while a photographer starts with a whole universe of subjects and needs to decide what to eliminate. Arriving at a beautiful place or finding an interesting subject, and trying to determine the best place to set up the camera, decide what lens to use, and identify what elements in the scene are most important, can sometimes feel overwhelming. Like all complex tasks, identifying good compositions can benefit from following a workflow, tackling one bite-size portion at a time.

STEP 1: SLOW DOWN, TAKE A DEEP BREATH

Unless the scene is at risk of changing dramatically in front of your eyes (such as wildlife getting spooked or fast-changing light), there is no reason to rush. Working too fast increases the probability for errors or missing important nuances or details. Leave the camera alone and take the time to appreciate the scene. Remember you want your images to represent something beautiful. Have a beautiful experience first before you set out to capture it in an image.

STEP 2: CREATE A VISUAL INVENTORY

Good compositions are the results of deliberate decisions—choosing an angle and perspective, identifying key elements and placing them in the frame, and excluding distracting ones. Good decisions require a good understanding of what you have to work with—your raw materials. Take a moment to survey and inventory the scene in front of you. The visual inventory does not have to be an actual itemized list, but rather an awareness of everything that might possibly be used in a photograph.

Specifically look for the following:
•Appealing elements: these are the things you find interesting and that you may want to include in your photograph.
•Distracting elements: these are the things you will want to exclude from your composition—

anything that either doesn't contribute or that may detract from the visual appeal of the final image you create.

•Lines: straight lines—horizontal, vertical, or diagonal—and how they should be portrayed (for example, attention should be paid to keeping the horizon level); curves and whether they can be used to lead the viewer through the frames; lines that can be used to point towards and lead to interesting elements.

•General visual relationships: size and prominence of important elements, distribution of colors and tones, separation or merging of elements in the scene.

•Light: where is the light coming from? Is this the best light for the scene, or should you plan to return at a different time of day (maybe even a different time of year) for more favorable lighting conditions?

Step 3: Visualize

Visualization is the ability to predict what the final image will look like (after applying all composition and processing decisions) while in the field. Try so see in your mind's eye the final image you want to produce, and work backwards from there to decide what you need to bring back from the scene.

Consider the following:
•What would the scene look like from a different vantage point or different perspective?
•What would it look like at different angles of view? Should you use a wide-angle lens, a normal one, or a long focal length to isolate specific aspects of the scene?
•What elements should be grouped together in the image? What should be kept out? Can it be done effectively?
•Is there more than one good composition?

Don't be afraid to walk around and examine the

scene from various perspectives, using your fingers to experiment with different framing options. Make sure you visualize the image in your mind before you set up the camera.

Step 4: Set up the Camera

After figuring out what you want to capture, next comes the easiest part: capturing it. Pick the most favorable perspective and the right lens to cover the framing you've decided upon. Set up your tripod and camera, and adjust your position, zoom, focus point, and any other settings needed to achieve your intended composition. Use a bubble level to keep the horizon straight.

Step 5: Make Final Adjustments

Before pressing the shutter, study the viewfinder image carefully. Make sure no rogue elements are peeking in, scan the edges of the frame to make sure no important elements are abruptly cut off. Verify that the composition as a whole works, now that you have actual frame lines blocking the rest of the scene. Make any necessary fine-tuning.

Sandstone Wave, Paria Canyon/ Vermillion Cliffs Wilderness, Arizona (by Joseph Rossbach). Previsualization and an awareness of the scene's elements helped Joe create this mesmerizing image.

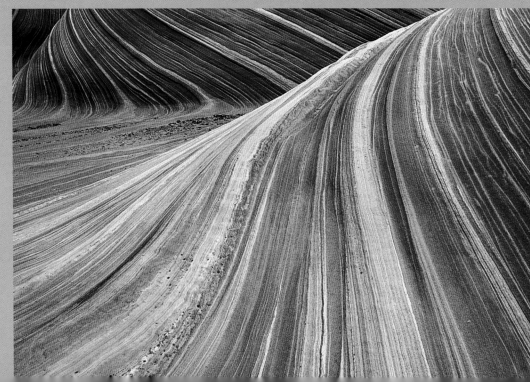

COMPOSITION ROUNDUP

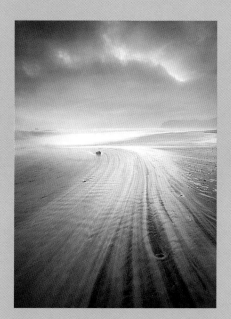

LEADING LINES

"Endless Journey," Olympic National Park, Washington (by Marc Adamus). Flowing surf creates a leading line (or curve) that takes the viewer's eyes through the scene.

CENTERED PORTRAIT

Playful raccoon (by Bill Lea). A centered composition puts the emphasis on the most important part of the image: the raccoon.

POWER SHAPE

Heath barrens, Dolly Sods Wilderness, West Virginia (by Jim Clark). A heart-shaped rock makes the perfect power shape: it is simple, bold, and graphic. The surrounding red leaves are a perfect complement.

COUNTERPOINT

Lone pine and crescent moon, Zion National Park, Utah (by Nye Simmons). The pine tree and crescent moon make excellent counterpoints to each other. The relationship between these elements is accentuated by the curving shape of the clouds.

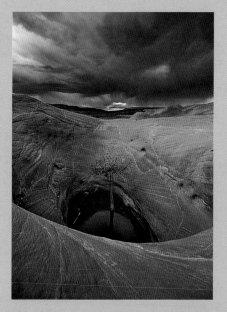

PERSPECTIVE PROGRESSION

"Sheltered", Grand Staircase-Escalante National Monument, Utah (by Guy Tal). Foreground sandstone leads to a lone tree in the middle ground, which points to the background in this pleasing composition.

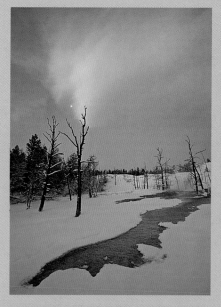

REPEATING PATTERNS

Angel Terrace moonset, Yellowstone National Park, Wyoming (by Ian Plant). The curving shape of the foreground thermal feature is mirrored by the shape of the cloud, establishing a shape-based relationship between the two elements.

COMPOSITION ROUNDUP

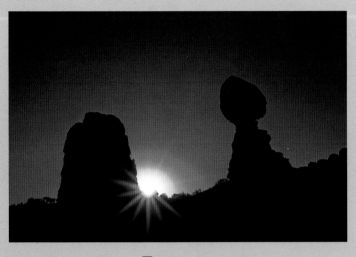

FRAMING

"Desert Dawn," Balanced Rock, Arches National Park, Utah (by Joseph Rossbach). Stone columns frame the setting sun in this bold and graphic image. The composition is enhanced by the silhouette treatment of the columns, thus focusing interest on the rising sun.

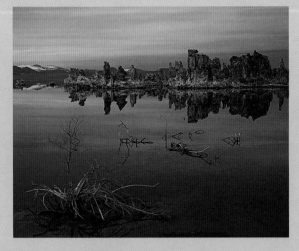

RULE OF THIRDS

Dusk, Mono Lake, California (by George Stocking). A classic composition adhering closely to the Rule of Thirds. The horizon line is placed on the upper third horizontal line, whereas the foreground bush is placed at the intersection of the lower third horizontal line and the left vertical line.

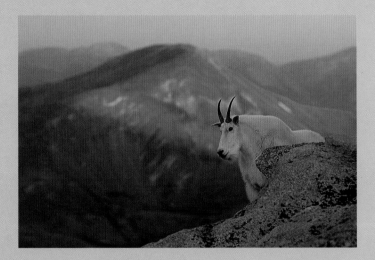

HABITAT

Mountain goat, Mount Evans, Colorado (by Richard Bernabe). Resisting the temptation to get a tight portrait of the goat, Richard instead backed away to show the animal in the context of its environment. As with all good habitat shots, Richard used other compositional techniques to make the image stand out. A leading line–the shadow line on the distant peak–points to the goat, giving it emphasis. Also, a subtle repetition of shapes helps hold the viewer's attention. The granite mound in the foreground relates to the shape of the background mountain peak.

PANORAMA

Sunrise over rhododendron blooms, Roan Mountain, North Carolina/ Tennessee (by Jerry Greer). Several photographs have been stitched together to make this image. Panoramic images can be made either by stitching or cropping a full frame image. Stitching is the preferred method because it does not reduce the image's resolution, as cropping does. As with regular images, care must be taken when composing panoramics, but special allowance must be made for the compressed format.

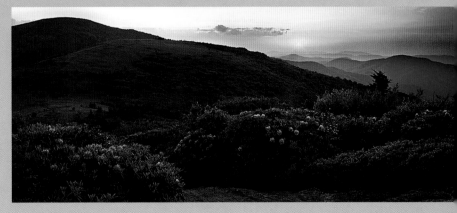

light

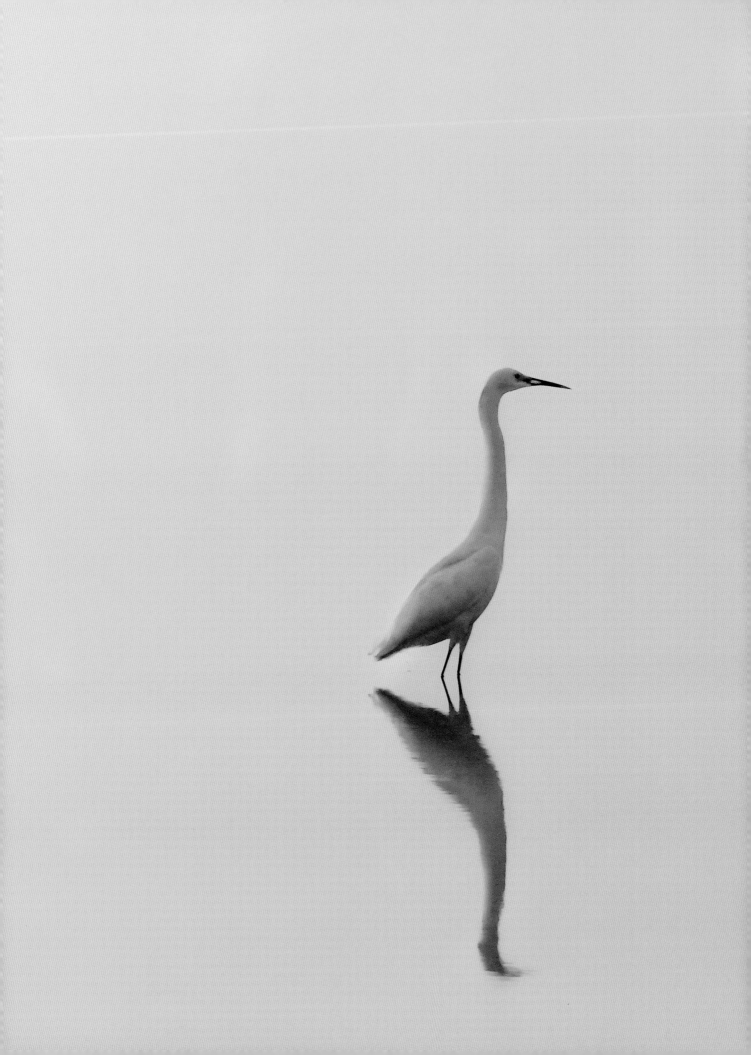

Light is critical to nature photography–it almost goes without saying that in fact, without it, we can't photograph anything at all. But to put it in a way that is more to the point of this book: without great light, we can't make great photographs. Light is ephemeral, unpredictable, at times subdued, at times mind-blowing. Learning to take advantage of different lighting conditions is key to mastering nature photography. But how does one tame the wild beast?

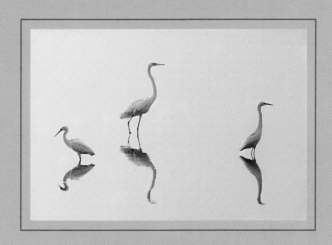

WHY IS LIGHT IMPORTANT?

Without light, photography would simply not exist. In fact, the word photography is derived from the Greek, literally meaning "writing with light" or "light writing." But light is much more than just a photographic necessity. It is the heart and soul of photography. Light determines the mood and emotion an image projects and can render a subject in many different styles, characters, and personalities. It can transform a boring, mundane scene into a theatre of drama and vice versa.

Perhaps you have witnessed the mysterious ritual performed by a group of photographers standing around with cameras and tripods ready, seemingly doing nothing! Even more mysterious is their answer if you ask them what they are doing. "Waiting for the light," one of them might say. This chapter will help explain what they might be waiting for and why.

There are three primary considerations you make when evaluating light for outdoor photography: intensity, direction, and color.

INTENSITY

Light can be soft, evenly illuminating the land and leaving no shadows. Light can be harsh, casting deep shadows and lighting features of the landscape so brightly we need to squint to look at it. Light can even be too bright to look at without damaging one's retinas; for example, looking into the sun! Or light can be an infinite variety of intensities in between, ranging from twilight, to light filtered through fog, to striking sunset light. Keen awareness of the intensity of light is critical in making sound judgments about how to approach a scene.

Above: Egrets in reflected twilight, Lemon Island, South Carolina (by Richard Bernbabe). A simple composition focuses attention on the wonderfully soft and colorful light of twilight.

Right: Tree shadow, Yellowstone National Park, Wyoming (by George Stocking). Sunrise filtered through mist creates a dramatic show of light.

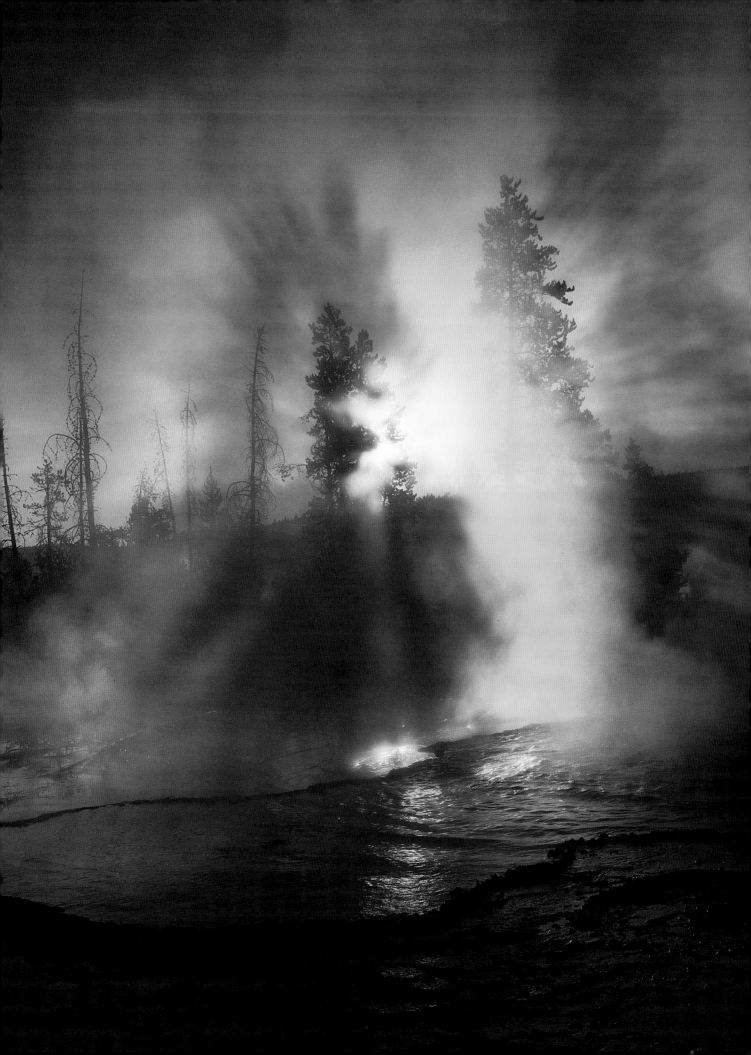

COLOR

The sun is the source of (most) natural light on Earth. This light from the sun takes on a variety of colors, and it constantly changes throughout the day.

At sunrise and sunset, light from the sun is orange or warm while at dusk, dawn, or in open shade, the light has a bluish cast to it. This imparts color casts to the landscape and the subjects we photograph in natural light.

Digital cameras have an auto white balance feature to remove these color casts and keep colors "normal." However, these colors of light (often referred to as color temperature as well) can enhance the overall image by creating mood and emotion in the scene.

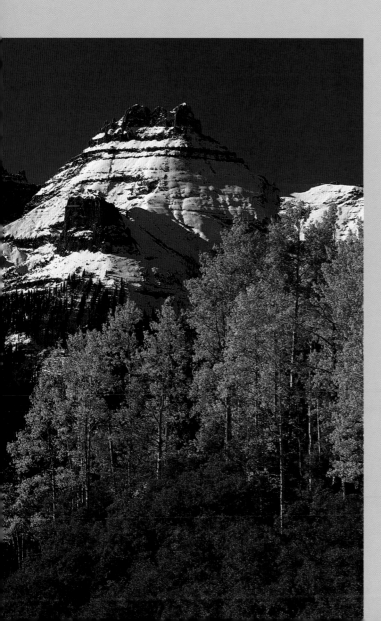

DIRECTION

Another element of light that photographers must be aware of is direction. The appearance of a scene can change dramatically with changes in the direction of light. For example, a field of alpine flowers may be directly front-lit at sunrise, and back-lit at sunset. Certain areas of a scene may be in shadow certain parts of the day and in light during others. Direction of light can be particularly important with wildlife, as strong side-lighting sometimes does not work with certain subjects.

LIGHT STYLES

Intensity, color, and direction interact to produce a myriad of lighting types. There are a few general types that stand out and are of particular importance to nature photographers. Not unlike with composition, there are opportunities to mix and match these styles, though to a lesser degree.

MIDDAY LIGHT

Most people think that bright, sunny days are beautiful—but not nature photographers! Light during the middle of a sunny day lacks discernable color and is often very harsh, producing hard shadows and bright highlights that exceed the contrast range of most digital sensors. As a result, photographers often avoid this light. There are certain subjects, however, that work well during midday light; in fact, some subjects even excel. For example, fall color juxtaposes well against blue skies, and some scenes naturally lacking in contrast benefit from harsher light. Just because midday light isn't stand-out pretty doesn't mean that it should be dismissed out-of-hand. Many great images have been made by photographers during the middle of the day.

Left: Dallas Divide aspens, Colorado (by George Stocking). Fall color is a subject that works well in sunny midday light.

Right top: Cabbage white butterfly (by Jim Clark). Overcast light often works well for macro subjects.

Right bottom: Fall colors along the Blue Ridge Parkway, North Carolina (by Nye Simmons). An example of chiaroscuro light.

OVERCAST LIGHT

Light from the sun is soft and diffused on cloudy or overcast days, illuminating the scene evenly and eliminating any deep shadows and intense highlights. Since the tonal range is compressed, exposure is easy. Wildlife portraits, macro flower images, intimate landscapes, waterfalls, and forest scenes are ideal for this type of light. Diffused, overcast light seems to embrace the scene, illuminating it evenly in soft light that enhances fine detail and rich color. This softening also occurs in foggy weather, shade, and at dawn and dusk when there is no direct illumination from the sun.

CHIAROSCURO

Italian for *light-dark*, it describes the interplay of both direct light and shadow across the landscape. Partly cloudy conditions or shadows from mountains and other landforms create chiaroscuro. The resulting contrast creates a sense of depth. You normally want the highlighted areas of the landscape to fall in an important part of the scene or focal point.

FOG

When the fog rolls in like pea soup, grab your camera immediately. More than just a convenient prop for mystery writers, fog gives us those wonderful, soft, mysteriously moody images we often seek. The light during foggy conditions is highly diffused, making exposure an easy task. In addition to setting a mood, fog can take a jumbled, complex scene and simplify it, removing distract-

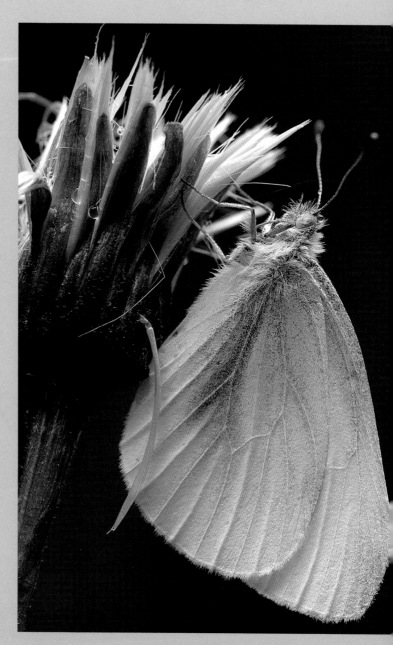

ing background objects and creating order out of a chaotic world.

Foggy light can actually take a fairly wide range of forms. Especially thick fog, or fog beneath a layer of clouds, creates the ultimate diffused light: colorless, flat, and with minimal shadows. Light fog with clear sky above can have color and cast soft shadows. Even lighter fog, with sun burning through, can create very dramatic light. Often, fog will progress through all three stages: starting off thick in the early morning, fog will gradually thin and lift, letting progressively more light through until it dissipates entirely. If you have fog over a particularly nice scene, stay put and keep shooting as the light changes.

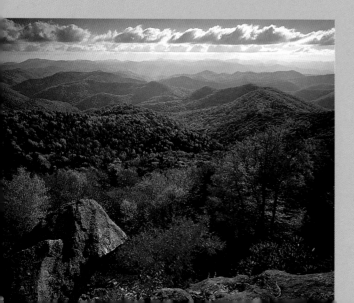

The Many Faces of Fog

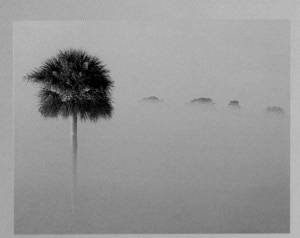

Sabal palm trees, Florida (by Bill Lea). *Fog helps isolate the subjects from a chaotic background.*

Autumn morning along the Blackwater River, West Virginia (by Jim Clark). *Lifting fog scatters dawn light and has strong color.*

Fog below Table Rock and the Mountain Bridge Wilderness, South Carolina (by Richard Bernabe). *Being above the fog can have its benefits too!*

West Canada Lake, Adirondack State Park, New York (by Ian Plant). *Heavy fog creates a scene with little color or contrast.*

Some of the most magical light often occurs on a morning when a thin layer of dense fog hugs the ground. As it slowly retreats, low angled sunlight begins to penetrate the hanging vapor. Light refracts off millions of moisture particles producing an effect like that of a thousand little fill-flashes illuminating the scene. Shadows are nearly non-existent due to the multi-directional effect of refracted light off all the tiny droplets suspended in air. Hence, fog has the ability to transform even an ordinary scene into something beautiful and magical!

Learning to predict when fog may occur, and planning to be on location to capture it, are important. To do so, one must become a student of weather. A basic understanding of the relationship between temperature and dew point is a must! On the night before a photo shoot study the weather. Wet conditions during the day followed by clearing and cooling skies on a windless night often augers fog the next morning. Fog is more likely in areas where there is a lot of moisture—such as streams and lakes—or regions with wide temperature swings within small geographic areas—such as valleys surrounded by steep mountains or hills. When in doubt, plan to be on location no matter what!

MAGIC HOURS

Photographers don't call the hours immediately after sunrise and preceding sunset magic for nothing! During the "magic hours" (also often referred to as the "golden hours"), direct light is relatively soft compared to that of midday, and its tone is warm and inviting—even magical, you might say. That is, of course, if the sun is not completely blocked by clouds. With no clouds, the landscape is often bathed in a warm light. Partly to mostly cloudy skies can sometimes block direct light on the landscape, but with luck the clouds will light up—of course, with even more luck, both the clouds and the landscape will light up.

TWILIGHT

The 30 or 40 minutes of light immediately preceding sunrise and after sunset are often as good, if not better, than sunrise or sunset themselves. The light is cool and soft but usually not in much abundance. Clouds can still glow with light after sunset. When it gets dark enough, the light still left in the sky will be the sole source of light on the landscape, bathing it in an eerie illumination. Exposure times can often be quite long.

Bristlecone pine, White Mountains, California (by Guy Tal). Clouds light up at sunset during the "magic hour."

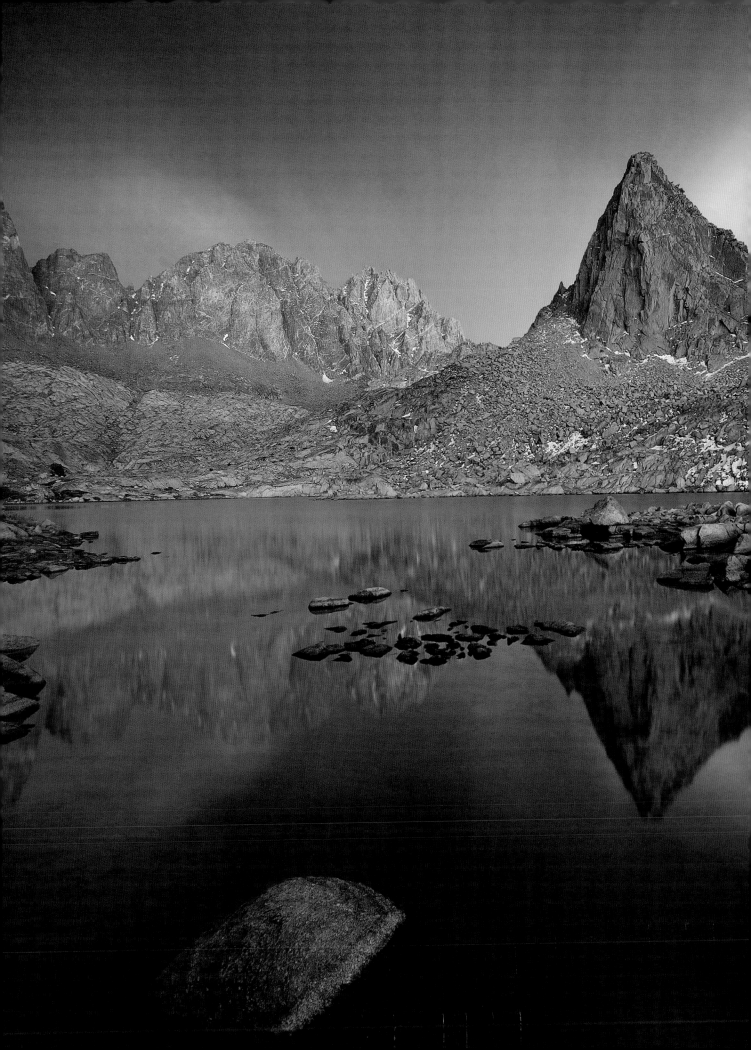

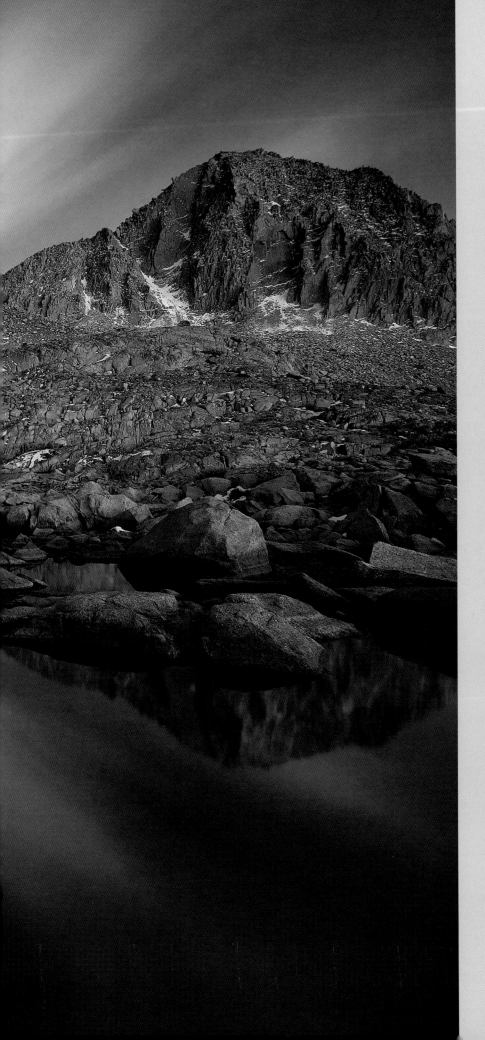

GLOW

Glow, known as "alpenglow" to mountaineers, is a phenomenon that occurs when the sole source of light on the landscape comes from light reflecting from the sky. Glow occurs during twilight (either after the sun has set or before the sun has risen, and therefore is not providing direct light). This effect is most pronounced when much of the sky is relatively dark, and only a portion of the sky or clouds have light on them. Glow light is similar to overcast light in that it is soft and creates muted shadows. But the similarities end there—unlike overcast light, glow light can be very colorful. Glow is often most pronounced when looking away from where the sun has set or is rising.

Left: "Alpine Luminescence", Isocoles Peak, Kings Sequoia National Park, California (by Marc Adamus). *Alpenglow lights the landscape and clouds streaking through a long exposure.*

Below: Mount McKinley, Denali National Park, Alaska (by Bill Lea). *First light makes glacier-clad peaks glow pink.*

FRONT LIGHTING

Front lighting evenly illuminates your subject when the sun is directly at your back. Beginning photographers are often taught to "keep the sun at your back" when photographing a subject or landscape, but this light often renders the scene as flat and two-dimensional with little texture or depth. Certain subjects benefit from front lighting, however—macro and wildlife subjects in particular are often shot using front lighting.

SIDE LIGHTING

Side lighting emphasizes texture and depth, giving images a three-dimensional quality. Particularly when it's at a low angle to the horizon, the light catches raised surfaces in the landscape while leaving low areas in shadow.

Since a polarizing filter works best when the camera is pointed at a 90-degree angle from the direction of the sun, this filter is always an option when working with side lighting, to help saturate colors and remove haze from the sky.

BACK LIGHTING

Backlighting is the most dramatic directional lighting. This involves shooting toward the sun, which causes translucent objects like foliage or an animal's fur to radiate and glow. Exposure is tricky when doing this and unless the desired effect is a silhouette, increasing your exposure is often necessary to keep the image from being too dark. Because you are shooting in the general direction of the sun, you must be aware of lens flare. Use your lens shade or have someone or something block the sun's rays from striking the front element of your lens at glancing angles. Sometimes, however, a little bit of flare can be a good thing, as it creates a warm cast to a scene.

Above: Cinnamon fern frond (by Jim Clark). Front lighting works well for this macro subject.

Right: The Egg Factory, Bisti Badlands, New Mexico (by Nye Simmons). Side lighting brings out the texture of this striking, alien landscape.

Left: Snow geese landing, Bombay Hook National Wildlife Refuge, Delaware (by Ian Plant). Back lighting adds drama and color to this otherwise tranquil scene.

PRO POINTER *by Ian Plant*

Exposure can be tricky when shooting into the sun. Check your histogram to make sure that you are not overexposing or underexposing important elements of your scene. It is best to shoot when the sun is relatively low in the sky; otherwise, severe contrast might prevent you from getting a balanced exposure. When the sun is low on the horizon, and heavily filtered by atmospheric particles, its light is much less intense than when it is high in the sky—and much more colorful as well. Use graduated neutral density filters, fill-flash, or HDR techniques (discussed in Chapter Five) to further reduce contrast. Even using all these techniques, you may find it impossible to simulta-neously hold detail in both shadow and highlight areas—let's face it, the sun is simply too bright! Don't despair; just use your best judgment to achieve an appropriate balance. Often, dark areas can be used to very powerful effect, such as when parts of the scene are rendered in silhouette. For the image at left, I made sure to be in position at dawn so that I could get the sun rising behind this trio of cormorant chicks. The sun was low enough on the horizon that its intensity was greatly reduced, allowing me to preserve highlight details while simultaneously rendering the rest of the red sky as a medium tone. Note the dramatic fringe lighting on the chicks.

SHOOTING INTO THE SUN

For some super-dramatic lighting, incorporate the sun in your image. The sun creates an eye-catching point of interest, and back-lit subjects can be very powerful, especially when juxtaposed against a dark background. Also, when you face the light you get reflections in water or on other surfaces. When using wide-angle lenses, there is an added bonus: by selecting a small aperture (f16 or f22), you can create an eye-catching "sunstar."

"Song of the Tides" (by Marc Adamus). The leading line of tidal flow points right to the setting sun in this image of the central Oregon coast.

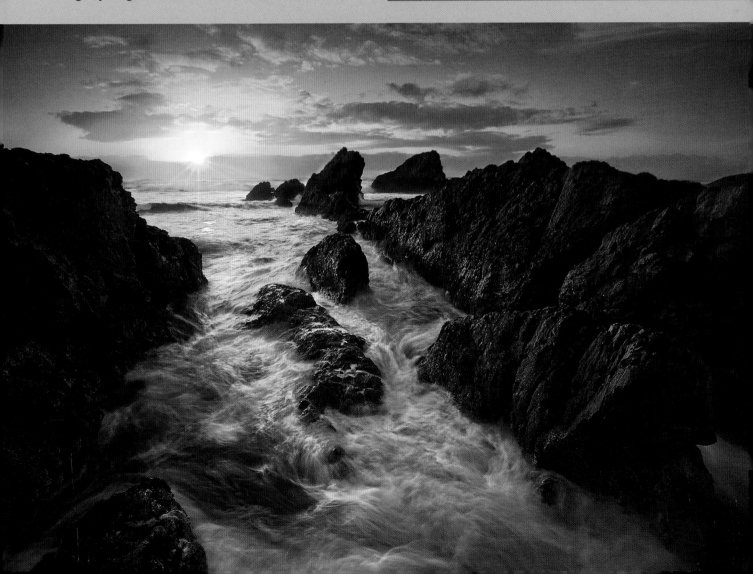

Morning mist, Great Smoky Mountains National Park, Tennessee (by Bill Lea). *Mist and light collide to produce this stunning image.*

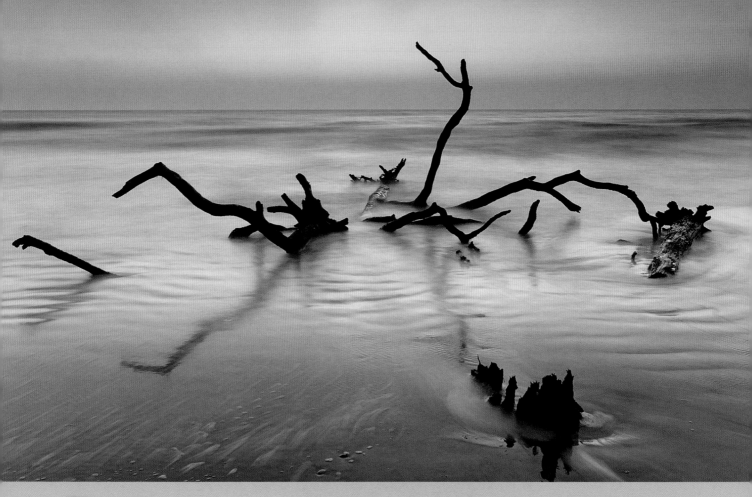

BOUNCED LIGHT

Bounced light is indirect, diffused light that can come from any direction. Light reflected from a canyon wall, mountainside, or cloudbank can act as a giant reflector, bouncing soft illumination into shadows and dark regions of a scene. A classic example of bounced light is a shadowed slot canyon, with parts of the canyon glowing with bounced light from sunlit rocks above.

WARM/COLD LIGHT

The reds, oranges, and yellows we see in light at sunrise and sunset are considered to be warm, and so is the light. Warm light occurs when the path the sunlight takes through the atmosphere is at a low angle and more blue light is scattered. Wildlife and most landscapes are especially evocative when bathed in the warm light of early morning or late evening.

Cool blues are found in open shade (that is, shade on a sunny day), predawn, twilight, and to a lesser extent, overcast conditions. When the scene is not getting any direct illumination from the sun or only getting reflected light from a blue sky, the light looks cold. Since most people would prefer warmth over cold, cool light is usually warmed up with a white balance adjustment. Certain subjects, however, like ice and snow, are more effective when rendered bluish or cold. The psychological effects of blue can make a winter scene feel almost as cold as being there.

Above: Hunting Island, South Carolina (by Richard Bernabe). A striking example of dawn light, and of warm/cold contrast between the pink and red sky and the blue water.

Inset: Ice swirls (by Joe Rossbach). A good example of a scene best rendered in cool tones.

What's even better than warm light or cold light? A mix of the two, of course! Sometimes color is best expressed in contrast with its opposite. That's why we often look for chances to juxtapose warm and cold light. Warm/cold opportunities arise whenever direct light and shadows intersect.

CREPUSCULAR RAYS

Crepuscular rays, also known as sunbeams, "Godbeams," or sunbursts, are rays of light streaming through gaps in clouds. Crepuscular rays are most common when conditions are partly to mostly overcast. They are most colorful when the sun is nearing the horizon—but don't wait until the sun is too low, as the effect will disappear! Crepuscular rays usually point down, but on rare occasions they point up.

SPOT LIGHTING

Spot lighting, very simply, occurs when a beam of light breaks through some form of barrier, such as

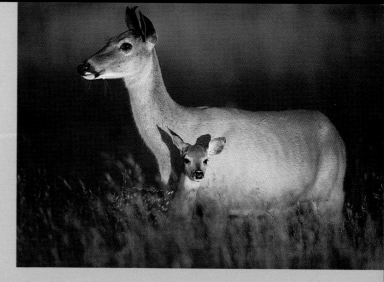

clouds or tall trees in a forest. Ideally, with spot lighting, only the subject of interest is illuminated, and all else is in shadow.

Above: Whitetail deer and fawn, Shenandoah National Park, Virginia (by Ian Plant). Warm spot lighting bathes the deer in pleasing tones.

Below: Sunburst over the Nantahala National Forest, North Carolina (by Bill Lea). Crepuscular rays form with partially cloudy skies.

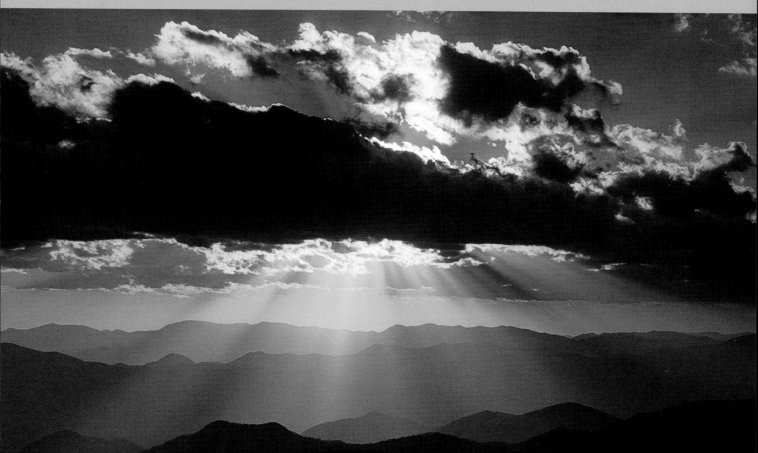

special effects

ometimes a literal expression of a nature subject just doesn't quite do it. Sometimes you want to get just a little more *creative*. Impressionism, cubism, fauvism, expressionism, pointillism, and all the other little *-isms* get a lot of play in the fine art world, but are not seen so much in nature photography. But hey, we're artists too, aren't we? So every now and then it's fun to dabble in the surreal. There are a lot of techniques, both in-camera and post-processing, that allow you to nurture your inner-Picasso. Here are some of our favorites!

SPECIAL EFFECTS USES

The phrase "special effects" is a bit loaded; it implies using digital magic to add elements to an image that weren't really there. To be clear, we're not going to discuss computer techniques that allow you to add Bigfoot hugging a rainbow to all of your shots. We will discuss a number of advanced photography techniques, however, ranging from techniques that every nature photographer should know, to abstract techniques that are used to create surreal images. Most of the techniques we will discuss can be used in a number of ways, so they are worth learning even if you plan to keep the Picasso to a minimum.

ESSENTIAL TECHNIQUES

Some special effect techniques might not look very "special" at all. They are used to subtly enhance images or to place emphasis on certain parts of the scene. The effect can be so subtle that it is not readily apparent to the untrained eye. Such techniques can become essential to much of your regular shooting routine, and in fact may become second nature.

WORK-AROUNDS

Some special effect techniques, at their most basic level, can be used to solve problems or get around technical limitations of digital cameras. These techniques are very useful to learn. Of course, they can also be pushed to the extreme and used to create artistic expressions. Learning these techniques and incorporating them into your overall digital workflow is a good idea, whether you use them for creative effect or not.

Above: Autumn forest abstract, Shenandoah National Park, Virginia (by Joseph Rossbach). Joe intentionally moved his camera during a long exposure to produce this impressionistic look.

Right: Star trails (by Guy Tal). An exposure time of several hours traces star trails across the night sky as the earth spins around its axis. Even dim night sky light will record in brilliant color if the exposure is long enough.

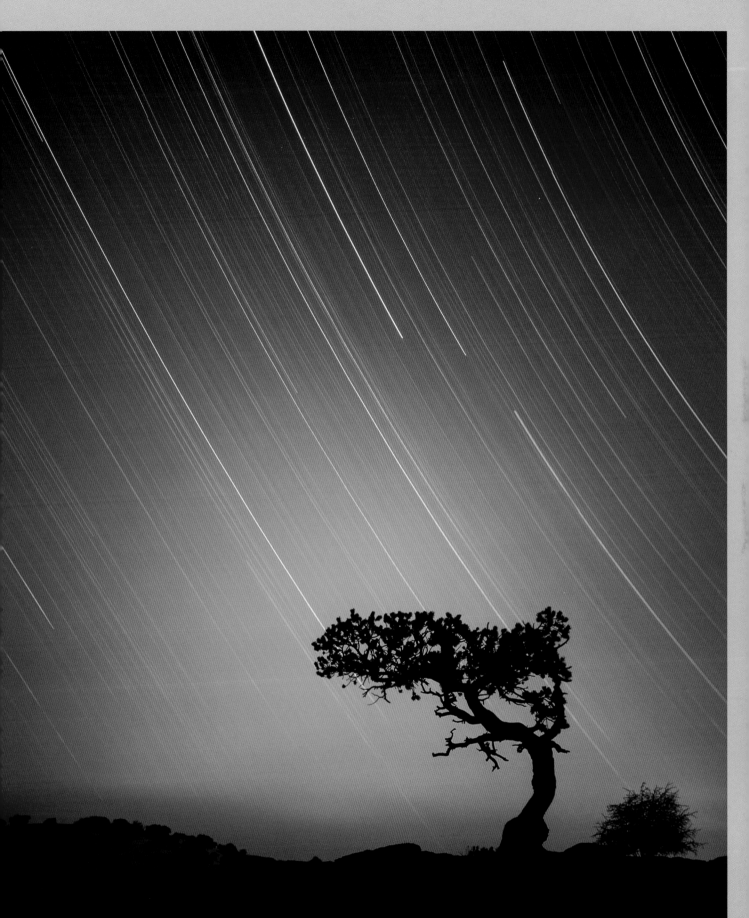

WEIRD STUFF

These techniques will go from realism to impressionism. Some special effects are simply used for reasons purely relating to creative expression. They can be used to transform an ordinary subject into something less mundane, or to represent the subject in a way that captures more than just its external appearance. These techniques allow you to alter the reality of a subject, to perhaps find its hidden essence. Or maybe you want to use these techniques just because they look cool. In any event, "weird stuff" techniques are not for the faint hearted—use them at your own risk!

SPECIAL EFFECT STYLES

What follows are some of our favorite special effects techniques. As mentioned above, many of these techniques have both basic and artistic uses.

HDR

"HDR" stands for High Dynamic Range imaging. HDR is really a set of techniques that allows one to record a greater range of luminance between light and dark areas of a scene than a digital sensor can record in one exposure. Whereas the human eye can simultaneously see detail in brightly lit and deeply shadowed areas, digital sensors often can only record detail in one or the other, but not both at the same time. At its most fundamental level, HDR is used to correct this disparity, and to more accurately represent the wide range of tonalities in a given scene.

There are many ways to create HDR images. Arguably the most basic way is to use a neutral density graduated filter to bring outlying tones in a scene within the range of the digital sensor. But to truly create an HDR picture, one needs to take multiple images of the same subject at different exposure levels. Essentially, an exposure is made that renders detail in highlight areas, but that underexposes shadows (which are rendered as pure black). Another exposure is then made that renders detail in the shadows but overexposes highlights (which are rendered as pure white). The two exposures are then combined on the computer so that both highlight and shadow areas are rendered with detail. In scenes that have extreme contrast ranges (such as a scene that

HDR

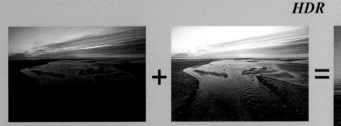

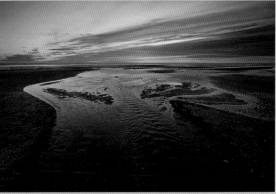

Tidal flow, Chesapeake Bay, Maryland (by Ian Plant):
Two exposures, one to record highlight detail and one to record shadow detail, are merged together to form one properly exposed image.

shows both a bright sunset and a deeply shadowed foreground), more than two images might be necessary to render all tones correctly.

There are a number of software programs that can be used to create HDR images. It is beyond the scope of this book to discuss these programs and the HDR process in detail. We can make a few suggestions about making HDR images, however. The biggest challenge in merging multiple exposures is making sure that neither the camera nor the scene move during the exposure. Although some programs will do a decent job aligning images even when registration is not perfect, it is best to shoot HDR images using a securely locked tripod. Avoid scenes where there is a lot of movement, such as clouds moving swiftly in the sky, branches swaying in the wind, or waves crashing on the shore. When making HDR images of such scenes, shoot your multiple images as quickly and as closely together as possible. Also, be sure to take as many exposures as necessary to accurately render all tones in a scene as smoothly as possible. Vary exposures by no more than two stops at a time. While some scenes may only need two or three exposures, some highly contrasty scenes may need as many as five or even seven different exposures.

HDR can be difficult to master, but in skilled hands it can allow for images that capture the wide range of tones in a scene in a fashion that approximates what the human eye would see. Also, with proper HDR technique one can manage transitions between light and dark areas of an image in a more natural way than through the use of neutral density graduated filters, which often render objects pushing past the grad line as black (such as trees sticking up into the sky). Of course, HDR can also be used to render scenes in a much more surreal and artistic way, pushing the scene past what the human eye can naturally see!

STITCHING IMAGES

Image stitching is the process of combining multiple photographs with overlapping fields of

view to produce a panorama or high-resolution image. Stitching enables the photographer to create photos with higher resolution and/or a wider angle of view than their digital camera or lenses would ordinarily allow—creating larger, more detailed prints and/or extra wide panoramic format perspectives.

Achieving a final image that seamlessly combines several photographs, however, is a bit more complicated than just taking a bunch of overlapping photographs, and then aligning them on a

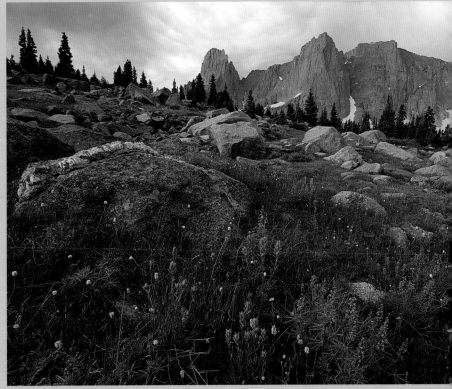

computer. One has to be careful to ensure that the stitch is not unduly complicated by lens distortion, varying exposures, and perspective mis-

Left: Hooper Strait Lighthouse reflected in window, Chesapeake Bay, Maryland (by Joseph Rossbach). Joe used HDR technique to create this "artistic" view of the lighthouse. The range of tones far exceeded the sensor's ability to record, necessitating the blend of several different exposures.

Above: Cirque of the Towers, Colorado (by Nye Simmons). Nye stitched three vertical images together to form a single horizontal image, giving him a wider field of view than what was possible with his available lenses.

alignment. Fortunately, there exist many software programs that can, with varying degrees of success, correct for such errors and automate the stitching process to produce (more or less) seamless results.

Stitching can be accomplished by several means. The easiest and arguably least effective is to simply pan the camera around taking multiple images. Another method is to use perspective control (PC) lenses, which allow the user to shift the lens up and down or left to right. Canon and Nikon have the widest range of PC lenses available, although a number of shift adapters exist that allow one to use medium format lenses on digital cameras. Both methods introduce what is known as parallax error, which is basically a misalignment of perspective that can make it difficult to create a seamless stitch. The final stitching method involves using specialized panoramic stitching plates, which eliminate parallax error and therefore allow for more seamless stitches.

If you wish to explore stitching further, here are some basic tips. Remember to be generous with your overlap between images. Be certain your tripod is completely level. Compose loosely—it's hard to tell where the final edges will be when combined into a composite. Set your meter to manual, pick a white balance that you like and make your exposures based on the lens being at neutral, that is, centered. This ensures that each frame is exposed and color-balanced identically, and the locked-in exposure settings are correct for the shifted frames. You can always adjust color balance during or after raw conversion.

BLACK & WHITE CONVERSION

Who hasn't wanted to create gorgeous black & white images like the master himself, Ansel

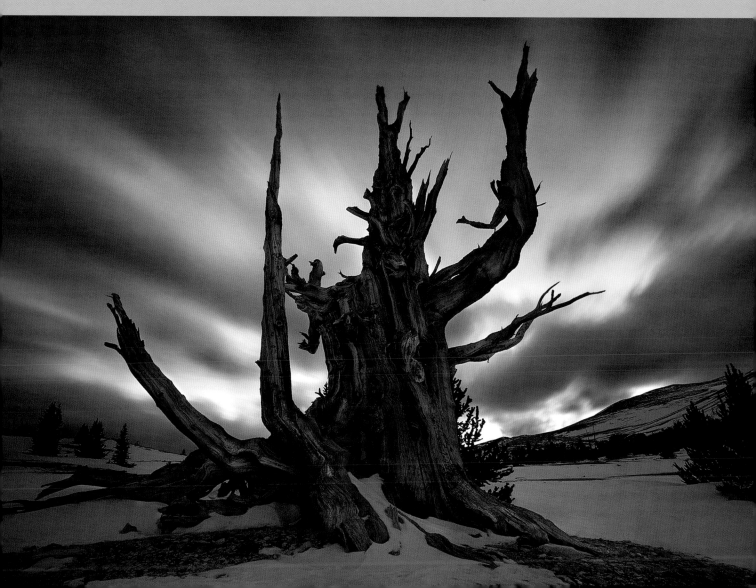

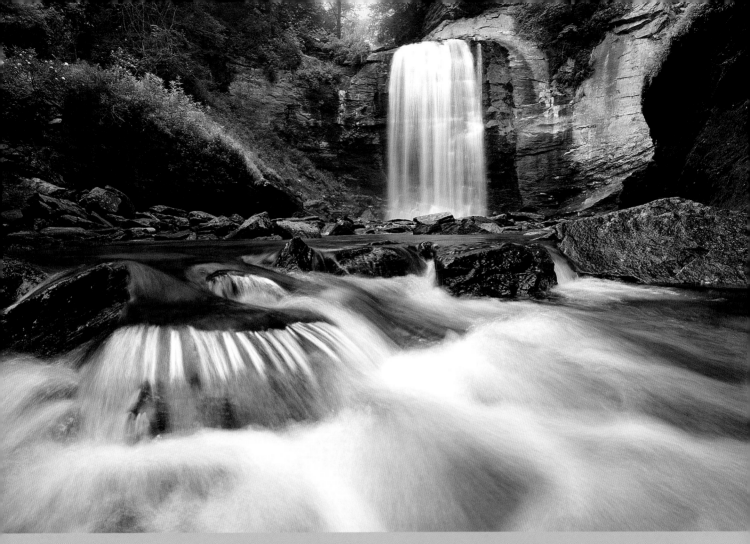

Adams? Of course, we don't envy the countless hours spent in the darkroom breathing toxic chemicals, but the results were truly incredible. But how does one make black & white images in the age of color digital cameras? Easy—and you don't need to spend even one second in the darkroom or breathe in any chemicals!

Most raw converters and digital editing programs, as well as a number of third party programs, allow for easy and powerful black & white conversions, as well as a number of classic alternative processing techniques such as toning, antique aging, and hand painting. Successful creation of black & white images relies, ironically, on effective manipulation of color. Back in the old days, photographers used color filters to control tonal values and contrast in their images. An orange filter, for example, would lighten yellows and reds while darkening blues. Although these colors would not appear in the final black & white image, their relative tonal values would change, enhancing contrast in the image. Digital black & white conversion still uses this technique, but it does so on the computer instead of before image capture. Black & white

conversion programs allow you to manipulate contrast in the image using a number of color sliders, which replicate the various color filters that were used back in the day.

Some newer camera models have black & white modes that allow you to convert images in-camera. Converting to black & white in-camera can save time, but will not give you the fine-tuned control you would have using a computer.

FORGET ABOUT SHARPNESS

We've talked a lot about the importance of keeping images sharp and in focus, and even strong-armed you into shooting every photograph with your camera securely attached to a rock-solid (and heavy) tripod. Now we're going to ask you to forget all such nonsense! Motion blur can be used to creative effect, in several ways.

Left: "The Tree God," White Mountains, California (by Marc Adamus). Scenes without a lot of color make for great black & white conversions.

Above: Looking Glass Falls, North Carolina (by Richard Bernabe). A classic use of motion blur is moving water in a stream.

Recommended "Blur" Shutter Speeds

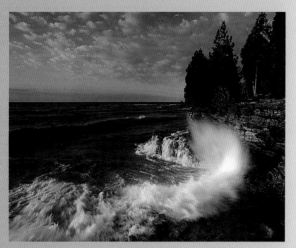

1/30—1/4 sec.	Crashing waves Flowing water (large stream)
1 sec. or more	Flowing water (small stream) Moving clouds
1/125—1/60 sec.	Flying birds Running animals

1/30—30 sec.	Blowing foliage
1/15—2 sec.	Pans, zooms, and blurs

Long exposures involving a tripod-mounted camera and moving subjects can create a sense of action and power. Crashing waves on the shore, birds exploding into flight from the water, or ferns in a forest blowing in the wind all become abstract studies in motion and time when you slow things down a bit. When shooting such motion-blurred subjects, it is often best to have some critical element of the scene "grounded in reality" by being in sharp focus, such as stationary tree trunks in a forest of swaying foliage.

Another way to create motion blur is to move the camera, or even the lens. Pans, swirls, and zooms are three common techniques that intentionally introduce camera movement during an exposure. They are used to create an abstract look to an image, to make a photograph look like a water-color or pointillism painting. Panning the camera up and down for vertical subjects or left to right for horizontal subjects is a great way to produce impressionistic photographs. Swirling is the act of moving the camera in a semi-circle around the subject. Remember to keep your main center of interest at the same point throughout the movement. The use of a tripod and lens with a rotating tripod collar is the best setup for this technique. Zooms are created using—you guessed it—a zoom lens, zooming it in or out during part of the exposure. Pans, zooms, and blurs work best during an exposure that is long but not too long: 1/15 of a second to two seconds often work best.

Use low ISO settings, small apertures, and polarizing and neutral density filters to achieve the longer exposure times necessary for these effects. Remember that when using long exposures you usually won't be able to predict what is going to happen. Luckily, the ability to instantly review images on a digital camera can tell you right away whether your experiment worked, or whether you need to try again.

MULTIPLE EXPOSURES

In the good old days of film it was easy to shoot multiple exposures on the same frame. Nowadays, many digital cameras don't give you this ability. Nikon users are lucky; Nikon cameras have two key features for creating multiple exposure images built right into the soft-

ware—the Image Overlay and Multiple Exposure functions. Users of other cameras can create multiple exposure shots, but they have to combine images on the computer. Multiple exposure images often work well with some of the panning, zooming, and swirling effects described above—instead of moving the camera during the exposure, one takes successive shots, moving the camera's position slightly for each new exposure. Or they can be used to other creative ends. A common use of multiple exposures in the film days was to add a moon to a scene. Today, one can achieve the same result by shooting the scene, then shooting a picture of the moon, and later combining the two images on a computer.

EXPOSURES GONE WILD

Okay, so here's another of our own rules we're asking you to break. Proper exposure is, well, proper, only if you are trying to make a more literal rendering of a scene. For a more abstract rendering, experiment with different exposure levels. Intentional overexposure creates what are known as high-key images. This technique can be

particularly effective when photographing bright, colorful objects, which in a high-key image will be set against a pure white background. High-key images may also be appropriate when the main subject is near white, producing an image that is an abstract study of various shades of white and gray. The resulting photograph often looks like a drawing or an etching. On the other end of the spectrum, you can also try to render scenes intentionally dark. Because of the noise that builds up in dark areas of a digital image, it is usually best to properly exposure the scene and lower the exposure during raw conversion or afterwards during image editing.

Top left: Crashing waves on Lake Michigan, Cave Point County Park, Wisconsin (by Ian Plant).

Middle left: Running fawn, Canaan Valley State Park, West Virginia (by Jim Clark).

Bottom left: Swirl blur (by Joseph Rossbach).

Above: "Ghost Trees" (by Joseph Rossbach). Joe created this shot by overlaying multiple exposures, moving the camera slightly between each exposure.

CREATIVE FOCUSING

Sometimes perfect focus doesn't give you the look you want. Feel free to experiment with creative focus. Use super wide apertures to render only a small portion of the scene in focus, or render the scene intentionally de-focused. Specialty lenses, such as tilt-shift lenses, can help create an artistic look. Instead of using the tilt feature to achieve an optimal plane of focus so that everything from near to far is in focus, go the other way and create a plane of focus so narrow that only a portion of the main subject matter is rendered in focus. Another specialty lens, called a "Lensbaby", can be used to take this effect to the extreme. A Lensbaby is essentially a very flexible uber-tilt lens, allowing one to achieve extremely narrow planes of focus. Creative focusing some-times works best if you have two subjects, one rendered in sharp focus and the other out-of-focus.

NIGHT EXPOSURES

The dark of night is the closest thing to a blank canvas we as photographers will ever encounter. Take advantage! Night photography may be difficult, but not being able to see anything is surprisingly conducive to creative image making.

You may have noticed that heavenly bodies such as stars and planets appear to move across the sky throughout the night. And although these objects are in fact moving through space-time at hyper-fast speeds, their apparent movement in the sky (to us) is really caused by the earth spinning on its axis. During a long exposure, stars, planets, and even the moon will trace trails through the night sky. If you point your camera north, you will be aligned with the Earth's rotation, and all stars in the sky will seem to wheel around a fixed point, which happens to be where Polaris, the North Star, resides. If you point your camera in any other direction, you won't get concentric star trail circles, but rather more or less diagonal streaks. Reverse all this if south of the equator!

When the moon is in the sky, it will illuminate the landscape with what looks essentially like daylight. That's because the moon is basically just

reflecting sunlight onto the Earth. Because of the bright light cast by the moon on the landscape, you may need to limit your exposure time to only several minutes to avoid overexposure. Moonlit clouds streaking through the sky can make for an interesting subject.

You may have noticed that most digital cameras have a maximum shutter speed setting of 30 seconds. If you are taking exposures that are no longer than 30 seconds, no problem—but how,

you ask, can one get an exposure time that is longer than the maximum? For most digital cameras, the answer is relatively easy: select the "B" or "Bulb" setting. This setting allows you to keep your shutter open for as long as you hold down the shutter release button. Use an electronic cable release with a shutter-release lock so that you don't have to stand by your camera for an hour pressing the shutter button. If your camera doesn't have a bulb setting, long exposures are trickier but not impossible; there are a number of "star stacker" programs (many of them free) that allow you to merge continuous 30-second exposures into one shot.

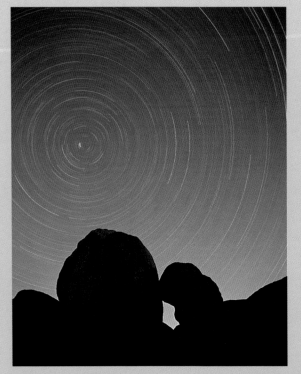

form of red, blue, and green dots. If the exposure is long enough, the dots will completely destroy image quality. To solve this problem, most digital cameras have a "noise reduction" setting. Essentially, noise reduction works as follows: the camera takes a second exposure of equal length to the main exposure; this second exposure is known as a "dark frame" because it is not actually exposing the sensor to information coming through the lens. Rather, the dark frame exposure is made to determine where all the colored dots are located in the image, so that the camera's processor can subtract the noise from the main exposure. Noise reduction should be used for any exposure over three minutes in length unless it is very cold outside (cold weather dissipates the heat that would otherwise build up on the sensor). Since noise reduction essentially doubles your exposure time, that means you will need to have double the battery power.

Determining exposure time can be tricky. Before starting a long exposure, take a 30-second "test shot" at your camera's highest ISO setting to see what your image will look like, and then calculate your exposure time accordingly. For example, if your 30-second test shot is properly exposed at ISO 3200, then an exposure time of eight minutes is needed at ISO 200 to get the same exposure; add or subtract time or adjust the aperture if the scene was under- or over-exposed in the test shot. Take as many test shots as necessary to ensure that you get the right exposure; there is nothing worse than spending several hours taking star trail pictures only to find out that your exposures, and your time, were wasted.

Most fully charged batteries will give you one to two hours of exposure time at most (if even that). For very long exposures, an external power source, such as an external battery pack or an AC or DC power source, is necessary. Cold temperatures help reduce noise, but they also reduce battery power. If your battery dies during an

Night exposures can last anywhere from several minutes to several hours. With exposures longer than two or three minutes, a number of technical limitations may arise. First, battery power will limit your exposure time. Second, digital sensors heat up during long exposures and generate noise. Unfortunately, the fix for the second problem actually compounds the first!

During long exposures, digital camera sensors heat up and generate random pattern noise in the

Top left: Flower abstract, Brookside Gardens, Maryland (by Joseph Rossbach). Joe used a "Lensbaby" special effect lens to selectively focus on the distant flower.

Bottom left: "Blue River," Glacier National Park, Montana (by Marc Adamus). A twilight exposure captures only blue tones.

Above: "Daughter of the Stars," Shenandoah National Park, Virginia (by Ian Plant). Ian used the Bulb setting on his camera to record two hours of star trails.

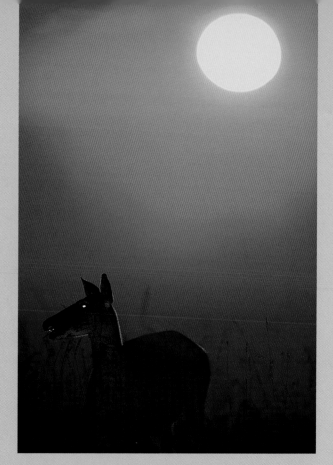

exposure (either during the main exposure or the noise reduction phase), you will lose the image completely. Take some test shots at home before doing any serious night work, so that you will have a sense of how long your batteries will last. Remember, cold temperatures can greatly reduce battery life, so play it on the safe side if you are not sure how much battery power you have left.

During a night exposure, your subjects and the sky itself may be lit by a variety of light sources, including starlight, moonlight, ambient light from distant cities (which often takes on an orange glow), or other sources of light of your own creation, such as campfires, car headlights, flashlights, or flash. Don't be afraid to be creative and paint with light!

LASH

Flash is one of the most important, and too often the least used, nature photography camera accessories. Learning how to use flash properly can open up a whole world of creative possibilities. Flash is most commonly used with wildlife to create catch lights in the eyes; the flash is set at a low power setting or a special attachment is used to create the catch-light without directly lighting the subject. Flash can also be used to freeze the action of fast moving animal subjects. Flash is also commonly used with macro photography, but less often used in landscape work. Flash can be used at low power to help fill in shadows or to subtly emphasize a foreground feature.

So these are the "play-it-safe" ways to use flash in nature photography. But if this book has one common theme, it is to encourage you to go way beyond the play-it-safe zone. Flash can be used boldly at full power to transform an ordinary scene into something edgy and intense. Try combining low light, long exposures, and full power flash to create "high concept" wildlife images. A technique known as "slow sync flash" allows you to combine ambient light with flash light; during longer exposures, this will allow you to freeze action while simultaneously capturing motion blur. Many cameras will allow you to sync your flash either with the beginning of the exposure (known as "front curtain" sync because the flash fires right after the shutter curtain opens) or

at the end (known as "rear curtain" sync because the flash fires right before the shutter curtain closes). When using flash as the primary source of light for wildlife subjects, you will notice that the flash will often make the eyes of your subjects glow with an unearthly light, which can give a surreal look to your photographs. Flash can also be used to create surreal landscape images. Used at night with colored gels, the creative potential of flash is unlimited. You can light a landscape scene at night using only flash, or have a mix of ambient light (such as moonlight) and flash illumination.

An off-camera flash comes in handy when you are doing a lot of flash work, as well as an external battery pack to ensure quick recycling times. For really complicated flash work, multiple flashes and wireless transmitters may be necessary!

Above: White-tailed deer, Shenandoah National Park, Virginia (by Ian Plant). Flash was used to fill in the shadows of a deer silhouetted by the setting sun, and to create a glowing catch-light in the eye for an edgier look to the image.

Right: Star trails over Thunder Hole, Acadia National Park, Maine (by Ian Plant). During a twenty minute star trail exposure, Ian fired his flash with alternating red and yellow color gels to freeze the action of several incoming waves. He then used flash with a blue gel to light the cliffs.

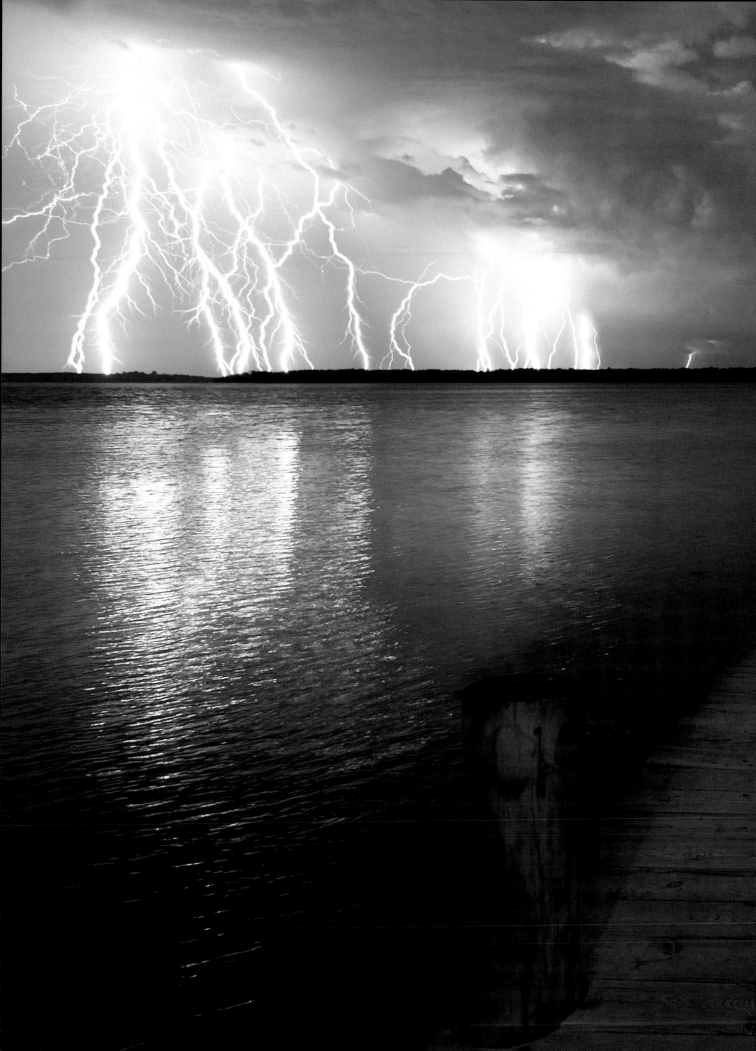

LIGHTNING

Okay, so lightning isn't exactly a "special effect," unless you consider it a special effect created by nature. Nonetheless, you may need to use some of the techniques described in this chapter to photograph lightning correctly. When shooting lightning at night, use long exposures—up to several minutes long—to record multiple lightning strikes. Turn on your noise reduction to reduce sensor noise resulting from the long exposure. Or, to avoid sensor noise altogether, overlay shorter, multiple exposures as described earlier in this chapter. To capture lightning during the day, use a Lightning Trigger, which detects lightning strikes and automatically triggers your camera's shutter in time to get the shot. Remember, lightning is dangerous, so make sure the storm is many miles away before setting up your electricity friendly metal tripod . . .

Lightning storm, Potomac River, Virginia (by Ian Plant). *Several minutes of exposure time captures multiple intense lightning strikes.*

chapter six
making magical images

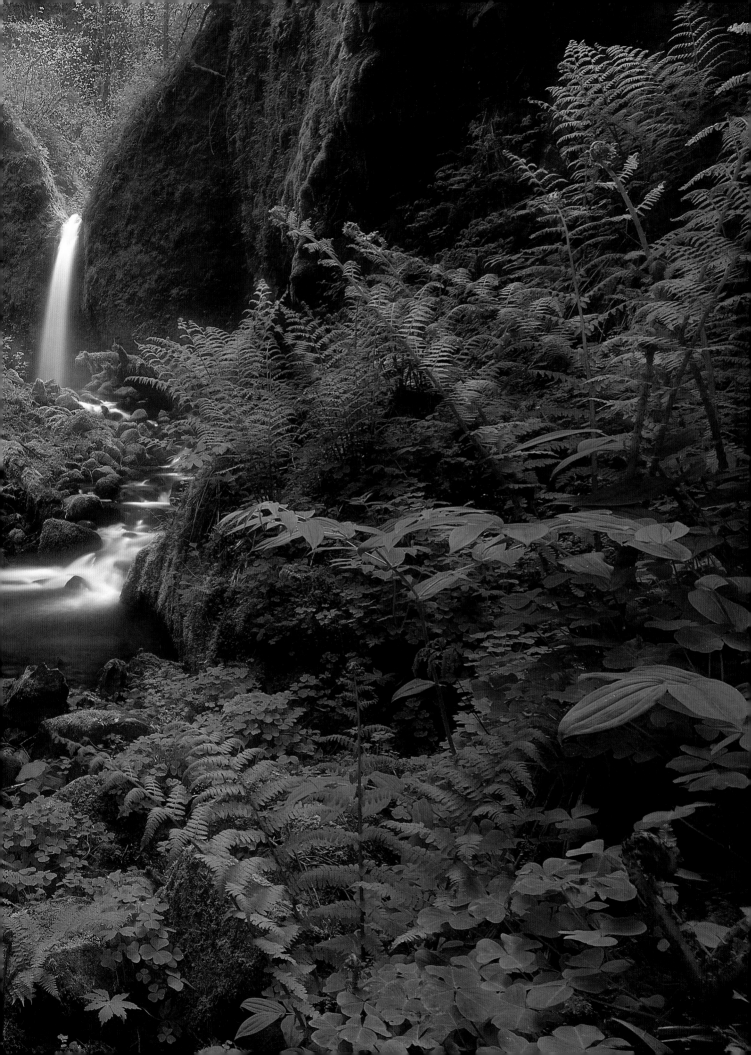

All right, so we've covered the basics, and then gone into some pretty complex stuff about composition, light, and everything else. Some of the material we have covered has been easy to grasp, some of it may take a lifetime to master. Some of it has been mundane, some esoteric, some perhaps downright confusing. So let's pull back for a moment and take a look at everything at a more fundamental level. How about some easy multi-step plans for making better images?

LANDSCAPES

You stand on the edge of a beautiful backcountry lake, surrounded by glorious glacier-clad peaks. The still waters of the lake reflect perfectly the mountains towering above you. The scenery is absolutely stunning—undoubtedly it will make a great picture! You set up your camera and compose an image to take in the whole majestic scene. After triggering the shutter, you recline on the shore and bask in the glory of your accomplishment before hiking back to the trailhead parking area.

Later on, when back in your hotel room loading images from the day into your laptop computer, you simply can't wait to see the shot from the lake. Anticipation builds as the image pulls up full-screen. And then something happens: expecting to be overwhelmed by its glory, you are instead profoundly *underwhelmed*. Although the scenery was magnificent, the shot seems decidedly less so; something about it reminds you of a postcard from the gift store. What happened?

Simple: you got carried away by the beauty of your surroundings and forgot to take the time to make a beautiful photograph! Beautiful scenery does not necessarily translate into incredible photographs. And conversely, unattractive scenery can sometimes yield beautiful images. You need to remember that any nature scene, whether stunning to begin with or not, needs to be treated the right way and shot in the right light to make it really stand out.

But how do you optimize your landscape photography experience? Here are some techniques that can help you turn any scenery—good or not so good—into great art.

Above: Fairyland Falls, Columbia River Gorge, Oregon (by Marc Adamus). Marc breathed some condensation on the lens to give this image a dreamy look. Sometimes attention to little details can transform an image from the mundane to the sublime.

Right: Great Star Dune, Great Sand Dunes National Monument, Colorado (by Joseph Rossbach). A powerful composition and bold primary colors helps translate great scenery into an eye-catching image.

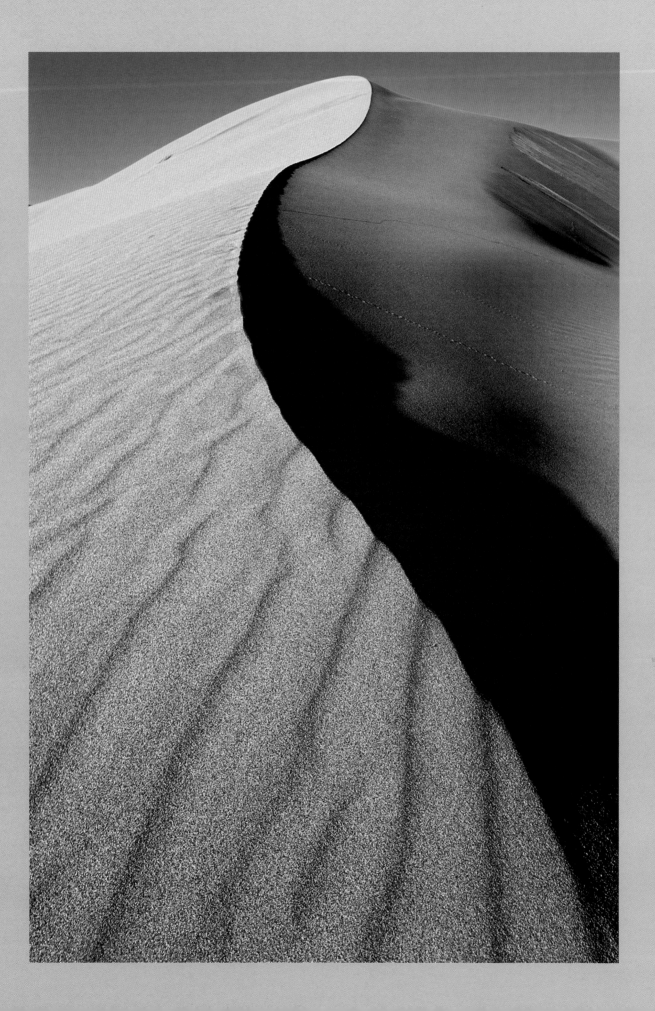

PRO POINTER
by Marc Adamus

One of the greatest challenges encountered within the photographic medium is how to use a two dimensional image to capture the way we see the three dimensional world around us. Learning to identify the types of lighting, atmosphere, angles and lines that draw the viewer into and through the scene we photograph is as essential as any aspect of photographing nature. The depth in one's images can be accentuated in post-processing as well, much in the same way a painter would use subtleties in the hue and tone to move the eye and create the sensation of distance. For me, depth is a very important part of describing what I saw to my viewer. The redwood image you see here is one such example.

I photographed these massive trees from an area shaded under thick canopy looking out towards a more open area of the forest. Because the background was naturally brighter than the foreground, the eye moves effortlessly into the scene. The angle of light was also important. Although there was no direct light upon the scene, a very soft filtered light partially illuminated the sides of the trees, accenting their shapes. Even at times without direct lighting, paying attention to the angle of light is very useful. Lighting from behind the photographer usually results in a flat appearance, where as backlighting and side-lighting help to better define your subjects. Also notice that the cooler colors in the foreground progress into warmer hues in the background, further helping the eye transition from near to far. Finding transitions within an image keeps the eye moving.

Even if lighting conditions aren't perfect, it can be helpful to find strong leading lines that direct the eye towards a focal point. Strong lines can be further accentuated by the use of a wide-angle lens, which is a great tool for creating extra depth. One reason for this is that the wide view helps separate the foreground from the background while maintaining sharp focus throughout. Wide lenses also tend to create distortion when tilted even slightly up or down, helping to draw elements together with radial symmetry that often compliments a main focal point.

WAIT FOR THE RIGHT LIGHT

You may have noticed that we put a lot of emphasis on the need for great light to make great photographs. This is especially true for landscape photography. Take the time to make sure you have the right light for the scene you are photographing. What is "right" may be different for every scene. For example, sunrise or sunset light may be best for coastal scenics and mountains, whereas overcast or diffused light might work best for forest scenes and waterfalls. Or the reverse might be true. Make sure that you are on location at a scene to observe what happens as the light changes. Above all else, don't fall into the trap of shooting a scene only when it is convenient. It may be a pain in the butt to get up several hours before dawn and hike a mile in the dark to your

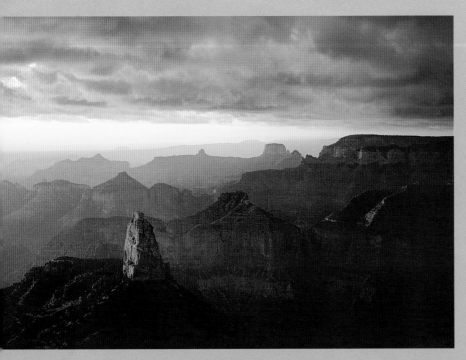

shots unworkable, but on the other hand, they can also bring rainbows, lightning, dramatic skies, fog, and other interesting atmospheric conditions. Whenever a weather front comes in or passes through, you have a good chance to get really interesting photographs. If storm clouds break at sunrise or sunset, the light can get downright incredible. Hard wind, blowing sand, or snow can also lead to dramatic results. Harsh conditions may present all sorts of challenges to equipment and the photographer, but to paraphrase the old saying, what doesn't kill you (or your equipment) makes your images stronger!

favorite mountain lake to make sure you are on location for sunrise, but you'll be happy you did when you see the great images you can make!

THINK ABSTRACTLY ABOUT SCENERY

As we said before, you'll get into trouble if you just try to take pictures of all the pretty scenery. You must train your eyes to not see mountains, lakes, trees, rocks, and waterfalls, but rather abstract shapes, lines, and curves. When you start thinking about the landscape in these terms, then the composition techniques discussed in Chapter Three will start to come more naturally. That way, when you are at that beautiful mountain lake, you'll start to look for powerful leading lines, repeating shapes, vanishing points, and all that other crazy stuff that somehow transforms even ordinary scenes into something better than a postcard image!

LEARN TO LOVE BAD WEATHER

Ah, blue sky, abundant sunshine, who could ask for better weather? Such weather may be perfect for most of the human population, but not for landscape photographers! Bad weather brings great photographic potential, so make sure to be ready and on location. Sure, gloomy skies and rain can make many landscape

Left: "Winter's Fury", Iron Mountain, Oregon (by Marc Adamus). Brutal winter conditions can make for stunning images!

Above: Sunset, Grand Canyon National Park, Arizona (by Nye Simmons). Waiting for the right light to complement a scene is worth the effort.

Below: Teardrop virga, Cabeza Prieta Mountains, Arizona (by George Stocking). George created a composition that relies on the relationship of abstract shapes.

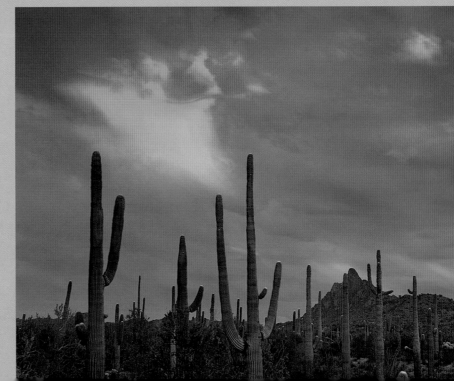

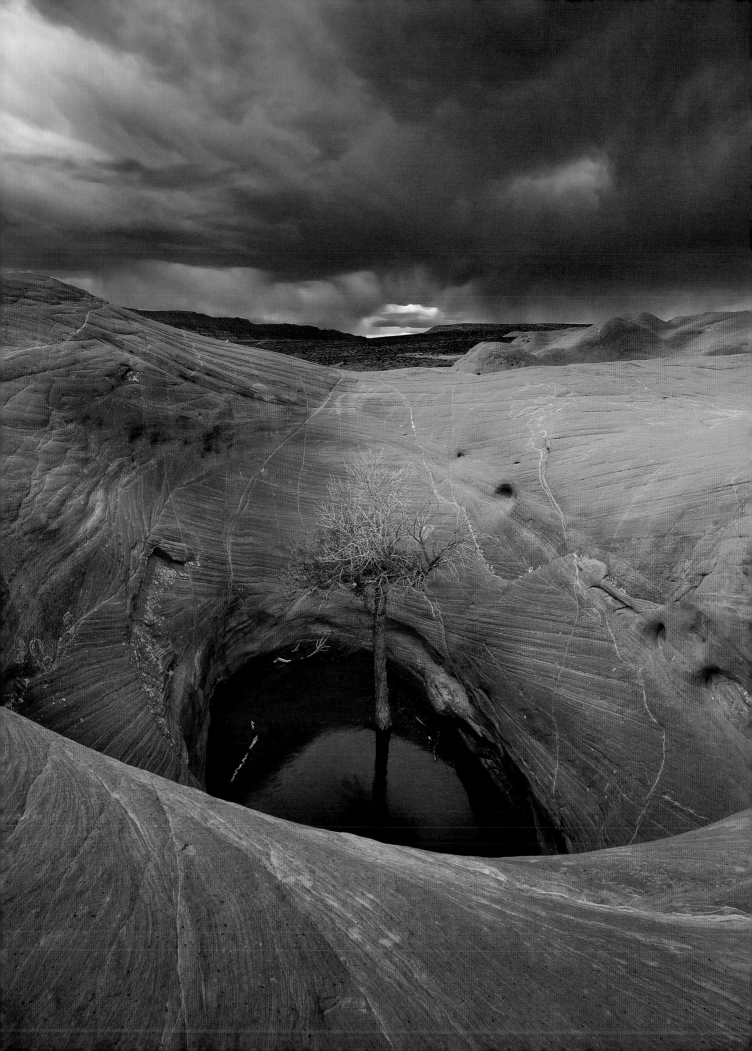

FIND INTERESTING FEATURES

Always be on the lookout for unique landforms, flora, or other interesting features of the landscape. Cracks in rocks or ice can become leading compositional lines; water- or glacial-carved rock can make for an interesting foreground; and unusually shaped trees can add compositional drama. Even the most barren landscapes might have features that can be the difference between getting a good shot or not.

TAKE A SEASONAL APPROACH

Great things happen with the change of seasons. Learn about what they are, and when and where they happen. In spring, incredible wildflower displays occur in many parts of the country—you just have to find them. Summer brings rhododendron blooms to the Blue Ridge Mountains and monsoon storm clouds to the Southwestern deserts. Maples paint the Northeast orange and red in autumn; whereas aspens fire the high elevations of Colorado with gold. Winter can bring ice and snow to many parts of the country, creating ever-changing landscapes. Do the research and create a schedule of seasonal events

that you want to photograph—and then get out there and shoot!

Left: "Sheltered", Grand Staircase-Escalante National Monument, Utah (by Guy Tal). Guy ranged far and wide to find this hidden pool with just enough water to (barely) support one tree.

Above: Trillium bloom, Shenk's Ferry Wildflower Preserve, Pennsylvania (by Ian Plant). Some places bloom with high concentration and intensity; find them and you will get memorable images!

Below: Autumn color frames Looking Glass Rock, Blue Ridge Parkway, North Carolina (by Nye Simmons). Fall color can be very intense in high elevations and cool parts of the country.

USE LONG EXPOSURES

Don't always seek to create a static representation of the world around you; every now and then you should try experimenting with long shutter speeds. Some scenes naturally benefit from motion blur, such as waterfall and stream images. A long exposure blurs the water, giving it a silky look. In other scenes, motion blur can be used to create a sense of action and power, or to create an abstract look. Take, for example, crashing waves on the shore: a quick exposure can completely freeze the action, a longer exposure can cause the wave to streak across the image frame, and an even longer exposure can record multiple waves and create a foggy look. Moving clouds, wind-blown sand, water, swaying trees—all can make compelling motion-blur subjects.

Sometimes it may be a challenge to get suffi-ciently long shutter speeds, especially if you need exposures lasting a second or more. See Chapter Five for more information regarding how to achieve blur effects, and for some recommended exposure times to get the look you want.

SEEK UNIQUE PERSPECTIVES

Look for extreme angles and fresh perspectives. Try to do something different than what is obvi-ous, or for some scenes, what has been done a million times before.

Use a wide-angle lens to get very close to a foreground subject, and choose a composition that relates the foreground to background ele-ments. Get off the beaten path once and a while, explore and try to find unique features of the landscape that will make interesting compositional elements. Challenge yourself to avoid shooting everything at eye level; once in a while get down low to the ground or find a way to safely get higher than normal. Work a scene with different lenses to see what you come up with; use a telephoto lens to focus on intimate portions rather than try to capture the whole scene.

Always be looking for something interesting and unique. The greatest challenge to being a nature photographer is the fact that nature photography is very popular, and seemingly everything has been done before. Work extra hard to find those scenes that are fresh, but that have their own special beauty.

Above: Wind-blown foliage and decaying barn, Green Mountains, Vermont (by Joseph Rossbach). Joe found this intimate scene, but the wind wouldn't stop blowing. Well, if you can't beat 'em, join 'em! Joe went with the flow and chose a shutter speed that would allow some motion blur in the image, in con-trast to the sharply rendered old barn.

Right: Autumn swirls, Zion National Park, Utah (by Guy Tal). Swirling autumn leaves in a pool of water is a classic motion-blurred scene. An exposure time of up to 30 seconds may be required for such an image.

Next pages: Mesa Arch, Canyonlands National Park, Utah (by George Stocking). George sought a unique perspective of this arch, getting in as close as possible to the rocks.

GET INTIMATE

Instead of always focusing on the grand landscape, take some time to notice the little details once and awhile. Instead of reflexively reaching for your wide-angle lens, determine if intimate portions of the scene can be "isolated" to create a more dynamic

image. Isolated scenics, although sometimes more subtle than wide landscapes, can have a beauty and power all their own.

Use longer lenses, even super telephoto lenses if necessary, to reach out and pluck a portion of the landscape scene that catches your eye. With their narrower fields of view, focal lengths of 80mm and longer transform the complex and busy into the simple and selective. Longer focal lengths seperate significant visual elements from the entire view, often helping to fashion a more well-defined composition. The next step is to include only those elements needed to craft a compelling image. Use nature's designs—shapes, forms, lines, and patterns—to guide the viewer through the scene.

With today's quality tele-photo zoom lenses, fine-tuning an isolated scenic composition becomes even easier. Zooms provide quick cropping and are great in situations where movement is restricted. Zooms can, however, lull us into staying put at one spot when photo-graphing. Move around and try different angles for composing the image. Take the camera off the tripod and explore other possibilities. Or just wander around without your camera for a while and see what you find!

Above: Yellow trillium, Great Smoky Mountains National Park, Tennessee (by Jerry Greer). Flowers make good isolated scenic subjects.

Below: Grand Prismatic Spring, Yellowstone National Park, Wyoming (by Jim Clark). Jim was attracted to the bold colors and repeating patterns.

Right: Incandescent sandstone, Paria Wilderness, Utah (by Nye Simmons). A beautiful sandstone pattern is complemented by warm sunset light.

WILDLIFE

Your heart races as a majestic bull elk approaches, unaware of—or unconcerned by—your presence. Your finger on the shutter button, you wait in anticipation for the bull to come within range of your lens. This is the moment you've been waiting for! Finally, the bull gets close enough for a tight, frame-filling portrait. Click-click-click-click-click! Your camera's motor drive goes wild before the elk ambles out of view. Your excitement builds as you review your images on the camera's LCD screen. The bull was so close, you reason, the shot must be incredible. But as your images pull up, euphoria fades to disappointment as you realize that your tight, frame-filling portraits are just that: portraits. You could have gotten the same shots at the zoo—or for that matter, the taxidermy shop. What is missing?

The answer? *Wild* is missing. Even though nothing surpasses capturing that special up-close-and-personal image of wildlife, if not done properly an image can seem static and lack a sense of the wild essence of the animal. That's why we came up with the concept of *wildscapes*. Wildscapes is more than just a set of photography techniques, it's a philosophy: it's a search for something basic and primitive, a quest to capture that heart-pounding feeling you get when you see animals painted on prehistoric cave walls, rendered as nothing more than sinew, horn, and fang, dripping with raw power. It's a quest for images that evoke wildness, and learning how to capture the essence of an animal, rather than a purely literal representation of its more obvious exterior appearance.

But how does one accomplish these lofty goals? How, basically, can you shift your focus from photographing *wildlife* to photographing *wildscapes*? What follows are some techniques to put the wild back into your wildlife photography.

ANTICIPATE THE MOMENT

An image is much more compelling if the wildlife subject is engaged in some interesting or unusual behavior. A duck taking flight from the surface of a lake says much more about the bird than a frozen

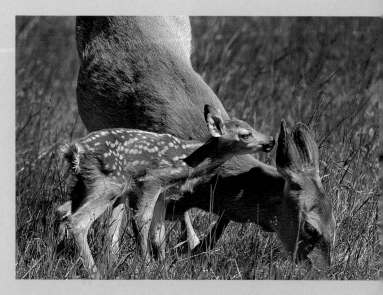

pose on a stick with a blurred-out background. Mating rituals, hunting for food or prey, or tender moments of affection between two living things are all examples of behavior that can turn an ordinary wildlife portrait into something much more special. Wait for the animal to do something interesting: a yawn, a fight with another animal, ruffling feathers, or a bugling call—all can help spice up your wildlife image.

You will need to exercise patience and be prepared at a split second to capture the experience. Stay a bit longer to see what unfolds with your subject. Often times when other photographers have moved on, you'll be treated to something special. One thing that helps you anticipate is to know what you are photographing. Become a naturalist first, a photographer second. Once you do, you'll be able to decipher animal behavior so you can be in the right situation to photograph that once-in-a-lifetime image. As with landscape photographers who wait for the right light, patience can also play a big part in helping you get an extraordinary wildlife image.

Left: Bull elk bugling, Jasper National Park, Canada (by Bill Lea). Bill waited for the right moment to capture this engaging portrait. Attention to composition (utilizing the Framing style of composition, see Chapter Three) helped make this image extra special.

Above: Doe and fawn, Shenandoah National Park, Virginia (by Jim Clark). Capturing a tender moment such as this is what it is all about!

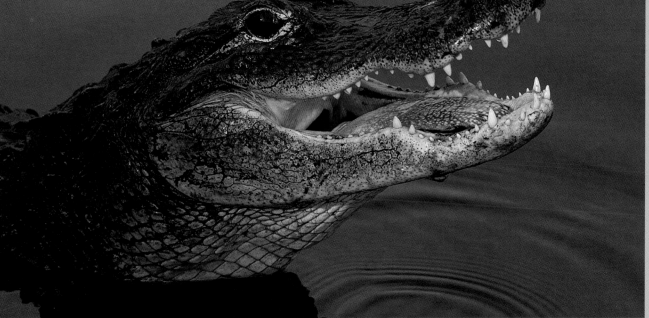

THE "EYES" HAVE IT

William Shakespeare wrote that the eyes are the windows to the soul. Having at least one eye of the subject visible can help make an image more successful. Eyes give personality to the animal, and create a point of interest. And when an animal looks straight into the camera, it makes the shot personal for the viewer, conveying a sense of being there with the animal. If the eyes are not sharp, the photograph is all for naught. Everything else can be out of focus, but if you have the eyes sharp, you have a composition that works. As with all of our "rules," of course, there are exceptions, and indeed, some shots work best without the eyes visible at all.

Another thing that can help is to photograph the animal when it has a catch light in the eye. Catch light is the reflection of the sun in the animal's eye and it appears as a small white circle, giving life to the subject. Without it, an animal can sometimes appear lifeless, like a museum mount. Animals with colorful red or yellow eyes don't necessarily need a catch light, but if it appears, snap the shutter. Sometimes the animal only has to move a fraction of an inch for the catch light to appear. You can also create a catch light using flash at low power settings.

GO LONG!

For wildlife portraits, you'll usually need a telephoto lens in the 300mm to 600mm focal length. Anything less and you could be putting the animal at risk by trying to get too close—not to mention yourself! Wildlife portraits also require tight close-up compositions that focus on the

Above: Smiling alligator (by Bill Lea). A comical moment and catch light in the eye make viewers smile as much as the gator!

Left: River otter (by Ian Plant). The catch light in the eyes help focus attention on this curious otter's whiskered face.

Right: Bighorn sheep (by Ian Plant). A super telephoto lens was used to get this tight portrait.

PRO POINTER *by Jim Clark*

When photographing wildlife, ethical considerations are important. I believe the rule for photographers should be similar to that for doctors: Do No Harm. Avoid doing anything that will harass or disturb an animal, its young, nest, or habitat. Some animals are skittish by nature, and your presence alone may cause them to flee—don't worry too much if this happens, as it will happen quite a bit, but on the other hand it is best to resist the urge to give chase in order to get a shot. Photographing an image should always remain secondary to the welfare of the animal. Set an example for others and when in doubt, walk away—another opportunity will always come along later.

animal. By creating a narrow angle of view, longer focal lengths help reduce distracting background clutter so the focus is on the primary subject. These longer focal lengths provide a safer and more effective working distance between you and the subject. With telephoto zooms, you can also frame the image much more easily, zooming in and out until you get the shot you want. Shoot wide open initially, especially if the animal is moving. You'll need the extra speed to freeze the motion, plus shooting wide open helps blend the background elements together so the emphasis remains on the critter, not the scene. If the light is strong enough or the animal is not moving much, stop down a bit to ensure sharp focus around the animal's eye and face. Adjusting the ISO can help in these situations as well.

GO WIDE!

We've previously discussed the habitat composition. Sometimes, zooming out or stepping

back—and placing the subject in its natural environment—can help create more compelling wildlife images. By expanding the scene and revealing more of the animal's environment, more information about the animal can be learned. The subject, the animal, is still the focal point of the image, but the subject merges with the animal's environment to help tell a story and holds the viewer's attention a little bit longer.

A wider composition can give the viewer clues about the animal's habitat and its relationship to other parts of the environment, or about the climate or the season. All this can pull viewers into the image and help them relate to the subject on a more emotional level. It is important to show elements of the animal's environment that strongly relate to the animal: showing a bird in it's nest, for example, or a mountain goat with vast peaks in the background. When showing the animal in relation to its environment, basic principles of composition are important. The wildlife subject will almost always be the focal point of the image and your viewer will be drawn there first. Other elements of the scene must relate to the animal in order for the overall composition to work effectively.

GET LOW

Strive to get at the same eye level as the animal. Such compositions can often be pleasing and powerful. For small critters, try photographing from your knees or even lying down. Shooting at this perspective can also help you frame a much better and complementary background. Make sure there is nothing in the foreground like a twig or piece of grass that will mar your composition. You can, however, photograph through a stand of grass or flowers at an animal; just make sure that you have a clear view of the animal's eye. This type of composition can result in a tight portrait, but at the same time puts a bit of the animal's habitat in the photograph.

Above: Pelican chicks on the nest, Chesapeake Bay, Virginia (by Ian Plant). Ian wanted to get a chick's-eye view of what life is like inside a pelican colony. By getting low and going wide, he was able to show these animals and their flying adult counterparts in the context of their environment.

Right: Canyon deer (by Guy Tal). Sometimes just a hint of animal is all it takes to make a great wildlife image. The deer in this image can be a little hard to find, but the wide angle view definitely shows the animal's habitat.

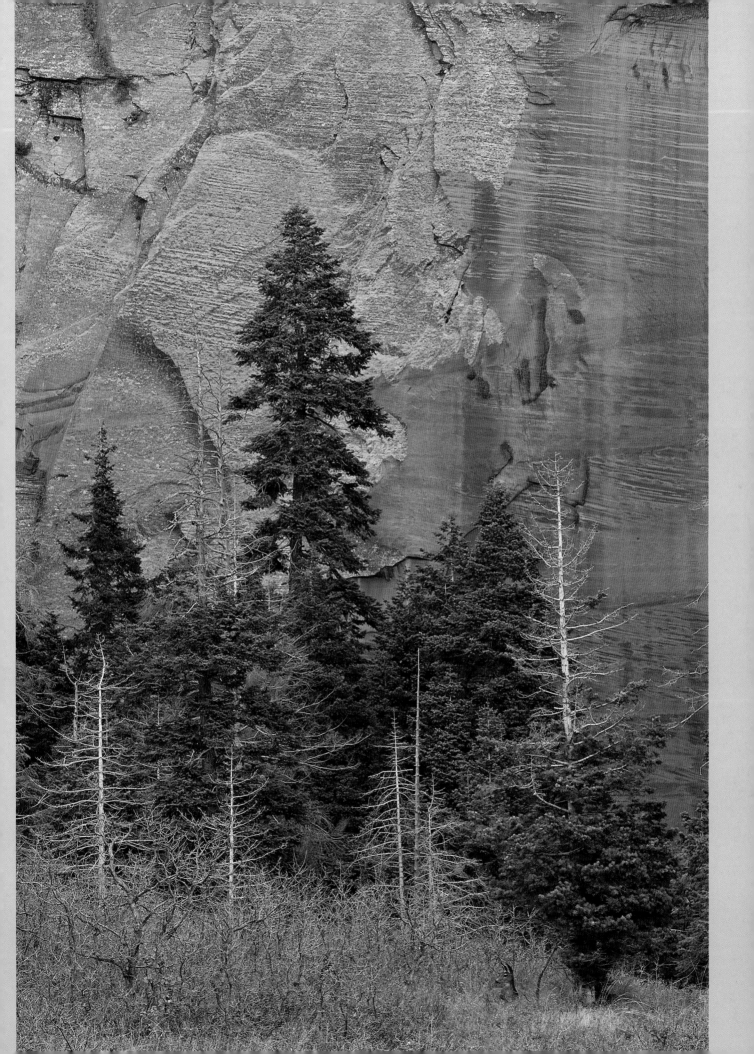

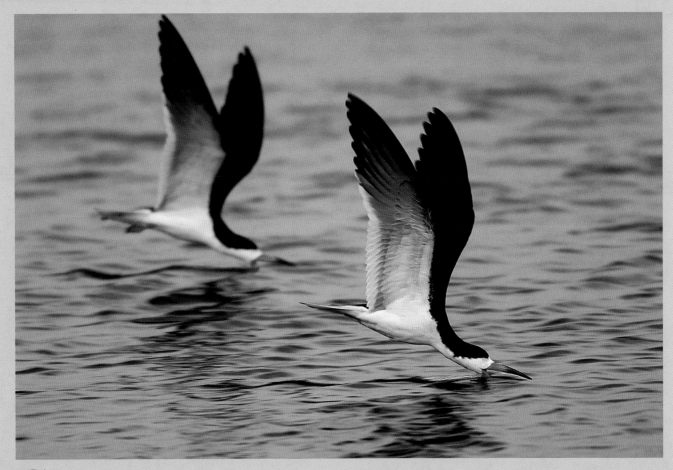

CONSIDER THE LIGHTING

Front lighting (with the sun directly behind you) ensures that light bathes the animal, revealing the texture and detail of the fur, feathers, or scales. Overcast light can also work well when shooting wildlife. The magic hours work with wildlife just as well as with landscapes, bathing your subject in a warm light. Side and backlighting make for even more dramatic images. For silhouettes, you'll be shooting toward the sun. Make sure to compensate for the light, which means you might have to increase exposure a bit. Most importantly, make sure the viewer will be able to tell what the animal is—have it profiled such that you can discern the features of its form such as the head, bill, neck, and legs.

LINE OF SIGHT

The subject's line of sight or direction of motion becomes an important leading line in the scene

Above: Black skimmers, Chincoteague National Wildlife Refuge, Virginia (by Jim Clark). Soft, warm light makes this a stand-out image.

Left: Great egret, ACE Basin, South Carolina (by Richard Bernabe). Richard selected a low angle to shoot this egret through a frame of marsh grass. Line-of-sight considerations dictated that he place the egret on the right side of the image frame, looking into empty space on the left.

Upper right: Pileated woodpecker (by Bill Lea). Bill selected a wide aperture to throw what would otherwise be a distracting background out of focus.

Lower right: Mexican gray wolf, Sevilleta National Wildlife Refuge, New Mexico (by Jim Clark). Jim gave the wolf a little extra room on the left to accommodate its direction of motion.

and it's imperative that this line works well with the overall composition. What this basically means is that generally, you want to have your subject looking or moving into open space within the image frame, not out of it. For example, a picture of a wolf running from right to left often works best if the image frame has some extra space on the left for the wolf to run into. Line-of-sight considerations can determine if the image has compositional or aesthetic balance or not. This often means waiting for the wildlife subject to turn its head in the right direction before pressing the shutter. But remember that sometimes the shot works best with the animal looking out of frame. And sometimes, a moving animal that is placed near the edge of the image frame in the direction it is moving can convey a sense of speed and power.

ISOLATE YOUR SUBJECT

Often it is useful to choose a composition that has an uncluttered background. Make sure the background doesn't detract from your primary subject, the animal, which is what you want your viewer to focus on. Make sure the background elements are not too overpowering and that they

complement the colors of the animal. You may have to move around a bit to create a background that will work. Wider apertures help to throw the background out of focus and to blend the background colors together. If the background is a considerable distance away from the animal, you may be able to use a smaller aperture to ensure sharpness on the animal and still have the background out of focus. For lighter colored animals, a darker background is often preferable, while the reverse is often true for a darker colored animal.

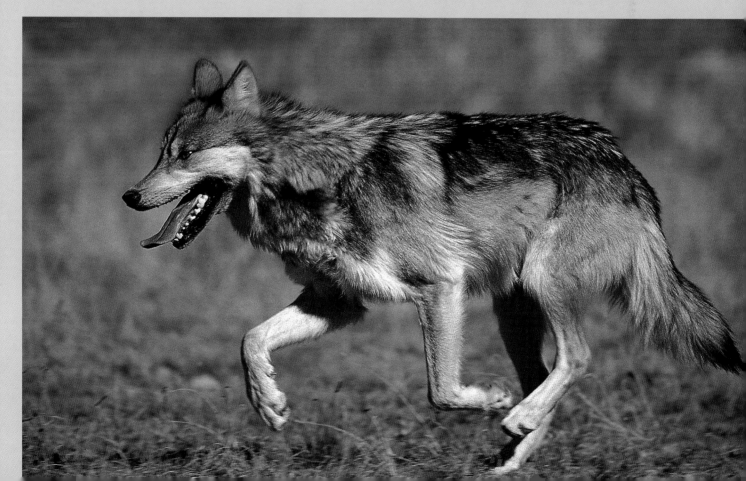

USE MOTION BLUR

Using high shutter speeds to stop the action of a moving animal can sometimes lead to static images. A little—or a lot—of motion blur can really bring an image alive.

Sometimes you want to freeze the action of the animal but allow for motion blur in parts of the image. For example, a picture of birds taking off from the water might work best if the birds are relatively sharp but the water flying through the air is streaking, or if some birds are moving while others are still and sharp. Or sometimes it is best to go all abstract!

Another motion blur technique is to pan with a moving subject. Basically, you follow your

subject as it moves, so that when you trigger the shutter, your subject stays sharp but the background blurs behind it. Selecting the appropriate shutter speed for any of these techniques will likely take some experimentation.

See Chapter Five for more information about appropriate shutter speeds for creating blur effects in wildlife photography. As always, using instant review of images on your camera's LCD can help you determine the best settings to use.

LASH

Get into the habit of using flash for your wildlife photography. As already mentioned, flash can be used to create catch lights in the eyes of your subjects. Flash is also useful to stop action with fast moving subjects in low light, or it can be used with a long shutter speed to create a slow sync flash effect. The flash is used to freeze action while the longer shutter speed allows for some motion blur. If trying to capture images of nocturnal critters, flash is a must. On-camera flashes simply will not have enough power for serious

Top left: Snow geese, Chincoteague National Wildlife Refuge, Virginia (by Joseph Rossbach). Joe used a slow shutter speed while panning in the same direction as the geese to get this blurred effect.

Bottom left: Deer and lightning, Shenandoah National Park, Virginia (by Ian Plant). Flash was used to illuminate the foreground during a night exposure. Ian kept the shutter open until a bolt of lighting appeared in the sky behind the deer—in this case, a real big bolt that was a little too close for comfort!

Below: Night coots (by Ian Plant): Ian fired his flash during a one-second exposure. The flash froze some of the action, whereas the long exposure blurred the motion of these frenetic birds, thus creating a mix of stopped and motion-blurred action, conveying a sense of their energy.

wildlife work. Get a powerful external flash instead. Consider purchasing an external battery pack to power the flash to ensure quick recycling times. A flash extender is also very useful for extending your flash's range.

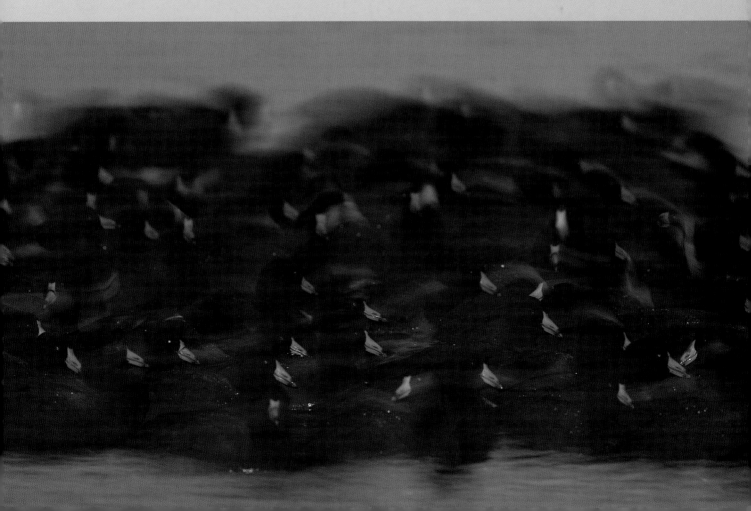

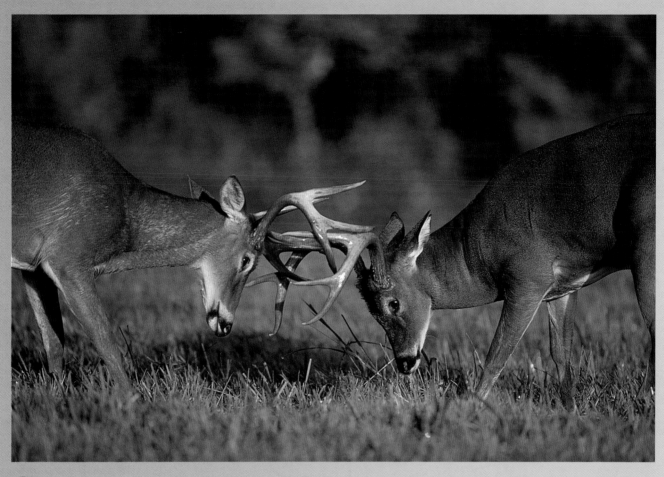

SPECIAL WILDLIFE EVENTS

Nesting and spawning, migrations, and other special events can bring large groups of animals together to one spot, creating exceptional photography opportunities. Also, during certain times of

year, animals can become more active. For example, deer, elk, and moose males start battling for female attention during the autumn rut. In addition to increased activity, many animals display bright plumage or engage in interesting mating rituals.

Learn when and where these seasonal wildlife events occur, and make sure you show up with camera in hand, ready to get some great shots! Park officials, biologists, and other wildlife experts can be an invaluable source of useful information about wildlife events.

Above: Dueling bucks, Great Smoky Mountains, Tennessee (by Bill Lea). Bill makes sure to always be on location during the autumn rut.

Left: Brown pelican feeding chick, Chesapeake Bay, Virginia (by Ian Plant). Many birds nest in large colonies during the summer, including the brown pelican. It's just a matter of finding and getting to the right places! The birds in this colony nest on a secluded island in the Chesapeake Bay.

Right: Horseshoe crab spawn, Slaughter Beach, Delaware (by Ian Plant). One of the most incredible—and creepy—wildlife events on the planet, every summer hundreds of thousands of horseshoe crabs come to spawn on the sandy beaches of the Delaware Bay.

Next pages: Snow geese liftoff, Bombay Hook National Wildlife Refuge, Delaware (by Ian Plant). Seasonal migrations often bring tens of thousands of birds to one location. The opportunities are endless!

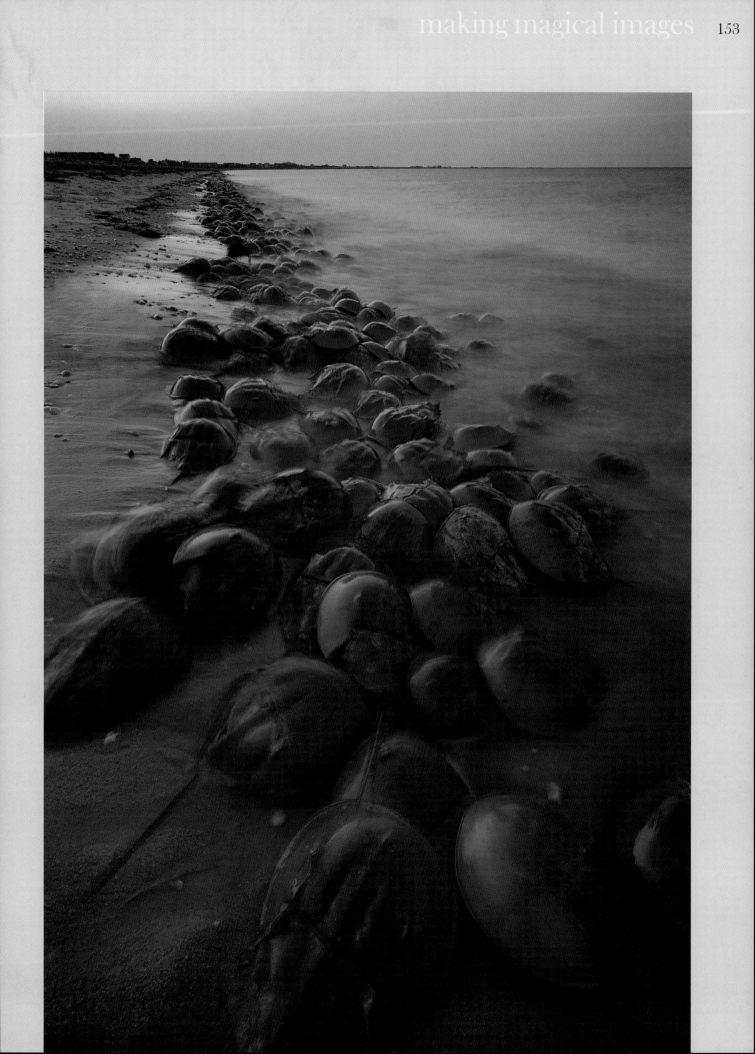

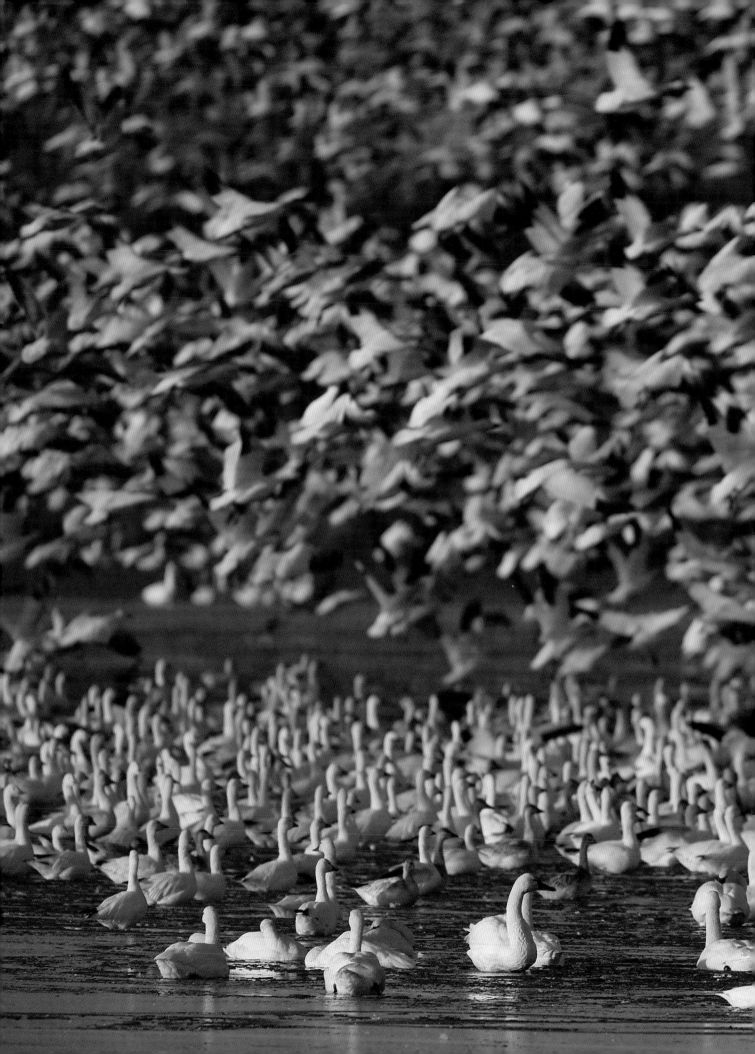

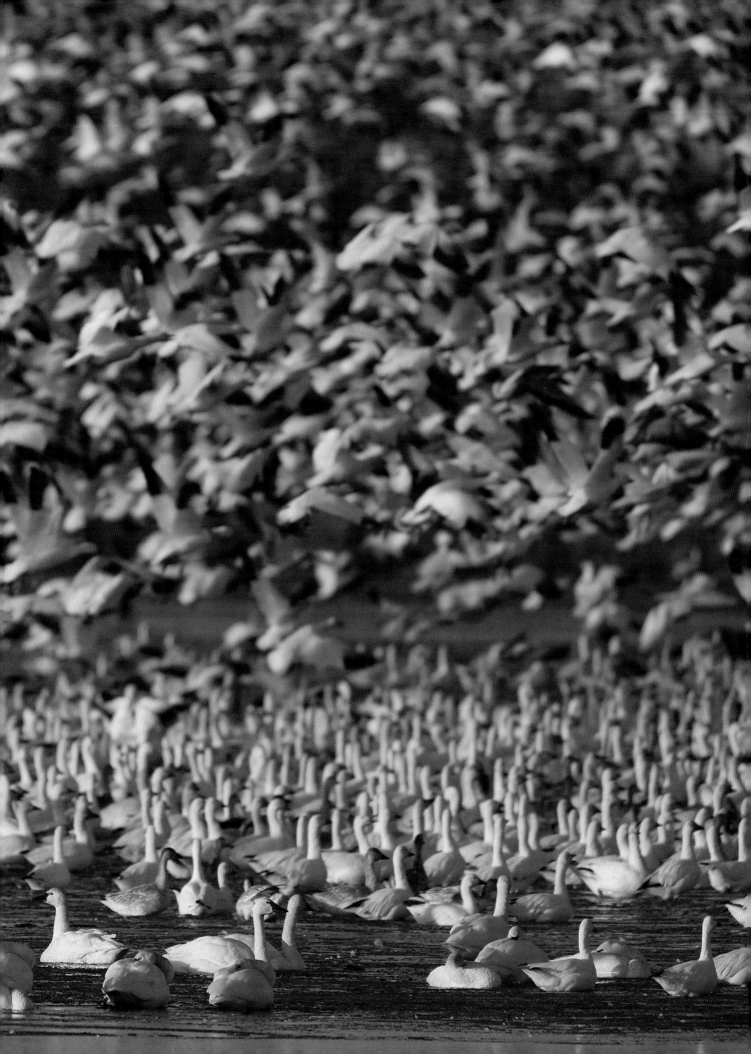

Macro

Everyone loves "charismatic megafauna" and grand landscape scenes. But sometimes it's the little things that make life special. And sometimes it's the *really* little things. Macro and close-up photography can open up whole new worlds of artistic expression—even the tiniest objects can be rendered with immense scale—if you can get your camera close enough. Here are some tips to help you get the most out of what is arguably the most challenging form of nature photography.

Use a Macro Lens

Well, duh, you say. But there are plenty of folks out there trying to shoot macro with regular lenses that have a "macro" setting, and are frustrated when they cannot get close enough. When photographing small objects, your lens' focal length and minimum focusing distance affect how small or large objects appear in the image.

Below: "Sparkling Shore," Stonefield Beach, Oregon (by Marc Adamus). A close-up view of pebbles on an ocean shore.

Right: Green tree frog (by Jim Clark). A macro lens and wide-open aperture allowed Jim to photograph this frog with a clean, out-of-focus background.

For example, if you're photographing a small insect, you want that insect to appear as large in the image as possible. Zooming the lens in on the subject will make that little insect large enough in some cases, but often you need to get even closer. Dedicated macro lenses are designed to focus much closer than your normal lenses—even those with "macro" settings—making your subject appear much larger in the final image. Most macro lenses achieve at least a 1:2 reproduction ratio, meaning the image on the sensor is one-half the size of the object being photographed. Many better macro lenses achieve a 1:1 ratio, meaning the image on the sensor is the same size as the object being photographed.

GET STABILIZED

When shooting close up with massive reproduction ratios, even a tiny tremor can seem like an earthquake. A tripod with cable release and the use of mirror lock-up are often essential when doing macro and close-up photography.

SEEK OUT A CLEAN BACKGROUND

If you really want your macro subject to stand out and be noticed, eliminate distracting clutter by seeking out a clean, even-colored background. Overly bright or dark areas, lines, and distracting shapes behind the main subject only disturb and confuse the viewer, making your macro image ineffective. You can reduce potential background distractions by shooting at wider apertures, which throw the background out of focus, and choosing longer focal lengths, which narrow the angle of view and background area, giving you more control over it.

MANAGE THE LIGHT

A great benefit of shooting close up and macro, as opposed to other types of nature photography, is the ability to easily control and manipulate natural light. Portable light disks, which contain

Above: White-lipped land snail and mycena mushrooms (by Jim Clark). Spot-lighting adds drama to this shot and helps separate the foreground from the background.

Left: Frozen oak leaves, South Carolina (by Richard Bernabe). Autumn leaves always make for nice close-up subjects.

Top right: Dewy web, Spruce Knob Lake, West Virginia (by Joseph Rossbach). Beautiful lighting and selective focus make for a compelling image.

Bottom right: Praying mantis eating monarch butterfly (by Ian Plant). Even the macro world can show dramatic interaction between ravenous predator and prey.

diffusers and reflectors, help manage natural light in small working areas. A diffuser can soften direct light, eliminating harsh highlights, while the reflector bounces light into any unsightly shadows. This light management makes for better exposures and more pleasing images.

LASH

A ring flash (which attaches around the lens to provide even lighting) or off-camera flash unit is instant light, whenever and wherever you need it. This is particularly useful in low-light environments or situations where you want to stop the lens down for greater depth-of-field and sharper focus. Also, remember that when you add extension to your lens, you lose light, which might make flash necessary to get the shot. Specialty-built flash brackets allow you to take the flash "off camera" for different angles of illumination, and some are designed for multiple flash units. Electronic flash fired directly from the unit onto the subject is usually a bit harsh, so diffuse the flash with a piece of tissue paper or bounce the light off of a reflector for more even illumination.

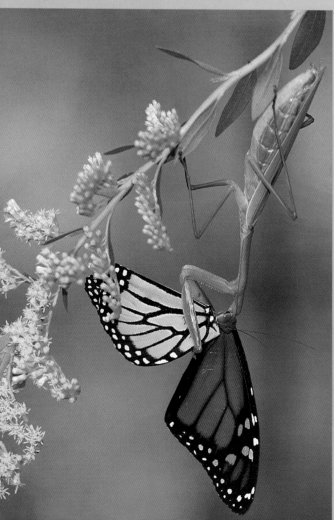

EXPERIMENT WITH DEPTH-OF-FIELD

All too often, macro and close-up photography is considered more documentary than other types of nature photography. Nothing can be further from the truth! Close-up photography can be as artistic and expressive as your imagination will allow.

One way to mix it up and experiment a little is to try various depth-of-field combinations to render your macro scene in different ways. By choosing a large aperture and selectively focusing only on your subject, the immediate foreground and background become a dreamy color wash. Stopping the lens all the way down will bring most of the scene, if not all, into sharp focus. Experiment with each scene and choose the variation you like best.

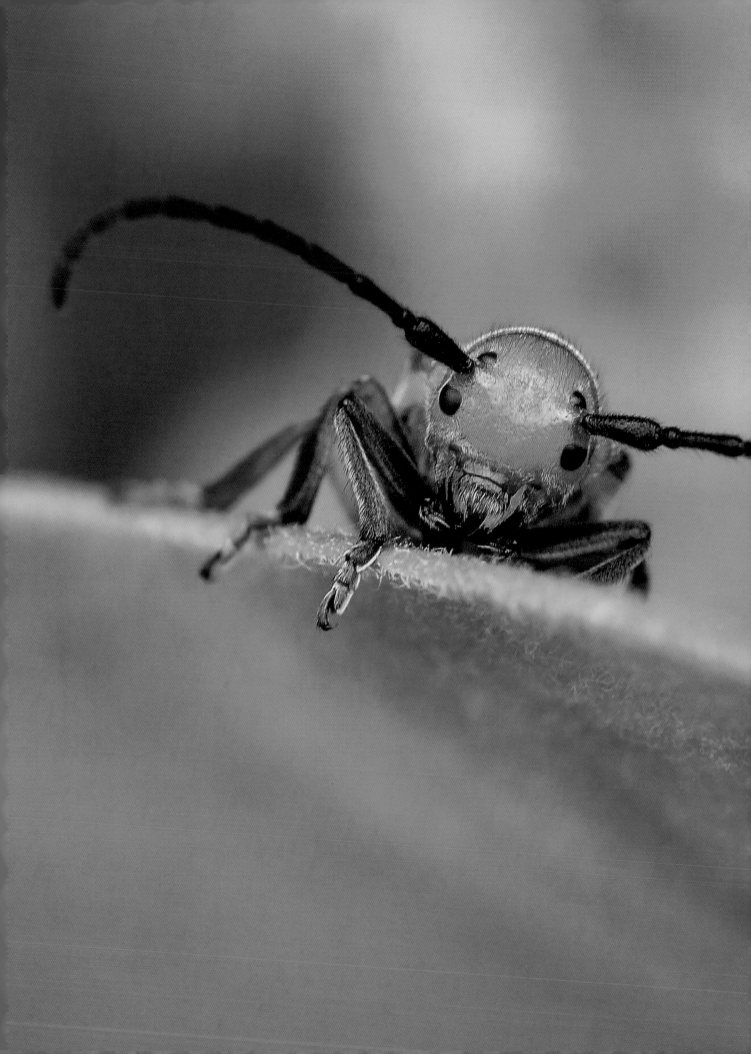

Milkweed beetle (by Jim Clark). *Jim found this color-ful beetle, but was not content with a simple close-up portrait. Utilizing the compositional guidelines from Chapter Three, Jim created a compelling, "in your face" image, placing the beetle off center to add inter-est. When working with macro subjects, it pays to crawl around a bit on hands and knees and to really concen-trate on the little details, exploring whole tiny worlds right beneath your nose.*

EXTEND AND GET CLOSE

One inexpensive option to buying a macro lens is using extension tubes. Extension tubes are simply hollow rings with electronic contacts on each end that can be mounted between the camera and the lens. This reduces the minimum focusing distance of that lens, allowing you to get physically closer to the subject. The closer you can get your camera and lens to any particular subject, the larger it will be rendered. Extension tubes contain no optics or glass, so there is no image degradation. Used in conjunction with a macro lens, extension tubes can allow you to get *really* close!

CLOSE-UP LENSES AND DIOPTERS

Another alternative to macro lenses is close-up lenses and diopters. These magnifying filters screw into the front element of any lens, making the subject in the viewfinder larger. The primary advantage of this close-up accessory is the ability to get macro images from your normal lens at a relatively inexpensive price.

Above: Water drops (by Joseph Rossbach). Joe used a narrow depth of field and selective focus to create an abstract image that focuses attention on one perfect drop.

Left: Dandelion seeds (by Joseph Rossbach). Joe moved in close enough to separate the densely packed seed pods and create order out of chaos.

Right: "Let's Do Lunch" (by Ian Plant). The last thing an insect sees before being eaten by a hungry mantis! Working with subjects such as a skittish mantis at hyper-magnification levels requires a fair amount of flexibility, patience, and a strong back. Ian worked this image for over a half-hour before the mantis was kind enough to stop moving and look at the camera for this scary portrait.

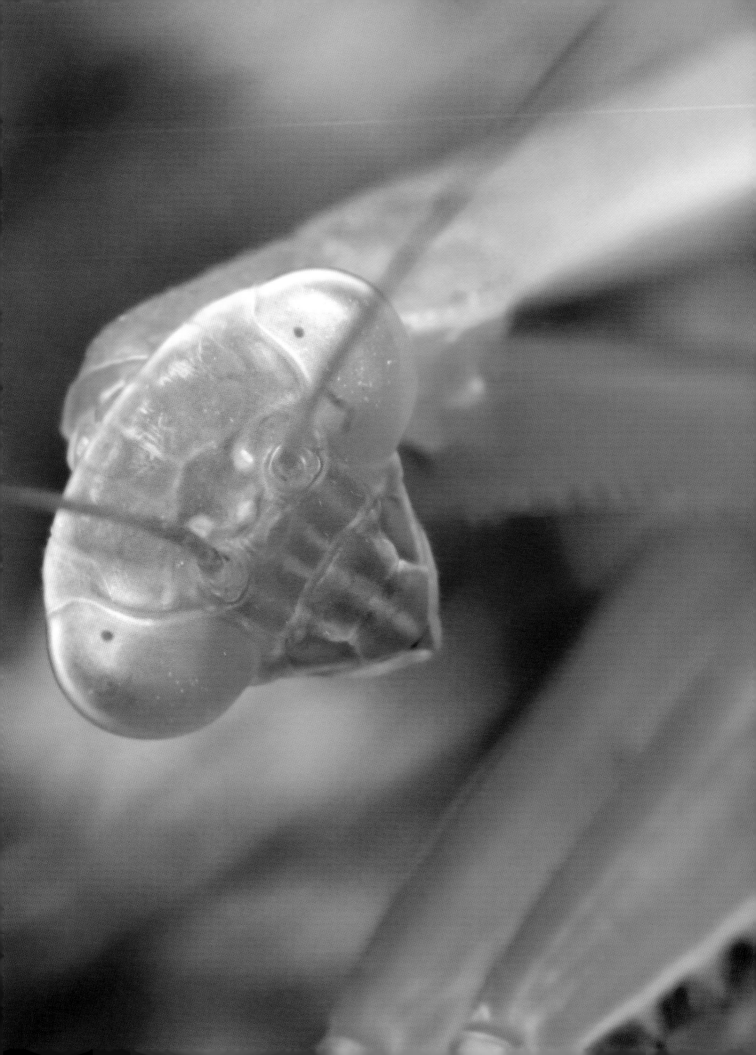

digital workflow

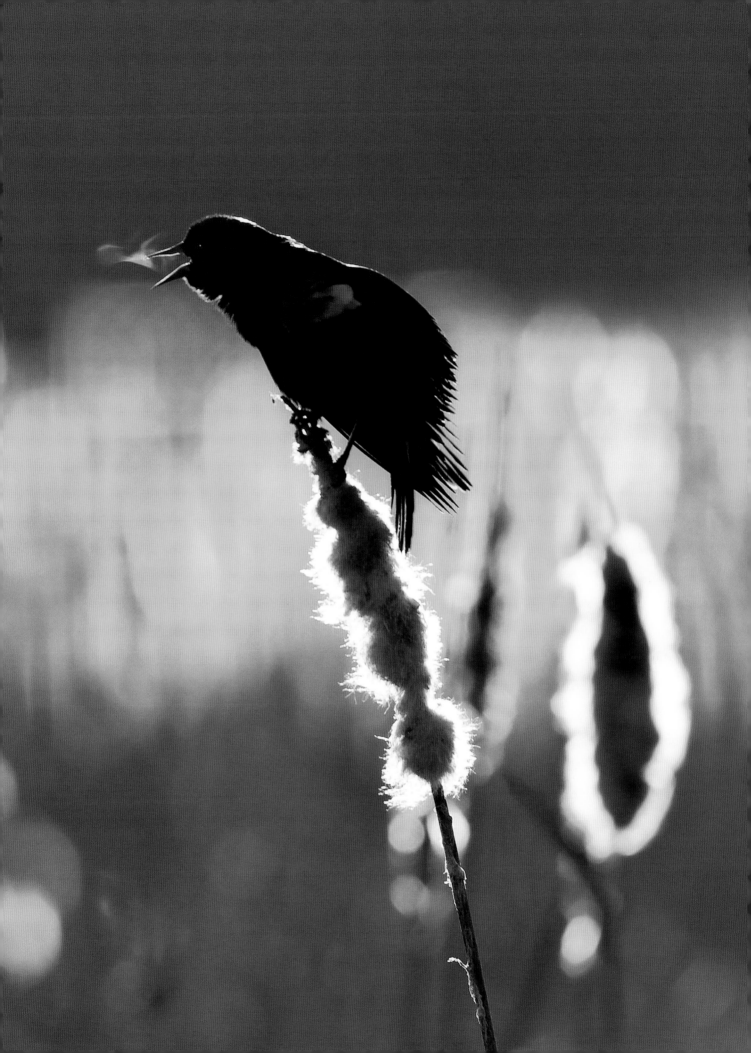

Nobody wants to be a slave to their computer. We all got into this in order to be out *there*, experiencing the beauty and glory of nature. But when you come back with hundreds—or even thousands—of digital images from your latest adventure, how can you get through them in a quick and efficient manner so that you can get back to the field? We know some folks who are simply overwhelmed by their digital files, and who are a year behind on their image processing. Don't let this happen to you!

DEVELOP A WORKFLOW

Digital workflow is the process and methodology of transforming the image files in your camera into the desired output, whether they are processed image files on your hard drive, photos on the web, or prints.

No matter what those processes are, it's important that the workflow is consistent and routine. A sloppy or inconsistent workflow can result in inferior results, at best, or lost image files at worst. It's also best that you develop a routine that you are personally comfortable with. There is no such thing as a perfect, one-size-fits-all workflow for everyone.

Many articles and books have been written on digital workflow and computer editing of images. It is a topic of immense breadth and depth, one that is frankly beyond the scope of this book. What we present here is a general overview of the subject, one that is enough to get you started and to allow you to master some basic and essential digital workflow skills. If you wish to learn more about digital processing, there are many excellent books and web resources that can help.

IMPORTING IMAGES

Once the images are captured, the files should be copied from your camera to your computer's hard drive. Note that the image files are *copied*, not transferred. You should always have at least two sets of your images at all times, and at this point in the workflow, the images should be on both the computer and the memory card.

A card reader is recommended for copying the images over to the computer. This is a better option than copying them directly from your

Above: Red-winged blackbird (by Ian Plant). A simple, efficient, and effective digital workflow helps bring this image to its full potential.

Right: Autumn vista, Blue Ridge Parkway, North Carolina (by Richard Bernabe). Sometimes a light touch is required when processing images.

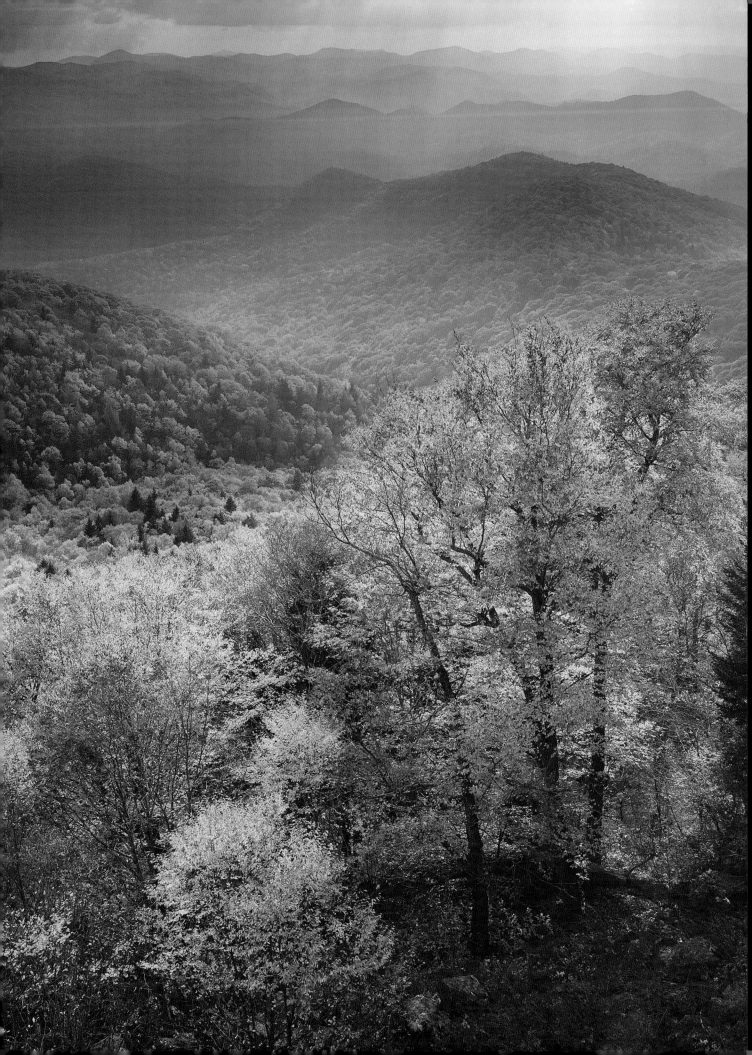

camera for a few reasons: 1) The images copy faster from a card reader than the camera. 2) Copying directly from the camera wears down the camera's battery life. This could be important during a photography trip or while working in the field. 3) It is safer to have your camera packed snug in the camera bag while the images are copying, rather than sitting on the edge of a desk or table with a cord attached to it.

Buying a few extra card readers and keeping them in strategic locations (such as your computer desk, camera bag, and/or laptop case) is a good idea. Most of these relatively inexpensive devices can read both Compact Flash and Secure Digital, the two most popular types of memory cards, and connect directly to your computer via a USB 2.0 or Firewire port.

The files should be copied to a new folder on your computer and given a specific name. The name of the place, event, or date they were taken should suffice. Of course, you may wish to develop your own filing system; just make sure it makes sense!

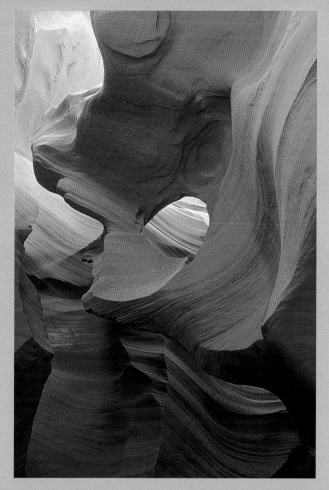

As your files grow, a rational computer filing system is necessary if you ever want to find a specific image.

EDIT IMAGES

Now that the images are in a folder on your hard drive, you will want to sort through them with an image browser or raw converter of some type. You can delete the obvious clunkers that are out of focus or suffer from bad exposure and assign a rating to the remaining keepers. Many image browsers allow you to rate images with a color code or a star number rating, which help you determine which images you want to take to the next step and those which may not make the cut.

ENTER METADATA

Entering metadata into the image, such as your copyright information and keywords, makes it easy to find, identify, and protect your image files. The keywords that you enter can be searchable, so locating certain types of images later is much

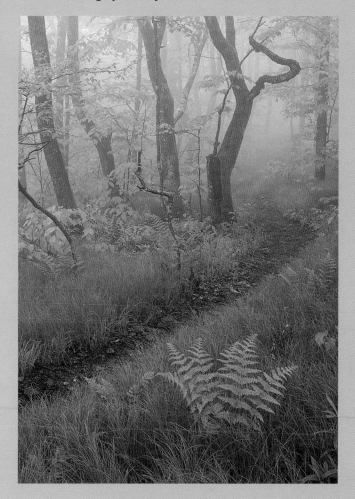

easier to do. Your copyright and contact information are important if a potential image buyer wants to contact you to license the image or to help protect it from possible copyright theft.

JPEG VS. RAW

If you have chosen JPEG as your format, then your work is largely done. As mentioned in Chapter Two, when shooting JPEG you camera applies pre-set saturation, contrast, and sharpening boosts. JPEG files, however, are not ideal for significant computer processing. If you are shooting raw, however, there's still plenty more for you to do.

RAW CONVERSION

For the keeper images captured in raw format, you will want to open them in a raw converter. This is where the first editing steps take place. There are several dozen very good raw converters on the market for photographers with a myriad of

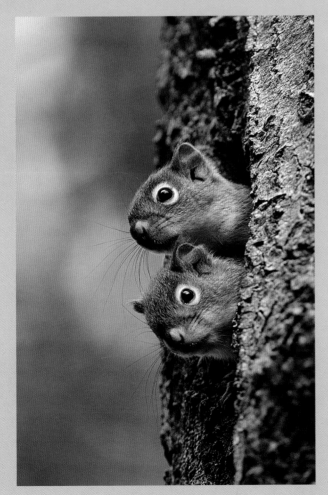

Facing page (top): "Canyon Watcher," Antelope Canyon, Arizona (by Joseph Rossbach).

Facing page (bottom): Fog along the Appalachian Trail, Cherokee National Forest, Tennessee (by Jerry Greer).

Below left: Red squirrels peering from their den (by Bill Lea).

Below right: Alamo Canyon and organ pipe cactus at sunset, Organ Pipe National Monument, Arizona (by George Stocking).

features, but all do the same basic function: interpret the camera's raw data, allow the user to affect the results, and convert those results to a standard image format that any imaging software can process.

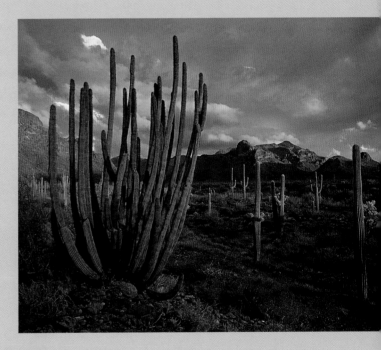

Some photographers choose to do as much image editing in the raw converter as possible before importing into an editing program, while other photographers prefer to do only a few basic functions in the raw converter and leave the rest to the editing software. It's a highly personal process. Most raw converters apply their changes globally, with little opportunity for local changes—for example, if you adjust saturation in the raw converter, it applies to all colors and all areas of the image. As a result, most fine tuning of images and local adjustments are done in an image editing program. Raw converters,

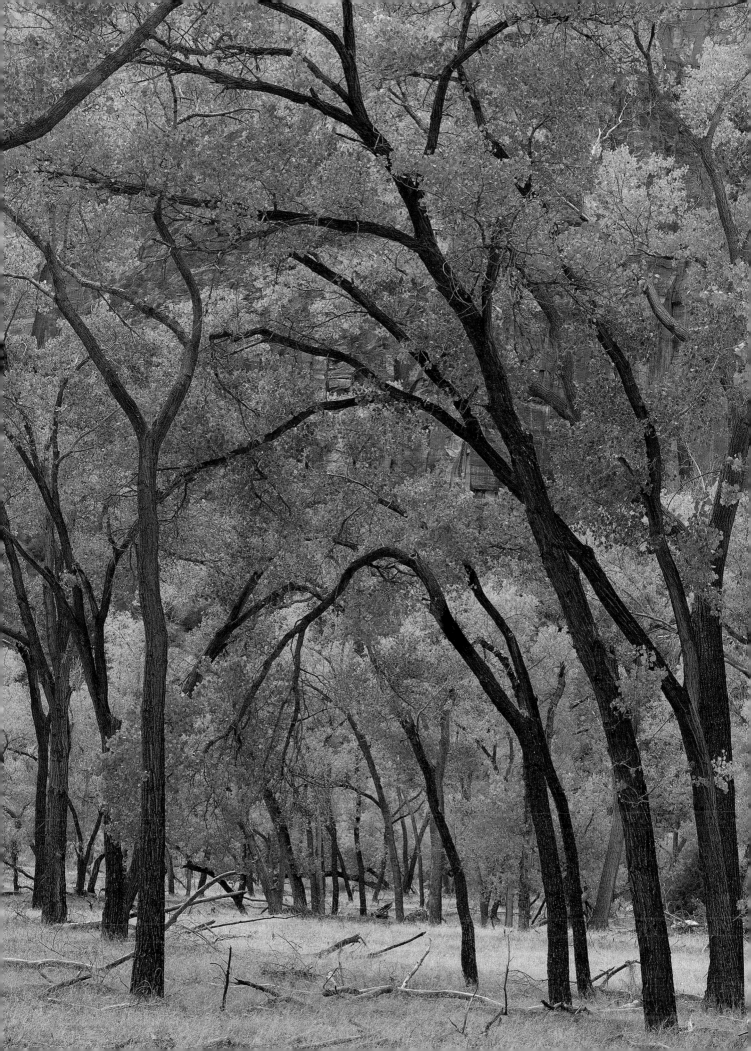

however, are offering an increasing amount of local adjustment features, blurring the distinction between converter and image editor. Regardless of your personal preference, there are a number of basic adjustments that can easily be made in the raw converter.

ADJUST WHITE BALANCE

If you shoot in raw, one of the necessary adjustments you must make in the raw converter is white balance. The great advantage of raw, as opposed to being locked into the white balance value assigned by your camera's setting, is that you can see the white balance changes previewed on your computer screen as you make them. See Chapter Two for more about white balance.

FINE-TUNE THE EXPOSURE

Although the exposure should be captured correctly (as close as possible) in-camera, the raw capture allows for tremendous latitude in changes after the capture. This is most important when "exposing to the right," as the image needs to be darkened during conversion to make it look properly exposed.

Clipped or blown-out highlights can be recovered to a certain extent in the raw conversion process. This is typically accomplished by reducing the exposure until the clipped highlights are restored, although many conversion programs have a "highlight recovery" tool that allows you to restore clipped highlights without darkening the entire image. Most converters also have a shadow recovery tool, allowing you to add "fill light" to dark areas of the image.

OTHER ADJUSTMENTS

There are many other adjustments that can be made in either the raw converter or in the image editing software. This includes adjustments to contrast, hue, saturation, and noise reduction; setting the white and black points of the image; and cropping the image, to name a few.

DNG?

A raw file is actually two files: the original raw

file and a separate "sidecar" file that contains information about how to apply the raw conversion setting you have chosen to the image. An alternative to keeping two files per image is to save the raw file as a DNG or Digital Negative.

DNG is an open source, universal raw container file format created by Adobe that will hold both the original raw data plus the changes you made. It solves the problem of having to keep up with two separate files. The DNG format is compatible with nearly every raw converter, including the camera-brand specific converters.

Left: Cottonwood Cathedral, Zion National Park, Utah (by Nye Simmons). A proper white balance setting to balance the warm and cool tones of this image was essential.

Above: Incoming wave, Lake Michigan, Cave Point County Park, Wisconsin (by Ian Plant). Raw's highlight recovery allowed Ian to slightly overexpose the brightly lit water in order to retain detail in the dark rocks, and then recover the highlights in the raw conversion process.

IMAGE EDITING

Once raw conversion is completed, the image can be opened into image-editing software for final editing and processing.

Adobe Photoshop is the industry standard in photo editing software, but not nearly the only option. Use a product that you are comfortable with and that fits within your budget.

BASIC EDITING

Here are some basic and essential image editing tools you should learn how to use. They should be part of your workflow for nearly every image:

Curves: The curves adjustment is useful for brightening, darkening, or adding contrast to an image. It is a tool found in nearly every image editing program and one of the most powerful in that it can selectively adjust specific tones.

Levels: The levels adjustment can do much of what the curves adjustment can do, but it is most useful for setting the black and white points of the image as well as mid-tone adjustments.

Contrast: Most image-editing software programs have a slider to globally increase or decrease contrast. It is not as precise a tool as curves, but is easier to use.

Hue and saturation: These two adjustments are often lumped together and influence the color values of your image. Hue refers to the basic properties of the individual colors while satura-

Above: "Painted in Spring," Painted Hills National Monument, Oregon (by Marc Adamus).

Right top: Mountain lion tracks (by Guy Tal).

Right bottom: Rain on aspen leaves, Blackwater Falls State Park, West Virginia (by Jim Clark).

tion affects the intensity of color. Both are subjective values and are left to personal taste and preferences.

Spot removal and image clean up: Most image editing software includes tools to help remove unwanted dust spots on the sensor and general blemishes. These tools include the clone tool, patch tool, and healing brushes. Each tool has unique features that make one better than the others for each particular need and situation.

Cropping: There are times when you just didn't get it quite right in the camera. Sometimes removing areas of the image makes for a more powerful composition. This is where cropping becomes an effective way to make more out of less. "Cropping" in-camera is always preferable to doing so after the fact because of the loss of pixels, but cropping after the fact is sometimes your only option.

You can also crop to change the aspect ratio of the image. Most DSLRs produce images in the 2:3 ratio. Other formalized aspect ratio possibilities that can enhance the effectiveness of a photo are 1:1 (square), 4:5, and 5:7. Feel free, of course, to choose whatever image ratio you want!

SAVING IMAGES

The preferred formats for image archiving are TIFFs and PSDs. A TIFF (Tagged Image File Format) uses lossless compression and may be edited and re-saved without losing image quality, unlike JPEGs. TIFF is probably the most widely used archival file type. A PSD (Photoshop Document) is an Adobe propriety file that has many of the advantages of the TIFF format and has gained wide acceptance in recent years. There is no clear advantage to using either format, although TIFF files are perhaps more universally supported.

BACK UP PROCESSED IMAGES

When all editing is completed, back up your results on a DVD or an external hard drive. It is impossible, really, to back things up too many times. If some tragedy strikes your computer's hard drive, your images can be restored.

Once you have backed up your images, it is safe to reformat your memory card. The memory card should be reformatted in-camera, not deleted on the computer. Merely deleting images can leave file fragments on your card, which could later lead to file corruption and lost images.

SHARPENING

Although raw converters and image editing programs all have actions that apply sharpening to your image, you should not apply sharpening to your master image file. Sharpen only when you create some sort of output from that master file. For example, if you want to post an image on the web, you should copy the master file and save the copy as a different file, resize the copy file, sharpen to taste, and post to the web. This will leave your master file intact. The reason for doing it this way is that different output uses require different amounts and types of sharpening. You will likely create several different sized outputs from any particular master image file over time. Each output should be sharpened according to its size and use. If you sharpen the master file, then sharpening artifacts can leave the image unusable for certain applications.

MONITOR CALIBRATION

In order to view images on your monitor as they should appear, you should calibrate your monitor. If you cannot trust the colors and brightness values displayed, all other color management and image editing is a waste of time. Therefore, calibrating your monitor should be a top priority. There are several products that provide both the hardware and software necessary to correctly calibrate your monitor to ensure that the colors you see are correct, enhancing compatibility with printers and for web output.

Above: La Plata Mountain in spring, Indian Trail, Colorado (by Jerry Greer). Jerry has survived many hard drive crashes without losing images, because he regularly backs up image files.

Right: Great blue heron at sunset, Blackwater National Wildlife Refuge, Maryland (by Ian Plant). Monitor calibration ensures that bold colors are rendered properly throughout the workflow process, looking consistent from monitor screen, to web application, to the final printed book page!

PRO POINTER
by Joseph Rossbach

Preparing images for the web: Whether you want to place your images on a website, post them on an online photography forum such as NPN, or e-mail to friends and family, knowing how to properly prepare your images for the web will allow your images to look the best they possibly can. Here are a few helpful tips:

1) First, never prepare an image for web presentation directly from your original file. Always make a copy first, and then make changes to the copy. This will ensure that your master file isn't accidently altered!

2) Resize your image with photo editing software. There is no need to set the image resolution any higher than 100 ppi. Most monitors display data at 72 or 96 p.p.i.

The pixel dimensions of the image depend on your intended use. Just keep in mind that the resolution of most modern displays are 1024 x 768 or higher, so a size smaller than that should guarantee that viewers will not have to scroll to see the entire image. Larger images also load much slower, and not everyone has a blazing fast internet connection speed.

3) If it isn't already, convert the image's color profile to sRGB, the standard RGB color space for the Internet.

4) Sharpen the image to your personal taste. Image sharpening is a function of image size, so this should only be done after the image is sized for your desired final output. View images at 100% when sharpening.

5) Save the image as a JPEG and set the compression to the best compromise between quality and file size.

Some image editing programs can help automate parts of this process, such as Photoshop's "Save for Web" function which converts the image to sRGB and allows you to set the quality and ultimate size of the file.

FINAL OUTPUT

At some point, you're going to want to share your images—in one form or another—rather than just look at them on your computer screen. How you want to share the image will determine how you will output the image. Remember to always keep a master file (as well as the original raw file) separate from any output files.

POSTING ON THE WEB

Posting images online is a very popular method of sharing photographs with others. A number of websites, including NPN, allow you to post images in online forums for a small membership fee. Note that many of these forums are for public comment and critique, so be prepared for some constructive (and maybe not so constructive) criticism from time to time. Nonetheless, these forums are a great place to learn and to find inspiration from others, so plunge right in!

Another way to share images online is to set up your own website. A number of online web hosting services make it easy to import images into a pre-designed template, some of the most popular being Flickr and SmugMug. If you want something a bit more personal, consider purchasing an HTML editing program that will allow you to design your own site without having to learn all sorts of nasty coding language. If you go that route, you will be responsible for domain name registry and web hosting subscription.

For more information about optimizing your images for the web, see the sidebar to the left.

PRINTING

Desktop photo printers have really come into their own in recent years. Now anyone can own a high-quality ink jet printer capable of yielding professional, display-quality prints. In fact, many pros no longer make prints using a professional lab, but rather use their inkjet printer to make fine art prints for clients. Modern ink jet inks are of archival quality, meaning that a properly framed and preserved print can last for decades without fading or shifting color.

The left crop, viewed at 50%, is properly sharpened, whereas the right crop has halos and other over-sharpening artifacts.

The main challenge in printing is having a properly calibrated workflow that ensures that what you see on your computer screen is what you get, more of less, when you print an image. Since printers and paper cannot handle all of the colors that your computer screen can display, you will never be able to get a 100% perfect match, but if you have a properly calibrated monitor, you can get pretty darn close. Another factor that helps with getting consistent results is to make sure you use profiles for your printer and paper. Most printers come with great profiles built in to the printer driver. Thus, it is simply a matter of selecting the right paper/printer profile when making a print. This is easily accomplished in your image editor's print dialogue—you simply select the printer and the type of paper you are using, and the driver will apply the correct profile for you. If you are having trouble getting good results, you may want to consid purchasing a printer calibration device.

When ready to make a print, size your image for output and then sharpen. View sharpening results at 50% on your monitor, which approximates very closely how the final print will look to your eyes. Avoid over-sharpening—the image should look crisp and clean, not jagged with halos and other sharpening artifacts. When sharpening is done, go ahead and make your print!

EDITORIAL SUBMISSIONS

Making money from one's photography, or at least seeing one's work in print, are common goals for many serious nature photographers. Before sending off some images to a magazine editor or to a publishing company, make sure you can make a thoroughly professional presentation. All images should be set to the publishing standard Adobe RGB (1998) color space. Electronic submissions on CD or DVD are commonplace now, although some publishers require electronic submissions to be accompanied by hard copy prints. Make sure all of your images are clean of dust spots, fully processed, and properly captioned. Limit your submissions to 20 or less images; most editors don't want to wade through hundreds of images. Only send your very best!

Appalachian spring, West Virginia (by Jim Clark).

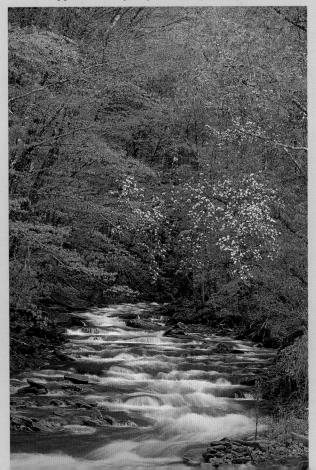

epilogue turning pro

So, you've decided to go for it and become a full-time professional nature photographer, eh? Well good for you! We have to warn you, though: it is a tough business. Many pros struggle to get noticed and to make a living. It's a highly competitive field, and it's not just the other pros you'll be competing with, it's all the serious amateurs as well. How can you make a go of it? Here's a few tips that might help you successfully launch a full time career:

Don't go pro all at once: Keep your day job and work as a part time photographer for as long as you can. Develop clients and a revenue stream before going full time.

Get your name out there: Participate in photo contests and online critique forums. These are great ways to market and promote your work.

Work your local area: Trips around the country can get expensive, real quick. Save money by working close to home as much as possible. Develop a relationship with local and regional magazines: these local clients can become the core of a successful business.

Write articles: It is often easier to get your photos published by magazines if they accompany an article. Not to mention, it is usually more lucrative!

Teach others: Photography workshops are a quickly growing business, and many professionals increasingly rely on workshop income to make ends meet. Local institutions and camera stores often offer instructional classes and are in need of instructors. Or, launch you own workshop business!

Reach out to local camera clubs: With the digital revolution, hundreds of new camera clubs have sprung up around the country. They love to have professional photographers come to present images. Camera clubs are a great place to sell prints and books and to promote workshops.

Good luck!

PRO POINTER *by George Stocking*

Turning pro was one of the most difficult decisions of my life. I spent twenty years as a photography hobbyist before taking the plunge. I essentially went cold turkey: after getting laid off from my job fifteen years ago, I decided to go for it and try to make my living as a full time nature photographer. I had not worked part time as a photographer before that, so I didn't have a revenue stream to rely on—I needed to scramble to find clients and outlets for my work. I'll be honest, it was very tough—in fact, if I knew how tough it would be I would never have done it. Frankly, I wish I had followed the approach we've laid out above. But nonetheless, after 15 years I now have a successful business. The market is always changing, however, with old sources of business disappearing in the digital age, and new sources arising. It is tough to keep up with changing times!

Right: Fog and aspens, Kebler Pass, Colorado (by George Stocking). Turning pro has its advantages! Having more time to spend in the field means you have a better chance of being on location when something rare, dramatic, and beautiful happens.

appendix one photo calendar

JANUARY

Death Valley, California (Second and Third Weeks) Death Valley's searing 120-degree summer heat is transformed into more comfortable 60s and 70s during mid-January. This may be the easiest time to capture the unique landforms, flora, and intriguing mineral deposits that make Death Valley such a popular and distinctive place to photograph.

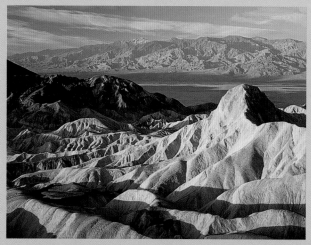

Death Valley National Park, California (by Ian Plant).

West Virginia Winter (All Month) Blackwater Falls State Park of West Virginia offers a myriad of winter opportunities for the landscape photographer. The surrounding Appalachian Mountains are frequently cloaked in fresh snow and rime ice, providing perfect natural frames for Blackwater Falls, Blackwater Canyon, and the park's numerous smaller waterfalls.

FEBRUARY

Yellowstone National Park, Wyoming (First and Second Weeks) Yellowstone National Park is winter wildlife at its very best. In fact, many photographers consider winter to be the prime time for landscape and wildlife photography. Crowds are long gone, wildlife wear their most luxurious coats, and the animals are not as shy about being approached by photographers.

North Carolina's Outer Banks (Third and Forth Weeks) With the tourists and most of the fishermen gone for the season, landscape and wildlife photographers have this paradise for their very own in mid- to late-February. Winter storms usher in amazing cloud formations, wild surf, and magical light. Many migratory birds, such as snow geese and tundra swans, make a stop at Pea Island NWR and are easy to photograph.

Platte River, Nebraska (Forth Week) For five weeks each spring, photographers can witness the sights and sounds of ninety percent of the world's sandhill cranes in the Platte River valley in south-central Nebraska. 500,000 sandhill cranes descend upon the valley to rest and feed from the fertile lands along the Platte. This amazing display begins in late February and continues into early April.

MARCH

Birds of Florida—Ding Darling NWR, Venice Rookery, Anhinga Trail, Shark Valley (First and Second Weeks) These are the prime times and the prime locations to photograph the large variety of wading birds that call South Florida home. Great egrets, roseate spoonbills, and blue herons are just a few of the photographer's favorites that call south Florida home.

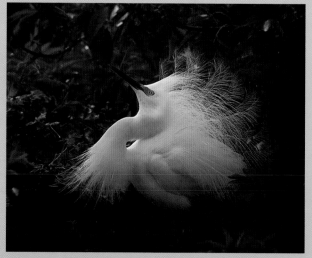

Venice Rookery, Florida (by Richard Bernabe).

Anza-Borrego Desert State Park, California (Second and Third Weeks) The rainy season brings a bounty of wildflowers to California's largest state park around mid-March of every

year. Some wildflowers to look for are the dune evening primrose, ghost flower, desert star, and Indian paintbrush. The degree of a bloom's success depends upon the rains, so there is never any guarantee, unfortunately.

Charleston, South Carolina (Third and Forth Weeks) There are very few places better in early spring for a photographer than the Charleston, South Carolina area. Blooming azaleas and a variety of lilies adorn the many cypress swamps and abandoned plantations. Alligators and wading birds are plentiful as well.

APRIL

Texas Hill Country (First and Second Weeks) The hill country of Central Texas is carpeted with colorful wildflowers in early April, and it's become a favorite event for landscape and macro photographers alike. Bluebonnets, Texas paint-brush, Indian blanket, greenthread, and winecup are just some of the many flower species that make this a special place for photographers during early spring.

Great Smoky Mountains National Park (Second and Third Weeks) Great Smoky Mountains National Park is often nick-named "Wildflower National Park," and mid-April is prime time to experience this Park at its best. Various trillium species, crested dwarf irises, lady's slippers, flowering dogwood and redbud trees are all in bloom, while the mountain streams are in their best shape.

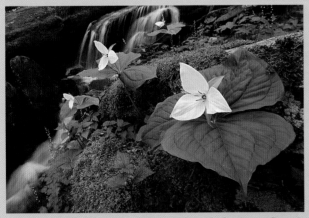

Great Smoky Mountains National Park (by Jerry Greer).

Antelope Valley Poppy Reserve, California (All Month) This state-protected reserve near Lancaster, California hosts one of the largest poppy blooms in the world. The poppy season varies from year to year, but visiting during the month of April ensures the best possibility of photographing this beautiful, prolific bloom.

Utah Red Rock Country—Arches National Park, Canyonlands National Park, Bryce Canyon National Park (All Month) The spectacular landscapes of Utah's red rock country can be photographed during any time of the year, but during April, the temperatures are very comfortable for hiking and the kids are still in school.

Sandstone in Red Rock Country (by Guy Tal).

MAY

Columbia River Gorge, Oregon and Washington (First and Second Weeks) The Columbia River Gorge contains countless cascades and waterfalls nestled among lush, green forests. Just to the east, endless rolling hills of wildflowers are in bloom, making the Columbia River Gorge a great destination in early May.

Yosemite National Park (Forth Week) The famous Yosemite waterfalls are at their most spectacular at the height of the snowmelt. In addition to the famous Yosemite, Bridalveil, Vernal, and Cascade Falls, there are over 300 waterfalls in Yosemite Valley, many without formal names.

Northern California's Redwood Coast (Forth Week) As if the coastal redwood trees weren't spectacular enough at any other time of year, late May adds the extra element of blooming rhodo-dendrons to the scene. Look for early morning fog so that you can make moody images of soft pink blossoms among these living cathedrals.

Delaware Bay, Delaware and New Jersey (New and Full Moons in late May/early June) Right at sunset of every full and new moon in May and June, one of the biggest and creepiest wildlife events on the planet occurs, as hundreds of thousands of horseshoe crabs come ashore to spawn. During peak spawning years, this is a spectacle not to be missed.

JUNE

Acadia National Park and Machias Seal Island, Maine (First and Second Weeks) Acadia National Park is home to rugged Atlantic seascapes, lush forests, and Cadillac Mountain, all favorite subjects for visiting photographers. Nearby Machias Seal Island is the summer home to spectacular nesting colonies of Atlantic puffins, razorbills, common murres and Arctic terns, among others.

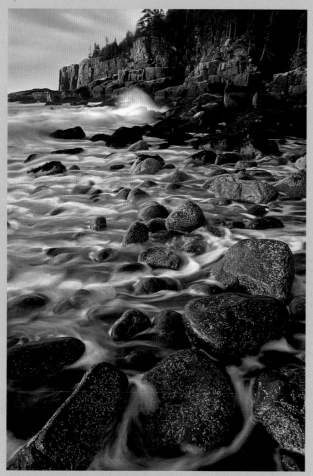

Acadia National Park, Maine (by Joseph Rossbach).

Grand Teton National Park, Wyoming (Second and Third Weeks) This is the time of year to capture that composition of foreground wild-flowers with snow-capped Tetons looming in the background. Arrowleaf balsamroot is the large yellow, sunflower-looking bloom that blooms in early June and peters out by early July. Lupines, columbines, and paintbrush can be found throughout the Park at this time as well.

Big Meadows, Shenandoah National Park, Virginia (Second and Third Weeks) Big Meadows is one the best locations to photograph newborn white-tailed deer fawns. During early June, you can witness fawns being born and young fawns that are just getting their "legs." Look for fawns closely following their mothers near sunset in the big, open fields.

Roan Highlands and the Blue Ridge Parkway, Tennessee and North Carolina (Second and Third Weeks) Catawba rhododendron and flaming azalea bloom at different times at different elevations, but early June is the best time to find these magnificent blooms along the Blue Ridge Parkway, while the third week is optimal for the higher elevations of the Roan Highlands. The Roan bloom, in particular, is one of the greatest wildflower spectacles anywhere in the United States.

JULY

Glacier National Park, Montana (Second and Third Weeks) By the month of July, the Going-to-the-Sun Road is open and wildflowers have begun sprouting up all over the mountainsides, generally following the snow line. Don't forget to catch sunrise at the western end of McDonald Lake and hike the Trail of the Cedars near Avalanche Creek.

Colorado Wildflowers, American and Yankee Boy Basins (Third and Forth Weeks) These two basins in Southwest Colorado are both premier summer wildflower locations. Although they both require some effort to reach, including driving rutted, 4-wheel drive roads, the quantity and quality of the blooms surrounded by dramatic, snow-capped peaks, make the extra effort well worth it.

AUGUST

Mount Rainier National Park, Washington (First and Second Weeks) Early august offers

the visiting photographer the opportunity to photograph fields of wildflowers against the backdrop of a hulking, glaciated Mount Rainier. Seasonal conditions can accelerate or delay the wildflower bloom, but the first week or two in August is always a good bet.

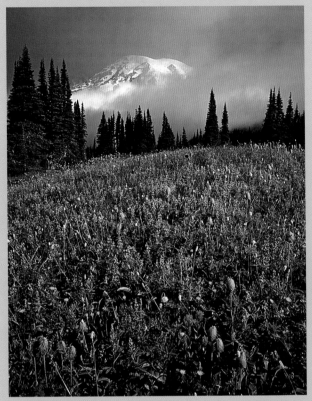

Mt. Rainier in summer, Washington (by Nye Simmons).

Katmai National Park, Alaska (First and Second Weeks) Alaska's Katmai National Park is one of the best places on Earth to photograph coastal brown bears safely at relatively close range in the wild. With the assistance of a guide, you can photograph these magnificent creatures fishing for salmon and interacting socially in a pristine environment.

SEPTEMBER
Denali National Park, Alaska (First Week) Denali National Park is true untamed wilderness, and a trip there during any month of the summer can be magical. The first week in September, however, coincides with peak fall color, the caribou migration, the start of the moose rut, and many active grizzly bears fattening up for the winter and hibernation.

Rocky Mountain National Park, Colorado (Second and Third Weeks) Few sounds in the wild are as haunting as the distant bugle of a bull elk. During mid-September in Colorado's Rocky Mountain National Park, this is a very common sound, as bull elk spar with each other, chase down cows, and keep general order within the harem. Be sure to keep a respectable distance and enjoy the show.

San Juan Mountains, Colorado (Third Week) Nowhere is the spectacle of autumn foliage any more amazing than in the San Juan Mountains of Colorado. Aspen-covered hillsides are ablaze in shades of gold, yellows and even orange, with the jagged peaks covered in snow. You may even be fortunate enough to visit during an early season snowfall and experience true photographer's bliss.

Baxter State Park, Maine (Third and Forth Weeks) The moose rut begins in mid-September and continues well into October in Baxter. Sandy Stream is the best place to see moose, although they can turn up anywhere in the Park. A sit-and wait approach is usually the best strategy for successful photography, and dawn and dusk are the best times.

OCTOBER
Autumn Colors—Green Mountains, Vermont; Adirondack Mountains, New York; White Mountains, New Hampshire; Great Lakes Region (First week) The finest autumn colors in the East and Midwest peak right around the first week of October in these premier locations. All of these locations feature classic Eastern hardwood forests with a high density of sugar maples, which are particularly spectacular in fall.

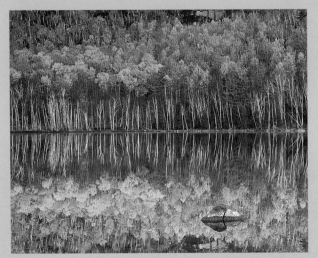

Adirondack State Park, New York (by Ian Plant).

Churchill, Manitoba (Second and Third Weeks) In mid-October, polar bears begin to congregate near the small town of Churchill in northern Manitoba, waiting for the ice to freeze on Hudson Bay. This presents rare, up-close encounters with polar bears from the safety of Tundra Buggies operated by a number of local polar bear tour companies.

Blue Ridge Parkway, North Carolina (Second and Third Weeks) Depending upon the area and elevation, some of the very best fall colors in the Southeast can be photographed somewhere along this scenic byway at nearly any time during the month of October. The blazing reds and yellows of fall complement the blue ridges of the distant mountains, making this an excellent autumn photography destination.

NOVEMBER

Zion National Park, Utah (First Week) Fall color peaks in Zion National Park sometime around the first of November, with a pleasant mix of golden cottonwoods and reds and oranges of the many deciduous hardwoods. All of this brilliant fall color, surrounded by the majesty of Zion, makes this a top photography destination for autumn foliage.

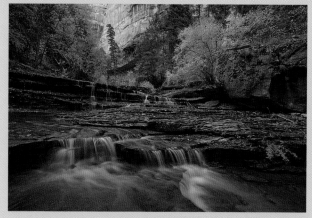

Zion National Park, Utah (by Guy Tal).

Chilkat Bald Eagle Preserve, Alaska (First and Second Weeks) In early to mid-November, the Chilkat Bald Eagle Preserve attracts hundreds of bald eagles with an abundance of spawned-out salmon and open water. The main viewing area is along the Haines Highway between miles 18 and 21, with the Chilkat River and the many bald eagles in clear view.

Cades Cove, Great Smoky Mountains National Park (Third and Forth Weeks) Late November offers photographers one of the best locations for capturing big white-tailed deer in the rut, with bucks chasing does and sparring with other bucks. Keep an eye out for wild turkey, coyotes, and an occasional black bear as well.

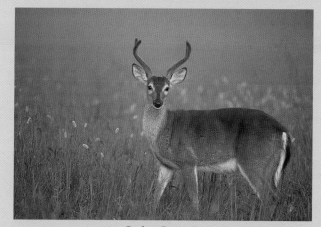

Cades Cove, Tennessee (by Bill Lea).

Bombay Hook NWR, Delaware; Blackwater NWR, Maryland; and Chincoteague NWR, Virginia (Forth Week into December) In late fall and winter, tens of thousands of migrating snow geese descend upon these three National Wildlife Refuges of the Mid-Atlantic, offering the photographer exceptional wildlife opportunities. In addition to the snow geese, Canada geese, tundra swans, great blue herons, bald eagles, and ducks are in abundance.

DECEMBER

Bosque Del Apache NWR, New Mexico (First and Second Weeks) During late fall and early winter, Bosque Del Apache hosts tens of thousands of migratory birds including the ever-vocal snow geese and sandhill cranes. Many professional bird photographers make annual pilgrimages to Bosque Del Apache for the abundance of birds and the amazing scenery as well.

Everglades National Park (First and Second Weeks) Everglades National Park in December offers great weather, few bugs, and concentrated wildlife viewing opportunities. This "River of Grass" supports an amazing array of wildlife photography subjects and beautiful and unique marsh landscapes.

"Beach Garden," Northern California coast during summer (by Marc Adamus).

appendix two scene tutorials

SUNSETS & SUNRISES

1) Be ready! One hour before sunset or sunrise is a good time to start scouting a location and setting up.

2) Wait for the "magic hour." The best light will usually happen during the half-hour period right before and after the sun sets or rises.

3) Sunrise and sunset images work best when there are some clouds in the sky. Breaking storms can make for the most dramatic images.

4) Use graduated neutral density filters to balance the exposure of the sky with the areas of the scene that are in shadow.

5) Use a lens hood or find some other way to shade your lens from stray light. This doesn't help much if you are shooting into the sun, but can prevent flare if you are working with side lighting.

Left: Autumn sunset, Blue Ridge Parkway, North Carolina (by Jerry Greer).

WATERFALLS & STREAMS

1) Use a sturdy tripod, the sturdier the better if you are set up in swiftly rushing water.

2) Try to get close to smaller foreground cascades to create perspective progression in the image.

3) Use a polarizing filter to remove unwanted glare from wet rocks and foliage.

4) Adjust your ISO and aperture to achieve a sufficiently long shutter speed to blur the water. Take some test images and use your camera's LCD display to see if you have achieved your desired effect. If you cannot get a long enough exposure, use a neutral density filter to reduce the amount of light coming in.

5) Most waterfall scenes work best in overcast or shaded light. A little bit of drizzle, or shooting right after rain, can help saturate colors and eliminate bright spots on dry rocks.

6) Consider bringing water sandals or waders with you when photographing waterfalls. This will allow you to wade into the water and give you more composition options. Just be careful if wading into fast moving water!

Right: Falls of Hills Creek, West Virginia (by Jim Clark).

WILDLIFE PORTRAITS

1) Use a long telephoto lens to capture images of wildlife.

2) Don't get too close! Avoid making the animal uncomfortable. Especially avoid making the animal eat you.

3) Use flash at a low power setting to create a catchlight in the subject's eyes.

4) Focus is critical. Make sure that the eyes are in focus. Manually focus if necessary.

4) As always, use a sturdy tripod!

5) Use image stabilization to prevent unwanted vibrations caused by moving the lens.

6) Pay close attention to the light at all times. Overcast lighting often works best for these shots. Mixed lighting can sometimes create too much contrast, but side lighting and back lighting can be very effective. Flash can be used to balance mixed lighting.

7) Be patient and wait for the animal to do something interesting or to make eye contact. Moments when animals are eating, grooming, or interacting with other animals can make for appealing photographs.

Right: Black bear (by Bill Lea).

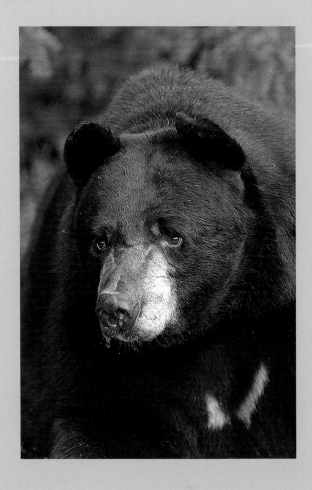

COASTAL SCENICS

1) Many coastal areas can have high tides and rough waves. Make sure you shoot from a safe spot so that you don't get stranded by the tide or dragged out to sea by a rogue wave!

2) Use shutter speed creatively to capture the motion of the waves. A longer shutter speed of several seconds or more will cause the wave action to completely blur, creating a misty or fog-like effect. A faster shutter speed, such as 1/4 to 1/30 of a second, can freeze wave action while still allowing for some motion blur, in the form of streaking waves. Take test shots and use your camera's LCD to make sure you have the right shutter speed.

3) Wait for the right moment! Trigger the shutter when waves crash on the shore. Try as many variations as time allows; each wave strike is different.

4) Use a polarizing filter to remove unwanted glare from wet rocky areas. Remember that polarizing filters block light—make adjustments to aperture or ISO as necessary to ensure you maintain your desired shutter speed.

5) Use a graduated neutral density filter if necessary to balance the exposure of the sky and water.

Above: "Ocean's Fury," Seal Rocks State Park, Oregon (by Marc Adamus).

AUTUMN COLOR

1) Conduct online research to determine when peak fall color occurs for a particular location. Peak color is usually the best time to be on location, although you can get great shots before peak when there is a mix of trees that have turned and those that have not.

2) Drizzly and overcast days can intensify the color of fall. Use a polarizing filter to intensify the color even further. Exclude white sky from the composition.

3) Wind can easily ruin a fall foliage scenic. Early mornings are often the calmest part of the day. If the wind is moving foliage a lot, consider using a longer shutter speed to create dramatic abstract images.

4) The bright colors of autumn give you many opportunities to juxtapose warm tones (foliage) with cool tones (such as blue sky or areas in shadow).

5) Look for reflections of fall color in flowing or still water. Remember that such scenes often work best when the foliage is lit by the sun, but the water itself (and any rocks in the water) is still in shade.

6) Fallen leaves give you an opportunity to control your scene. Experiment with autumn still lifes by arranging fallen leaves in an interesting pattern. When shooting landscapes, scatter fallen leaves in key areas to enhance your composition. Just make sure it looks natural!

Left: "Layers of Fall," San Juan Mountains, Colorado (by George Stocking).

DUNES

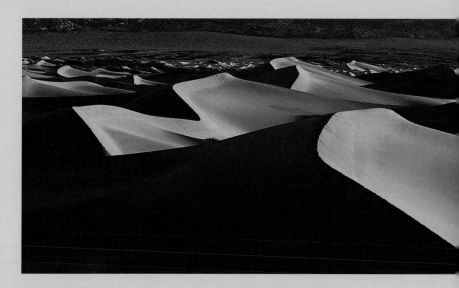

1) Sunrise and sunset are the best times to photograph dunes. On clear days, consider excluding the sky and concentrate on the interplay of light and shadow on the dunes. If there are some clouds in the sky that light up, include them in your composition.

2) Look for sinuous s-curves and repeating shapes when photographing dunes.

3) Wind is your friend when photographing sand features. Wind removes footprints left by yourself or others, and creates ripples in the sand and dramatic features at the crests of dunes. Blowing sand itself can make an interesting subject.

4) Set up your shot at an angle that will catch dunes, ripples, or other sand features at a side-angle, so that you can create dramatic contrast between lit areas and shadow.

5) Consider bringing a wide range of lenses. You will have opportunities to shoot wide angle images as well as intimate long lens images.

Right: Sand dunes, Death Valley National Park, California (by Nye Simmons).

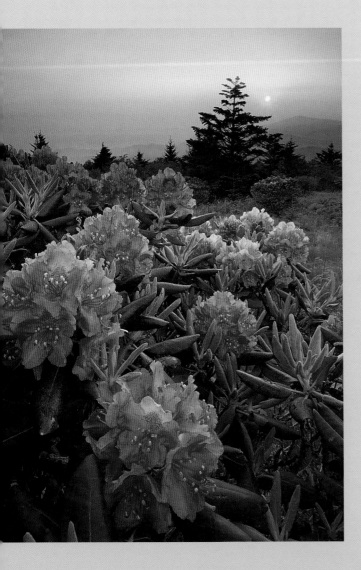

WILDFLOWER BLOOMS

1) Conduct online research to determine the peak bloom for a particular location. Remember that different flowers bloom at different times. Many areas experience blooms that start in early spring for certain species, and continue on to late summer or early fall for other species. Some blooms last for only a short period of time, so check an area as often as you can when peak bloom period nears.

2) Drizzly, misty, or overcast days can be great for photographing spring blooms. If working in mixed lighting, consider close-up shots of individual blooms.

3) Wind is particularly annoying when photographing flowers, especially if you are shooting macro or close-up shots. Early mornings are often the calmest part of the day. Use wide apertures or high ISO settings to freeze action.

4) Consider using the tilt feature of a perspective control lens to achieve near to far focus when photographing a clump or a field of flowers.

5) Bring macro lenses and extension tubes when photographing flowers. Use of an extension tube with a wide-angle lens can give you a dramatic close-up perspective.

6) When shooting fields of flowers, use a wide-angle lens to get in close to nearby flowers, and use more distant flowers as middle-ground and background elements.

Left: Rhododendron bloom, Roan Highlands, North Carolina & Tennessee (by Richard Bernabe).

BIRD IN FLIGHT

1) Use a long telephoto lens to get in close to the action.

2) Choose a fast shutter speed to freeze the action: 1/500th second or higher is best.

3) Wait for a moment when the bird wheels in the sky, or when it is about to land or take off. Having the bird's wings extended up is usually better than when the wings are extended down.

4) Use flash at low power to create a catchlight in the eye and to bring out the bird's color.

5) Sometimes it is best to shoot these images hand-held, as a tripod may not allow you to move fast enough to keep your lens aimed at the bird. Consider using a shoulder mount to help stabilize the lens. Make sure you turn on your lens' image stabilization.

Right: Swainson's hawk with prey (by Guy Tal).

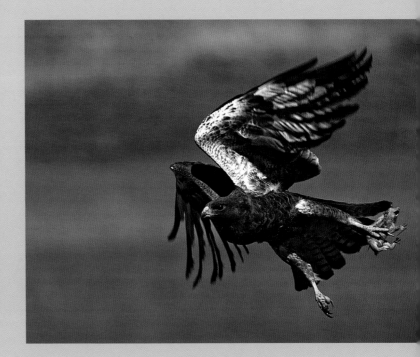

STAR TRAILS

1) Set up your composition when it is still light out. Setting up in the dark can be tricky! Bring a compass or a GPS with you so that you can figure out where north is. If you want your shot to be polar-aligned so that concentric star circles will form around the North Star, you need to point your camera north.

2) Choose a scene that will not require too much depth of field. In order to ensure clear star trails, you want to shoot as wide open as possible. F5.6 and f8 both work well if you need a little depth of field.

3) You can get the best star trails on a clear cold night with no moon, as far away as possible from light pollution sources such as cities or towns.

4) Wait until it gets dark—completely dark—before you start your exposure.

5) Take a 30-second test image using your highest ISO setting to check your exposure. Lower your ISO to the desired setting and increase your exposure time accordingly. Set your ISO to anywhere between 100 and 400.

6) Using your camera's bulb setting, start your exposure and lock your remote. The longer your exposure, the longer your star trails will be. Anywhere from 20 minutes to 2 hours will give you great star trails. Use an external battery pack for longer exposures.

7) Turn on your camera's noise reduction setting if temperatures are above freezing.

Right: Old Faithful at night, Yellowstone National Park (by Ian Plant).

CLOSE-UPS

1) Use macro lenses and extension tubes to get the magnification you desire.

2) Use wide apertures to throw the background out of focus, or stop down when deep focus is required.

3) Control your light using diffusers, reflectors, or flash.

4) Use mirror lock-up and a remote shutter release to ensure that there is no camera or lens vibration when you trigger the shutter.

5) Focus is especially critical when shooting macro subjects. Use Live View at 100% magnification to focus your image.

6) A macro slider—a device that allows for very precise forward/back and left/right movements—may be very useful when composing macro images.

Left: Skipper and pink water lily (by Ian Plant).

MOUNTAIN LAKES

1) Sunrises and sunsets make great subjects to reflect in the waters of a mountain lake. Having some clouds in the sky works best.

2) Look for foreground features such as boulders in the water.

3) Select a small aperture to maximize depth of field, such as f11 or f16.

4) Use graduated neutral density filters to balance the exposure of the sky and the water.

5) Wind can ruin reflections in the water. Try to shoot when the water is still.

6) A layer of fog over the water can enhance the mood. Cool, moist nights improve your chances of getting mist in the morning.

Right: "Tranquility," Sparks Lake, Oregon (by Marc Adamus).

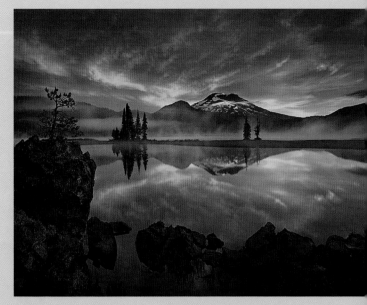

FOREST ABSTRACTS

1) Overcast light works best for these scenes. Mixed light may produce too much contrast. Waiting until after a light rain is good—it will saturate the colors and darken tree trunks, creating the perfect amount of contrast for your image.

2) Use a tripod with a head that pans up and down independent of other movements.

3) Use a polarizing filter to reduce glare, intensify colors, and reduce the amount of light coming in through the lens. This will help you get a longer shutter speed.

4) Using a shutter speed of one-half or one second, smoothly pan the camera up during the exposure. Make sure you leave some room at the top for extra panning when composing the image.

5) If you are using a camera with multiple exposure capability, or if you are comfortable with blending multiple exposures on the computer, take a bunch of exposures, panning the tripod head up an incremental amount between each exposure.

6) Use your camera's LCD screen to view your results. Experiment often and try many variations—it may take a while before you get the results you want.

7) Don't be afraid to gives these shots a fair bit of color boost. Because of their abstract nature, extra bold colors can enhance their mood and help bring the image to life.

Left: "Spring Woods Abstract," Great Smoky Mountains National Park, Tennessee (by Joseph Rossbach). This images was created using multiple exposures, with the camera position moved slightly between each exposure.

Principal Authors and Executive Editors

Richard Bernabe has had thousands of images published in magazines, calendars, and books. His first book, *South Carolina Wonder and Light*, was published in 2006. He currently serves as Editor-in-Chief of Nature Photographers Online Magazine. Richard is a managing partner of Mountain Trail Press and Mountain Trail Photo.

Ian Plant's work has appeared in numerous calendars and magazines (including *Outdoor Photographer* and *National Parks*). Ian is the author and photographer of six books, and a Contributing Editor to Nature Photographers Online Magazine. Ian is a managing partner of Mountain Trail Press and Mountain Trail Photo.

Contributing Authors

Jerry Greer's award-winning images have been published in six books and numerous calendars, magazines (including *Backpacker* and *Mountain Bike*), and conservation and advertising campaigns. Jerry is a managing partner of Mountain Trail Press and Mountain Trail Photo.

George Stocking's award winning images have graced the covers of such publications as *Arizona Highways*, *Outdoor Photographer*, and the Audubon Engagement Calendar. George has also won awards in international competitions such as Wildlife Photographer of the Year and Nature's Best.

Bill Lea's photos have appeared in numerous books, calendars, magazines, and other publications, including Audubon calendars, *BBC Wildlife*, National Geographic books, *Nature Conservancy*, *National Wildlife*, and many others.

Joseph Rossbach's work has been published in magazines, calendars, advertising campaigns, web sites, art galleries and books. A few of Joe's clients include *Blue Ridge Country* Magazine, *Digital Camera World*, and *Photo Techniques* Magazine.

Guy Tal's internationally-acclaimed images and articles have been published worldwide in such publications as *Outdoor Photographer* Magazine, *Popular Photography*, *Digital Photographer* (UK), *Unique Image* (Taiwan), and numerous others.

Jim Clark is a contributing editor for *Outdoor Photographer* Magazine, and his images have appeared in many other magazines such as *Nature's Best, Defenders,* and *Wildlife Refuge*. Jim is the author and photographer of three books, and a past president of the North American Nature Photography Association.

Marc Adamus' photographs have been published extensively worldwide in a large variety of media ranging from calendars, books, advertising and the publications of National Geographic, *Outdoor Photographer*, *Popular Photography*, and many more.

Nye Simmons has been published in regional as well as national publications, books, posters, calendars, and exhibits. Nye is the author and photographer of four books, including most recently "Best of the Blue Ridge Parkway."

About the Mountain Trail Photo Team

Mountain Trail Photo was formed to promote the art of nature photography. Collectively, the Team has sold more than 100,000 books and calendars; their images have appeared in many top outdoor and photography magazines; and they have led numerous nature photography workshops. To see more of the Team's images, or to book a workshop with one of the Team members, visit **www.mountaintrailphoto.com**.

About the Nature Photographers Network

The Nature Photographers Network™ (NPN) is an international cooperative network of amateur and professional photographers dedicated to the art and technique of nature photography, and the use of nature photography as a means for generating interest in habitat and wildlife conservation.

Nature Photographers Online Magazine—**www.naturephotographers.net**—is the official website of NPN. The site features instructional articles, gear and location reviews by some of today's most talented nature photographers. The site also features lively discussion forums and image critique galleries, making it an extraordinary online resource for all nature photography enthusiasts. Additional information on NPN membership can be found at **www.naturephotographers.org**.